SECRETS OF LOVE

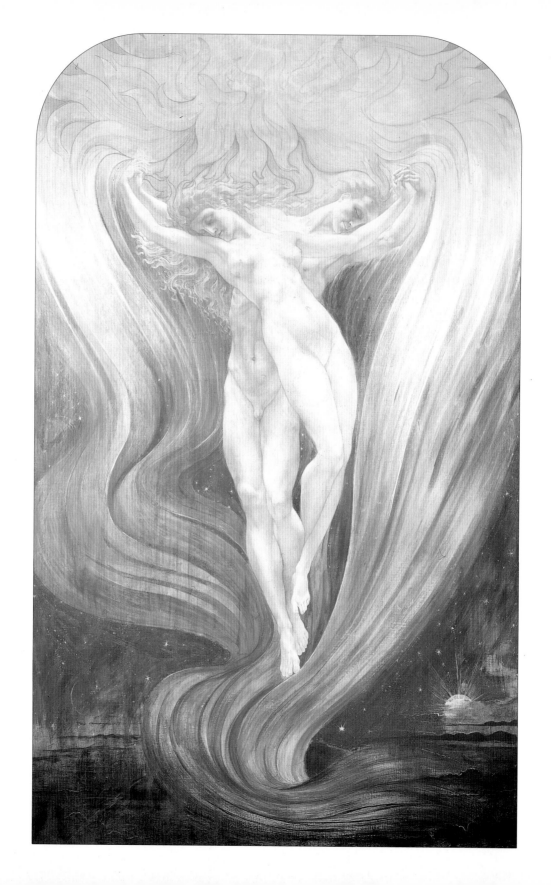

SECRETS OF LOVE

The Erotic Arts Through the Ages

NIGEL CAWTHORNE

HarperSanFrancisco

An Imprint of HarperCollins*Publishers*

SECRETS OF LOVE: *The Erotic Arts Through the Ages.*
Copyright © 1997 by Nigel Cawthorne; illustrations © as in the
acknowledgments on page 192.

For information address HarperCollins Publishers,
10 East 53rd Street, New York, NY 10022.
HarperCollins Web Site: http://www.harpercollins.com
HarperCollins®, 📖 ®, and HarperSanFrancisco™ are trademarks of
HarperCollins Publishers Inc.

Library of Congress Cataloging-in-Publication Data
Cawthorne, Nigel.
Secrets of Love: The Erotic Arts Through the Ages/Nigel Cawthorne.
--1st ed.
p. cm.

ISBN 0-06-251362-1 (pbk.)
1. Erotica. 2. Erotic art. 3. Erotic 1. Title.
HQ460.N37 1997
306. 7--dc20 94-23173
CIP
97 98 99 00 01 PAV 10 9 8 7 6 5 4 3 2 1

Frontispiece: Jean Delville's *Soul Love* shows the ideal of love – two bodies fusing into one.

CONTENTS

Preface 6

THE OBJECT OF DESIRE 14

THE ANATOMY OF LOVE 36

SWEET SURRENDER 60

THE ACT OF LOVE 86

FORBIDDEN FRUITS 130

Further Reading 192
Photographic Acknowledgments 192

\mathscr{P}REFACE

The Western world is obsessed with sex. It is used as a marketing tool, as a weapon in political struggle, as the mainstay of modern journalism and as the daily fodder of soap operas and afternoon shows. In the process, its currency has been debased. Sex has become mechanical – to the point where modern sex education concentrates on biology, contraception, social responsibility and the prevention of disease.

In contrast, the ancient instructional tracts discuss the aesthetic aspects of sex, its joys and its delights. The humanist writing of the Renaissance and the erotic memoirs of the eighteenth and nineteenth centuries speak of its robust pleasures.

Artists and painters have also struggled to depict the human sexual experience. For in sex we are most truly human – at once both animal and god-like. Certainly sex is not something we can do without. No amount of mortification of the flesh will still the sexual impulse. In the fourth century St Jerome tried it. To escape from sin, he became a hermit in the desert. But still he could not get sex off his mind:

I, who from the fear of hell had consigned myself to that prison where scorpions and wild beasts were my companions, fancied myself among bevies of young girls. My face was pale and my frame chilled from fasting, yet my mind was burning with the cravings of desire, and the fires of lust flared up from my flesh that was as that of a corpse.

In ancient China it was said:

In this world no one can completely free themselves from the Seven Feelings and Six Desires. There is no escape from the fatal circle of wine and women, and wealth and ambition...Experience shows that of these four evils woman and wealth bring the most disaster.

The inscription on the plinth of a statue of Sardanapalus, the son of Anacydaraxes, who

Sigmund Hampel's *Fantaisie*. Everybody has their secret fantasy lover.

Opposite: A prince and his lady practise a combination of two canonical positions from the *Kama Sutra*.

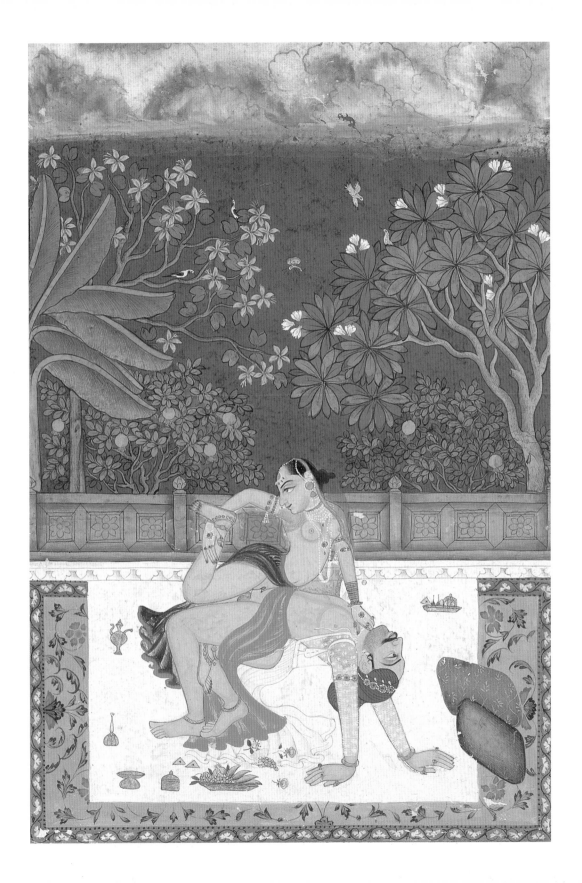

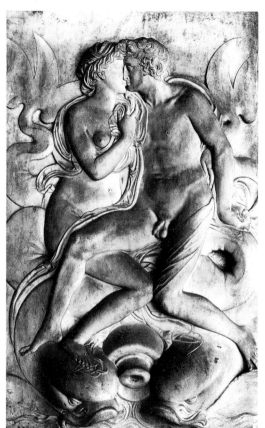

A kiss was, plainly, not just a kiss in fourteenth-century Florence.

conquered Anchiale and Tarsus on a single day, put it more simply: 'Eat! Drink! Love! For there is nothing else.'

From the earliest times, artists, poets and writers have tried to unravel the secrets of love and to commit what they have learned to paper. In the second century AD the Greek author Longus wrote:

> While hunting game on Lesbos I saw in a grove of Nymphs the most beautiful vision I ever saw...As I watched, I yearned to duplicate the sight. I searched out the explanation of the vision and wrote it down in four books, which are an offering to Eros and the Nymphs and Pan, a joyful possession for everyone which will heal those who are sick with desire and console anyone in sorrow, will remind anyone who has loved and prepare anyone who is yet to love. For it is a universal truth that no one has ever or will ever escape desire as long as there is beauty and the eyes to see it. May God grant us soundness of mind as we write of the experiences of others.

The Roman poet Ovid, who lived around the time of Christ, wrote the *Ars amatoria*, which is one of the earliest Western sex manuals. It begins:

> If anybody here does not know the art of loving, let him read this.
> After reading my poem, he will be an expert lover.

Love, he believed, was an art. To the many who are disappointed in it he said:

> I will reveal the cause of your downfall: you did not know how to love.
> You lacked art: it is only by art that loves survives.

In the East, love and sex had been the subject of serious literature for centuries before Ovid. The editor of the ancient Chinese book *The Art of the Bedchamber* wrote:

> The Art of the Bedchamber forms the pinnacle of human emotions, encompassing the Tao [or Supreme Way]. The ancient rulers regulated man's outer pleasures to control his inner passions

From the earliest times artists have struggled to depict sex. Here Ramses II makes an offering to the god Min.

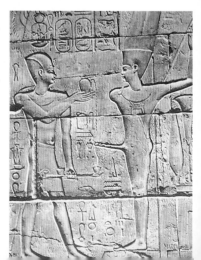

and made detailed rules for sexual intercourse. It is written: 'Sexual pleasure was created by the ancients to govern all human affairs.' If you control your sexual pleasure, you will be at peace and live to a great age. But if you abandon yourself to pleasure, disregarding the rules as laid out here, you will become sick and endanger your life.

Taoists believed that love and the whole of life was about the balance of the *yang* – or male essence – and the *yin* – or female essence:

If the yin and yang are balanced, the souls find a place where they can merge. The *yang* spirit is the soul of the sun; the *yin* spirit is the soul of the moon. When the sun and the moon come together, they form a house. Man's nature is governed internally and makes a shape. Man's passion is governed from without and forms the walls of the house. Once these walls have been established, the two people can safely go ahead. Passion unites the *ch'ien* and the *k'un*. The *ch'ien* moves and is strong, his vital essence spreads out and his semen is stirred. The *k'un* remains still and harmonious. She is a haven for Tao. When the hard has shed its essence, the soft dissolves in moisture. Nine times returning, seven times resuming, eight times coming back, six times staying. The man is white, the woman is red. When the metal has mixed with the fire, the fire is extinguished by the water.

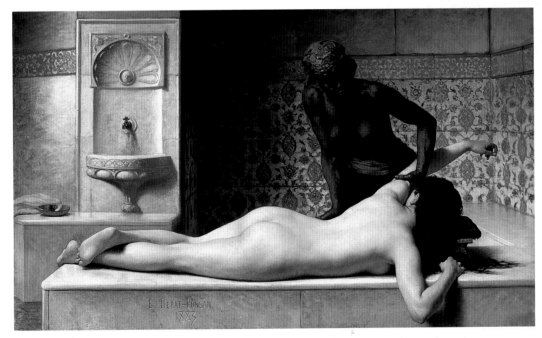

The Massage, by Edouard Debart-Ponsan, depicts the act of touching as a supremely sensual experience.

Pompeii's secrets of love were buried under ashes for centuries.

According to the Chinese, sex is also vital in the prevention of disease and the promotion of longevity. Su Nü, sexual adviser to the Yellow Emperor, wrote:

> All men's illness can be attributed to the incorrect exercise of the sexual act. Woman is superior to man in the way water is to fire. Those who are expert in sexual intercourse are like good cooks who know how to blend the five flavours into tasty broth. Those who know the art of *yin* and *yang* can blend the five pleasures. Those who do not will die an untimely death, without really having tasted the pleasure of the sexual act.

Although the Taoist view of sex has a lot to recommend it, it is easy to get lost in the mumbo-jumbo. This book aims to take a more relaxed view of the secrets of love. As the Roman writer Achilles Taitus said:

> Love is handy and resourceful, a clever philosopher, who can turn any place into a temple for mystical thought. The casual in sex is far more sweet than the carefully prepared. For its pleasure is natural and simple.

The Arabs have always had a more robust attitude to sex. *The Book of the Thousand Nights and One Night* says simply:

> Love is not content with blushes,
> Kisses taken from pure lips,
> Not content with wedded glances;
> Love must have a thing which dances,
> Love must have a thing which gushes,
> Love must have a thing which drips.

Balthus's *Nude with a Cat* expresses the pleasure of sexual longing.

While in modern-day Japan there is a classic sex manual called *How to Make a Nymphomaniac Faint with a Single Thrust*.

But, for me, the English poet John Attey put the pleasures and pains of love in proper perspective. In the poem 'My Days, My Months, My Years', written in 1622, he captures the fleeting delights of sex:

> My days, my months, my years
> I spend about a moment's gain,
> A joy that in th'enjoying ends,
> A fury quickly slain.

Hindu asparas, or water nymphs, provided sexual pleasures in paradise.

A frail delight, like a wasp's life
　　Which now both frisks and flies,
And in a moment's wanton strife
　　It faints, it pants, it dies.

And when I charge, my lance in rest,
　　I triumph in delight,
And when I have the ring transpierced
　　I languish in despite;

Or like one in a lukewarm bath,
　　Light-wounded in the vein,
Spurts out the spirits of his life
　　And fainteth without pain.

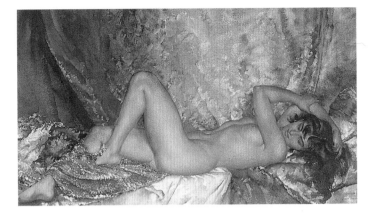

Sir William Russell Flint's nude is an unattainable object of desire.

Sexual love is both profound and frivolous, enduring and ephemeral, base and transcendent – a mirror to life itself. This book aims to explore the secrets of love imparted by the ancients and to look behind the bedroom doors of history – not in a prurient way, but to discover our common humanity. It aims to shed light in the dark corners of our lives and to find beauty in what many consider base. For surely true civilization rests on the worship of beauty and a proper appreciation of what it is to be alive.

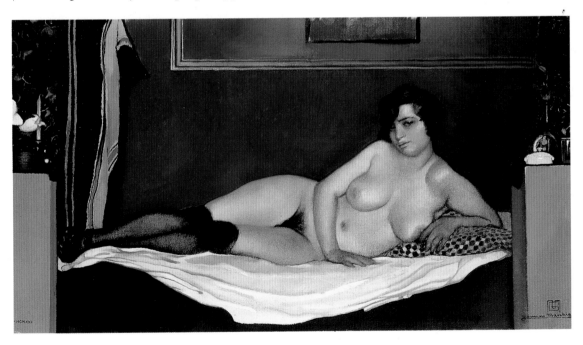

Nu Couché appears much more available.

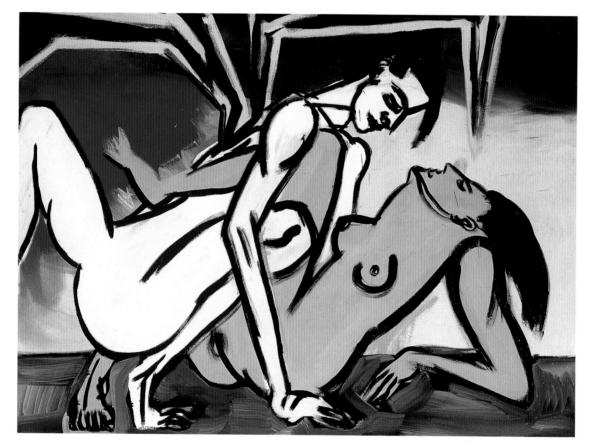

Above: Rainer Fetting's *Vampire* is not content with biting necks.

Opposite: Picasso's *Couple* celebrate in the innocent enjoyment of love.

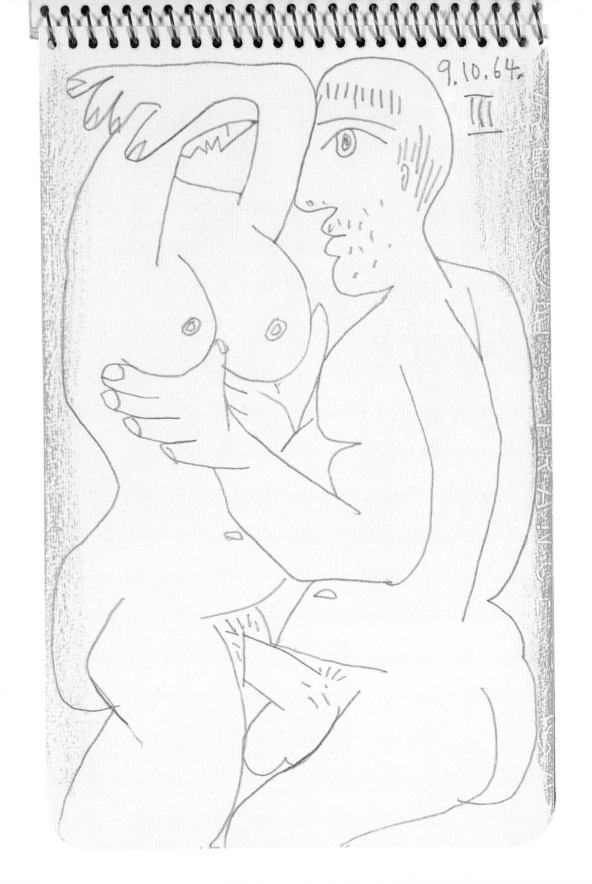

9.10.64.
III

THE OBJECT OF DESIRE

Praise be to Allah, who bejewels young girls with bell-shaped breasts and who weaves the thighs of women into anvils for the pounding sledge hammers of men.

THE SCIENCE OF COPULATION

Guillaume Seignac's *Portrait of a Young Beauty* is a man's idealized vision of a lover.

Throughout history men and woman have dreamt of finding the perfect sexual partner. Women have been at a great disadvantage when it comes to finding their ideal object of desire. Usually they have had to wait and hope that the right man would come along. Men, on the other hand, have had the opportunity to go out and look for the ideal lover. They have had to make choices, and there is no end to the advice that literature gives on what to look for in the perfect woman. But it usually amounts to one thing – get them young. One ancient Chinese text says:

> A man should pick young women whose breasts have not yet developed and who are well covered with flesh. They should have hair fine as silk and small eyes, where separation of the pupil and the white is well defined. Her face and body should be smooth and her speech harmonious. Either she should have not pubic hair or it should be fine and smooth.

Of course, these days it is not usually practical for a man to discover whether a woman has pubic hair or not, or whether it is smooth or rough, before he begins courting. But in ancient China it was perfectly possible to send someone to check out the potential part-ner. In *Secret Sketches of the Han Palace*, the anonymous author describes a journey that Madame Wu and the eunuch Ch'ao made around AD 150 to examine the daughter of a general, Nu Ying, on behalf of the Emperor Huang Tsi:

Opposite: Even an angel can be seduced by beauty, as in Antonio Canova's *Psyche Revived by the Kiss of Love*.

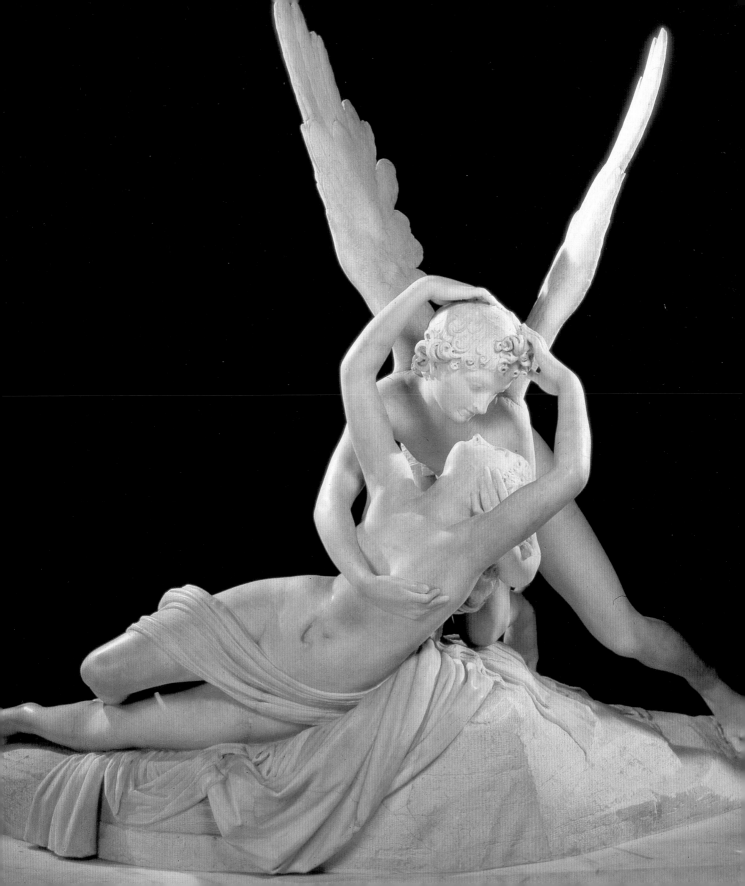

A woman is all the more sensual for being real. Anders Zorn, *Nude Standing in an Interior.*

With Ch'ao in the outer room, Madame Wu took Nu Ying into the bedroom. The maids were sent away and the door was locked. Nu Ling's face was lit by the sun. She looked radiant, like snow in the morning sunlight. Her eyes were as clear as a tranquil sea. Her eyebrows were long and shapely. Her white teeth stood out against her tiny red mouth. Madam Wu pulled out Nu Ying's hairpin and her hair cascaded like black satin to the floor.

After feeling the hair, Madam Wu told Nu Ying to take off her underwear. Blushing, the young girl refused. The older woman told her that it was an imperial order and she must obey.

Nu Ying began to cry and turned her face to the wall. Then Madame Wu gently undressed her. She carried her naked body into the sunlight. It was smooth. Her skin was creamy and the fragrance of her body filled the air. Her breasts were firm and large enough to fill a cupped hand and her navel was deep enough to carry a pearl half-an-inch in diameter.

Madame Wu was delighted with Nu Ying's slightly raised pubic mound. Then, gently, she parted the young girl's thigh to find her jade gate scarlet like a glowing fire. 'She is a pure and chaste virgin,' cried the older woman.

Until recent times a high price was put on virginity – these days the premium is on experience. Virginity was particularly prized in China, but not for the usual reasons of masculine pride. The master Peng Tsu explains:

> If a man wants to obtain the greatest benefit from sex, he should find inexperienced women. Making love to virgins will restore his youthful looks. What a pity there are not more virgins about. The ideal virgin is between fourteen and nineteen, though any woman under thirty will do, provided she has not had a child. My late master followed the principles strictly and he lived to the age of 3,000. One can become immortal if one takes herbs at the same time.

Tibet's Vajravarahi, a Dakini and the partner of Heruka, is the female personification of intense passion.

A young woman is initiated into Dionysiac mysteries in the Villa of Mysteries in Pompeii.

The Taoist masters' approach to lovemaking concentrates on its benefits to health and longevity. But that did not mean there was no room for love. A poet from the Ming Dynasty perfectly explained the facets of sexual attraction:

> I think you are totally adorable
> Your skirt reveals your thighs
> Stirring painful passion in me
> I think your waist is like a willow tree
> Your smell is like an orchid
> Your face its flower.

Another Ming poet, Shen Mao-hseuh, took these ideas of female beauty into the bedroom:

> Shrouded by the lace bed curtains.
> She is beautiful and shaped in the nude.
> The heart of the flower is ruby red
> Almost as red as rouge.
> So fragrant, she melts like the snow
> 'You reckless devil, do not crush
> The flowers in my hair.'
> She fondly blames my growing vigour.

Ideas of female beauty are much the same in different parts of the world, though there are variations in emphasis. Over 3,000 years ago in ancient Egypt, an anonymous poet described his love:

> She is one girl, there is no other like her.
> She is more beautiful than any other.
> Look at her, she is like a star goddess arising
> at the beginning of a new year;
> brilliantly white and bright skinned;
> with beautiful eyes for looking;
> with sweet lips for speaking;
> she has not one word too many.
> With a long neck and a white breast,
> her hair is of lapis lazuli;
> her arms are more brilliant than gold;
> her fingers are like lotus flowers,
> with heavy buttocks and slender waist.
> Her thighs offer up her beauty,
> with the brisk step she walks on the ground.
> She captures my heart with her embrace.
> She makes all men turn their heads
> to look at her.
> They look at her passing by,
> this woman, the only one.

Many centuries later the Orientalist Sir Richard Burton laid out a vision of perfect Arabian loveliness:

> She hath those hips conjoined by thread of waist: hips that o'er me – and her,
> too – tyrannize;
> My thoughts, they daze whene'er I think of them – and jewel between, that fain
> would cause prickle to upstand.
>
> The veil from her shoulders had slipt – and show her loosened trousers. Love's seat
> and stay –
> And rattled the breezes her huge hind-cheeks, and the branch whereon two little
> pomegranates lay.
>
> Boylike of backside: in the deed of kind, she sways and sways the wandlike
> boughs a-wind...

Opposite: Clementine Hélène Dufau's *Moorish Beauty* is a European fantasy.

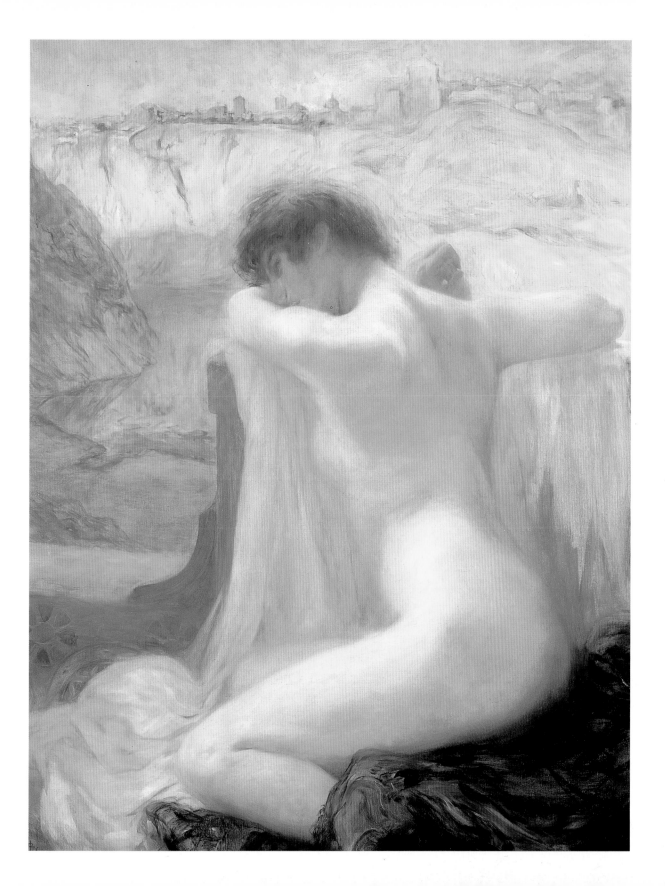

If I likened thy shape to the bough when green, my likeness errs and I sore mistake it;
For the bough is fairest when clad the most, and thou art fairest when mother-naked!

Her bosom is a marble slab, whence rise two breasts like towers on lea;
And on her stomach shows a crease, perfumed with perfumery;
Beneath which, same, there lurks a Thing: limit of my expectancy;
A something rounded, cushioned high – and plump, my Lords, to high degree;
To me, 'tis likest royal throne: whither my longings wander free;
There, 'twixt two pillars, man shall find benches of high-built tracery;
It hath specific qualities, driving sanest men to insanity,
Full mouth, it hath, like mouth of neck – or well-begirt by stony key;
Firm lips with camelry's compare, and shows it eye of cramoise [crimson cloth];
And draw thou nigh, with doughty will, to do thy doing lustily:
Thou'll find it fain to face thy bout, and strong and fierce in valiancy;
It bendeth backward every brave, shorn of his battle-bravery;
At times imbibe, but full of spunk, to battle with Paynimry [paganism]:
'Twill show thee liveliness galore, and perfect is its raillery,
The sweetest maid it is also like, complete in charms and courtesy.

The Greek physician Dioscorides left us some idea of what the men of ancient Greece liked:

They drive me mad, her rosy lips,
The vermilion gate of song,
Wherefrom my soul its nectar sips,
And her soft and whispering tongue.
Her eyes with liquid radiance dart,
Beneath their lashes close,
Traps to ensnare my quaking heart,
And rob me of repose.
Her breasts, twin sisters firmly grown,
A milky fountain pour,
Two hills that love their master own,
More fair than any flower.

An English vision of female loveliness is outlined in 'She Lay All Naked in Her Bed', written in 1656:

Louis Robert Carrier-Belleuse, *La toilette*. Many artists get a voyeuristic pleasure from depicting a woman washing.

Goya's *Naked Maya* reveals the splendour only implied in its clothed counterpart.

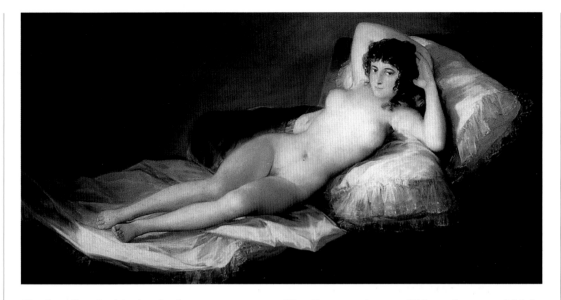

She lay all naked in her bed.
 And I myself lay by;
No Veil but curtains about her spread.
 No covering but I:
Her head upon her shoulders seeks
 To hang in careless wise,
All full of blushes was her cheeks,
 And of the wishes were her eyes.

Her blood still fresh into her face,
 As on a message came,
To say that in another place
 It meant another game;
Her cherry lip moist, plump and fair,
 Millions of kisses crown,
Which ripe and uncropt dangle there,
 And weigh the branches down.

Her Breasts, that swell'd so plump and high,
 Bred pleasant pain in me,
For all the world I do defile
 The like felicity;
Her thighs and belly, soft and fair,
 To me were only shown:
To have seen such meat, and not to have eat,
 Would have angered any stone.

Her knees lay upward gently bent,
 And all lay hollow under,
As if on easy terms they meant
 To fall unforc'd asunder;
Just so the Cyprian Queen did lie,
 Expecting in her bower;
When too long stay had kept the boy
 Beyond his promis'd hour.

 Similitudes to make?'
Mad with delight I thundering
 Threw my arms about her,
But pox upon 't 'twas but a dream
 And so I lay without her.

The sensuality of *La Venus de Pradier* by Lenhoir is perfectly expressed in white marble.

From the earliest times literature is full of men dreaming of their perfect loves. In the sixth century Macedonius wrote:

> In my arms I held her tight,
> And saw her eyes with laughter gleam,
> Close together in the night,
> Though it was just a dream.
> All her body I caressed,
> Nor did she reluctant seem.
> Each soft limb on me pressed,
> And yielded – in my dream.
> But everything I tried
> To plunge deep in passion's stream,
> By Cupid I was denied
> And lost my lovely dream.
> Oh, he is a jealous boy,
> And lies in ambush, so it seems
> He will not give us perfect joy
> Not even in a dream.

The woman is all too real in 'The Maid a Bathing', written in 1650, and the results are altogether more satisfactory:

> Upon a Summer's day
> 'Bout middle of the morn,
> I spy'd a Lass that lay
> Stark nak'd as she was born;
> 'Twas by a running Pool,
> Within a meadow green,
> And there she lay to cool,
> Not thinking to me seen.
>
> Then she did by degrees
> Wash every part in rank,
> Her Arms, her breasts, her thighs,
> Her Belly and her Flank;
> Her legs she opened wide,
> My eyes I let down steal,

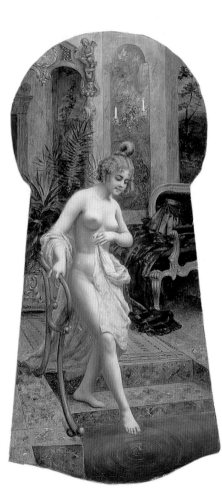

Views through Keyholes: the Bath by Moritz Stifler is blatant with its voyeuristic delight.

Until that I espied
 Dame nature's privy Seal.

I stripped me to the skin,
 And boldly stepped out to her,
Thinking her love to win,
 I thus began to woo her:
Sweetheart, be not so coy,
 Time's sweet in pleasures spent,
She frowned, and cried, away.
 Yet smiling, gave consent.

Then blushing, down she slid,
 Seeming to be amazed,
But heaving up her head,
 Again she on me gazed.
I seeing that, lay down,
 And boldly 'gan to kiss,
And she did smile, and frown,
 And so fell to our bliss.

Then lay she on the ground
 As though she had been sped,
As women in a swoon,
 Yield up, and yet not dead:
So did this lively maid,
 When hot blood fill'd her vein,
And coming to herself she said,
 I thank you for your pain.

An illustration by Maillol for Lucian's *Education of a Courtesan.*

Sadly, the poet Sir John Suckling did not get that far with Lady Carlisle, the beautiful mistress of the powerful Lord Buckingham. Nevertheless, each day he would watch her take her walk around the gardens at Hampton Court, undressing her in his mind, and wrote:

I was undoing all this wore
And had she walked but one turn more
Eve in her first state had not been
So naked or so plainly seen.

The nineteenth-century poet Algernon Swinburne had more luck. He describes his perfect mate in more intimate surroundings in 'Love and Sleep':

> And all her face was honey to my mouth,
> And all her body pasture to mine eyes;
> The long lithe arms and hotter hands than fire,
> The quivering flanks, hair smelling of the south,
> The bright light feel, the splendid supple thighs
> And glittering eyelids of my soul's desire.

But finding such a flawless specimen did not necessarily guarantee undiluted pleasure. Dark sexual forces could easily lure one to destruction. Lü Yen, a poet of the T'ang Dynasty who practised virtue through the mortification of the flesh, warned:

> Beautiful is the sweet maiden of eighteen years
> Her breasts are soft and white –
> But below her waist she carries a double-edge sword
> That will bring destruction to all foolish men.
> Although one does not see their severed heads roll,
> Yet it drains your bones of the last drop of marrow.

Spoilt for choice – *The Sultan and His Four Thousand Women* by Thomas Rowlandson.

As an Arab philosopher once said: 'Three things are insatiable: The desert, the grave and a woman's vulva.' And the Arab world is full of dire warnings about the power of woman's sexuality. 'Man's shame extends from his navel to his knees; while a woman's shame extends from the top of her head to the tips of her toes,' runs one proverb. Another says: 'Man is fire, woman is tinder.'

Pandit Kalyanamalla, the author of the *Anangaranga*, believed that a woman's sexual desire is ten times stronger than a man's and wrote: 'A man can never keep a woman under control; women are always unbridled in their passions.'

But the real fear for men is that they can never know what women are thinking. It is said that for a man:

> It is easier to discover flowers on the sacred fig-tree, or a white crow, or the imprint of fishes' feet than to know what a woman has in her heart.

Even selecting a woman in the harem is fraught with danger:

> Display your discernment by picking one who has not only firm breasts, a slim waist and heavy hips – but also one with large buttocks. Muslims and Negroes venerate protruding buttocks, particularly if their natural parts are large, but in proportion.
>
> The Hebshee females are especially sought after. Her strong interior muscles produce a greater intensity of carnal pleasure. But, over all other considerations, be careful not to pick a *sehheekeh*.

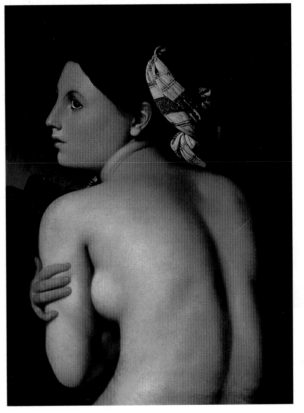

Jean-Auguste Ingres seeks pleasure from just one woman in *Naked Lady from Behind.*

A *sehheekeh's* greatest pleasure comes from rubbing her clitoris against another clitoris, playing with the eunuchs who still have a penis and watching them play with baboons. She hates ordinary virile men. She loves to arouse a man until his penis is at its fullest erection, then have a eunuch slice it off. Some, as a foreplay, beat the man's testicles, twist and crush them, or tear them out with her razor-sharp fingernails. Others are so devilish that they will tear off an erect penis or bite off its swollen head with their teeth. These women are picked out by their ugly faces and their protruding clitoris.

In literature, men have tried to get to grips with female longing, though male writers use it as a source of fantasy. In 'To the Rescue', poet-playboy Hemman bin Ghalib el-Feredek describes a woman craving a lover:

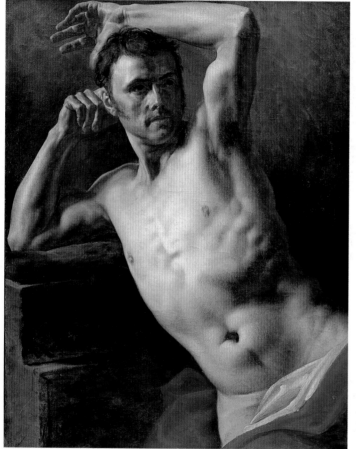

Man Naked to the Waist, attributed to Théodore Gericault, idealizes masculine beauty.

Said she as genuine desire
Ran riot inside her,
While the shadowy veil of night
Fell like a dark tide:
'Oh night, in your blackness
Is there no-one to come to me?
Is there no swordsman for this sheath
Among all men far and wide?'
Then with her hand she rubbed her sex
And said, while she sighed
The sighs of the melancholy
The sad, the weepy-eyed:
'As the toothpick helps reveal
The beauty of the teeth,
So the penis
To the cunt applied
Shows the beauty of the sheath!
Oh Moslems, don't your pricks stand up
On end and is there none
Amongst you who will save her
Who begs relief,' she cried.

And who can save this poor, pining maiden? Why, Hemman bin Ghalib el-Feredek himself, of course:

Then my rod thrust out, erect
From underneath my clothes,
And said to her: 'Here! This is for you.'
And while I untied
The laces of her pantaloons
She made a show of fear and said:
'Oh Allah, who are you?'

'A young man who answers to
Your beck and call,' I replied.
And straightaway I fell to thrusting in
Her slit a wrist-thick yard –
A lusty stroke that well-night left
Her buttocks mortified.

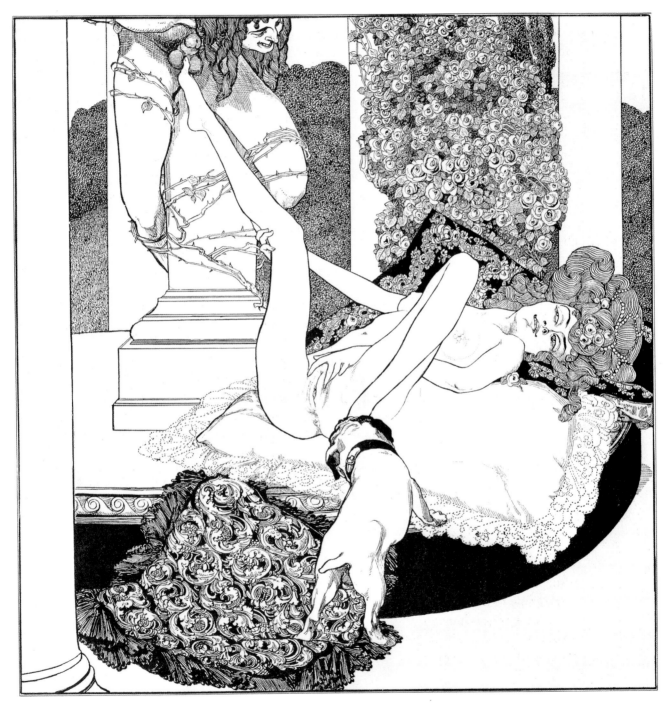

Tantalus from Marquis Franz von Bayros's *Tales at the Dressing Table*.

In ancient China another beautiful woman is waiting. In his essay *On a Beautiful Woman* the Han-Dynasty writer Szu Hsaing-ju describes this lovely girl in her room, reclining on a couch, like a strange flower of unsurpassed elegance. And while she waits, she sings:

> By myself in the bedroom, it seems unbearably lonely.
> Dreaming of a handsome man, my feelings hurt me.
> Why does the delightful stranger delay his arrival?
> Time is fast running out, this flower will wither –
> I would entrust my body to him, for eternal love.

She, too, is in luck. She has poured a drink for him, and while he drinks it she sings a song, accompanying herself on the lute. Then:

> She stuck one of her hairpins under his cap and her long silk sleeve brushed over his robe. The sun was setting and the room filled with shadows. A cold breeze blew outside and snow flakes started falling. But inside the bedroom you could not hear a single sound. Then she prepared the bed with luxurious bedding, even scenting the quilt with a bronze incense burner. With the mattresses, quilts and pillows prepared, she let down the curtains that surrounded the bed. She took off her robe and her undergarments, revealing a white body with thin bones and soft flesh. When they made love, her body was as soft and moist as ointment.

In literature, as in art, there is a concentration on the female nude. But in the first century, in his *Pastorals of Daphnis and Chloe*, the Greek writer Longus described the awakening of sexual longing in thirteen-year-old Chloe at the sight of the naked body of sixteen-year-old Daphnis, when she helps him wash after he has fallen into an animal trap:

> Going to the Nymph's cave with Chloe, Daphnis gave her his tunic and wallet to hold while he stepped into the spring to wash his hair and his entire body. His hair was black and thick. His body was darkened by the sun, though one could have thought it simply the shadow of his hair. As Chloe watched him, Daphnis seemed beautiful to her. Because she had noticed his beauty before, she thought that the bath was the source of it. And as she washed his back, his flesh felt soft to her touch. Secretly she touched herself, testing to see if he were more delicate. The sun was already setting and they drove their flocks home. And Chloe suffered nothing worse than the desire to see Daphnis bathe again.

But the next day she hears him playing the pipes in the fields and cannot conjure up the sight and feel of his flesh, which attracts her to him, or the pipes. So she conducts an experiment:

Lover's idealize
each other in
János Vaszary's
Aranykor.

She asked him if he would come to the bath again, and when she had persuaded
him, she watched him bathing. As she watched, she put out her hand and touched
him. Before she went home she admired his beauty. And that admiration was the
beginning of love. But she did not know what she was suffering from. For she was
but a young girl, brought up in the country. As for love, she had never even heard
the name of it. But her heart was vexed within her. Her eyes wandered this way and
that. And she talked only of Daphnis. She could neither eat nor sleep. She
neglected her flock. She would laugh, then she would weep. She would lie down to
rest and leap up again. Her cheeks were pale, then blushing. In short, no heifer
stung by a gadfly was so restive and frisky as Chloe.

One day when she was alone she cried out in lamentation: 'I am ill, but what is
my disease? I don't know, except that I feel a pain and there is no wound. I grieve,
but none of my sheep are dead. I burn, although I sit in the deepest shade. Thorns
have torn me and I have not wept. Bees have stung me and I have not cried out.
But what pricks at my heart is worse than any of these. Daphnis is beautiful, but so
are flowers; the sound of his pipes is beautiful, but so is the song of the nightingale
– and yet I care nothing for those. Would to God that I were the pipe in his mouth,
or a goat so that he might tend me.'

Fortunately, Daphnis knew what the problem was – and how to cure it. He had already had an erotic education at the hands of Lykainion, who has sex with him:

> You must also learn this, Daphnis, Lykainion said. I am a woman, not a maid, so this did not hurt me. Long ago another man educated me and took my virginity as his payment. But when Chloe wrestles you in a bout like this, she will scream and cry and end up lying in a pool of blood as if slain. You should not be afraid of that blood, but when the time comes that you have persuaded her to offer herself to you, bring her here, so that even if she cries out, no-one will hear her. If she weeps, no-one will see. And if she is bloodied, she can wash herself in the spring. But remember, it was I who made you a man before Chloe.

However, Chloe was not as naive as she made out:

> She told him to sit as near to her as he could and to kiss her with the type and number of kisses he was used to, and as he was kissing her to embrace her, and to lie on the ground. After he had sat down, kissed her and laid on the ground, she found that he was erect and ready for action. She raised him from his lying position, onto his side. Then she lay down and spread herself under him, and led him to her fancy, the place he had long sought. Then she did nothing that was strange. Lady Nature herself shewed him how to do the rest.

The eye, ravished by the sight of the lover's body, quickly lures lovers into sex. For Fanny Hill, though, it was different. The preamble to her lovemaking was often cursory, and she stopped to examine the beauty of her lover only after the act:

> It was then broad day. I was sitting up in the bed, the clothes of which were all tossed, or rolled off, by the unquietness of our motions, from the sultry heat of the weather; nor could I refuse the pleasure that solicited me so irresistibly, as this fair occasion of feasting my sight with all those treasures of youthful beauty I had enjoyed, and which lay now almost entirely naked, his shirt being trussed up in a perfect wisp, which the warmth of the room and season made me easy about the consequence of. I hung over him enamoured indeed and devoured all his naked charms with only two eyes, when I would have wished them at least a hundred, for the fuller enjoyment of the gaze.
>
> Oh! could I paint this figure, as I see it now, still present to my transported imagination, a whole length of an all-perfect, manly beauty in full view. Think of a face without a fault, glowing with all the opening bloom and vernal freshness of an age in which beauty is of either sex, and which the first down over the upper lip scarce began to distinguish.

Study of Man, attributed to Théodore Gericault, depicts the body, but searches for the soul.

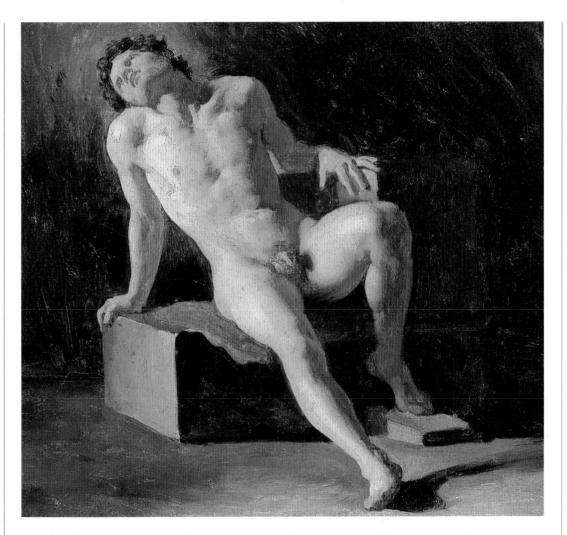

The parting of the double ruby pout of his lips seemed to exhale an air sweeter and purer than what it drew in: ah! what violence did it not cost me to refrain the so tempted kiss!

Then a neck exquisitely turned, graced behind and on the sides with his hair, playing freely in natural ringlets, connected his head to a body of the most perfect form, and of the most vigorous contexture, in which all the strength of manhood was concealed and softened to appearance by the delicacy of his complexion, the smoothness of his skin, and the plumpness of his flesh.

The platform of his snow-white bosom, that was laid out in a manly proportion, presented, on the vermilion summit of each pap, the idea of a rose about to blow.

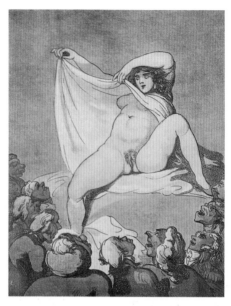

Thomas Rowlandson's *The Peep Show* – a woman tempts men with views of a body they would dearly like to possess.

Nor did his shirt hinder me from observing the symmetry of his limbs, that exactness of shape, in the fall of it towards the loins, where the waist ends and the rounding swell of the hips commences; where the skin, sleek, smooth and dazzling white, burnishes on the stretch over firm, plump, ripe flesh, that crimped and ran into dimples at the least pressure, or that the touch could not rest upon it, but slid over as on the surface of the most polished ivory.

His thighs, finely fashioned, and with a florid glossy roundness, gradually tapering away to the knees, seemed pillars worthy to support that beauteous frame; at the bottom of which I could not, without some remains of terror, some tender emotions too, fix my eyes on that terrible machine, which had, not long before, with such fury broken into, torn, and almost ruined those soft, tender parts of mine that had not yet done smarting with the effects of its rage; but behold it now! crest fallen, reclining its half-capt vermilion head over one of his thighs, quiet, pliant, and to all appearance incapable of the mischiefs and cruelty it had committed. Then the beautiful growth of hair, in short and soft curls round its root, its whiteness, branched veins, the supple softness of the shaft as it lay foreshortened, rolled and shrunk up into a squab thickness, languid, and borne up from between his thighs by its globular appendage, that wondrous treasure-bag of nature's sweets, which, rivalled round, and pursed up in the only wrinkles that are known to please, perfected the prospect, and all together formed the most interesting moving picture in all nature, and surely infinitely superior to those nudities furnished by the painters, statuaries, or any art, which are purchased at immense price.

When Fanny got what she wanted, she knew how to appreciate it. The problem is how to pick a winner in the first place. When the Empress Wu Tse-t'ien decided to replace her current consort, the monk Huai-yi, she enlisted the help of her daughter Princess Tai-pung, who soon found what she considered to be the perfect lover for her mother. The Tang scholar Chang Mu recorded the women's conversation:

'Your Majesty must not worry,' the Princess whispered. 'I have found out what he is like down there. I held a dinner party at the Emerald Green Pond the other day. After it, I instructed the guests to bathe. I spied on him through a glass screen. He is different from other men. His body is fair and muscular, and without a flaw. His penis is particularly impressive. It is plump at the top and finer along the stem. Although it does not look big when it is flaccid, it can obviously expand tremendously. I can tell that from the size of the crown at the top.'

The Empress was delighted and asked: 'Have you tried him out.?'

'I would not dare,' the Princess replied quickly. 'But I asked a maid to try him so you could get a full report.'

The maid was then called and she was ordered to tell the Empress everything. The girl knelt down and whispered: 'At first, his penis was tender and smooth, like a fresh lichi from Canton. But after a few thrusts, it grew bigger and bigger inside me and gave me a feeling of fulfilment. He was very understanding and left me to make the pace. When he had finished, the pleasure lingered for a long time.'

The Empress was pleased. Smiling at her daughter she said: 'You are astute to have found him. Huai-yi is strong and wears me out. A man's penis should not be full of muscle and sinew. When making love, tenderness is all important. Ch'an-tsung seems to be the right man.'

Not many women would be prepared to have another, not even a maid, try out prospective lovers for them. So perhaps a more scientific approach is required.

Pandit Kalyanamalla, the author of the Indian love text, the *Anangaranga* or the Code of Cupid, took an analytical approach to the selection of sexual partners. He broke women down into four different types:

1. The lotus woman – the perfection of womanhood. Every sweet and delicate quality belongs to her. Her breasts are small, firm and spherical; her hips narrow but ample; her waist thin; her vulva smooth and tiny, resembling the lotus bud; and her love-water is perfumed like the newly-burst lily.

2. The art woman – the perfection of the courtesan. Her beauty is equal to that of the lotus woman, except that it is not innocent but worldly. Her lips are slightly wider, and her vulva a trifle plumper. The down is thin and the mons is soft, raised and round. Her love-essence is hot, bearing the perfume of honey and producing from its abundance a distinct sound during lovemaking.

3. The shell woman – the common variety. She is the ideal wife for labour and breeding. She is highly sexed, and as capable at love-making as the art woman. Her breasts are fuller and slightly

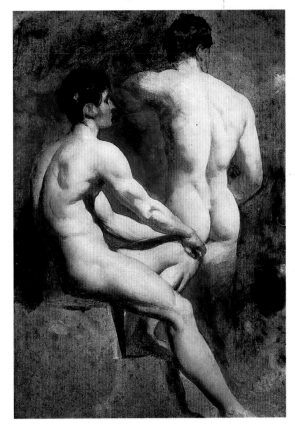

William Etty seeks beauty in an academy study of the male form, but desire is barely concealed.

pendulous; her hips wide and waist thicker; and her vulva, ever moist and covered with thick hair, much larger.

4. The elephant woman – the most undesirable of the four types. She is of little value for work, but her sexual capacity is that of a rabid beast in rut. Coarse and indelicate, she is the bodily extreme with thick protruding labia and clitoris; pudendum which suggests the condition of genital elephantiasis. Her vulva is nigh to impenetrable because of hair, and her copious love water bears the savour of the juice that flows in spring from an elephant's temples.

Men are similarly classified, though the size of their penis is considered the single most important factor:

1. The hare man – the ideal of manhood. He is lithe and strong, the counterpart of the lotus woman. In erection, his penis exactly fits her vulva. It is small – two or three inches long – and proportionately thin.

2. The buck man – the perfection of warriors. He is swift and graceful, the counterpart of the art woman. His penis is slightly thicker and longer, four or five inches.

3. The bull man – the tough muscular artisan type. The counterpart of the shell woman, his penis is from six to seven inches long if he is a tradesman and seven to eight inches long if he is a farmer.

4. The stallion man – the most coarse and vulgar of the group. He is worthless and indolent except for propagating his kind. The counterpart of the elephant woman, he is of the servile class. Adorning his body is a nine- or ten-inches tassel; and his seminal water flows like the Ganges in flood.

Kalyanamalla believed that men and women should only have sex with those in corresponding groups. It was defilement for a lotus woman to sleep with a stallion man, or a hare man to sleep with an elephant woman, he thought.

Su Nü, the principal female adviser to the Chinese Emperor Huang Ti, recommended relationships of unequal ages:

If an old man and an old woman mate, even if they do manage to have a child, it will not live long.

But if a man of eighty makes love to a girl of eighteen, or even fifteen, they will have children that will live long. And a woman of fifty can often still have a child, if she had sex with her young man.

Beyond these broad generalizations, the rest is left to chance. Our hearts guide us – but often in the wrong direction. We often know with our heads that we have made a disastrous choice. But where the heart leads, we are powerless to resist.

Opposite: Salvador Dali's *Femme nue sur un arc en ciel* carries female desirability into a heavenly realm.

\mathcal{T}HE ANATOMY OF LOVE

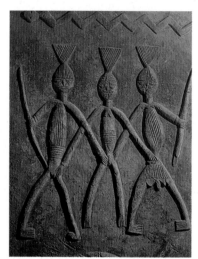

In African art, the genitals are often exaggerated, as in this carved door panel from the Ijebu region of Nigeria.

> Allah made the penis and the cunnus for no other reason than that they should be joined together, and He made the male for no other reason than that he should penetrate and ejaculate into the female.
>
> KHOJEH 'OMAR HALEBI, DOCTOR AND ISLAMIC MYSTIC

A woman's religion is her vulva, declared Shayh 'Omar bin Sidi en-Nefzawi, the Tunisian author of the *Book of the Site of the Heart's Delight*. Her god is the penis, and neither reason nor trust can keep her chaste once her womb has sounded the call to coition.

Man, on the other hand, by virtue of the pride he takes in his penis, is destined to roam the face of the Earth, systematically impregnating every woman he can lay his hands on. However, this does not necessarily put men and women in conflict. In fact, it is the genitals that draw men and women into harmony. Shayh 'Omar bin Sidi en-Nefzawi wrote:

> Praise be to Allah, who had placed the fountainhead of man's greatest pleasure in the natural parts of a woman, and who has placed the source of woman's supreme enjoyment in the natural parts of man.
>
> Praise be to All-bountiful Allah who has not bestowed well-being up the sexual parts of the female, who has not accorded these organs satisfaction and happiness, until they have been penetrated by the sexual parts of the male. Likewise, the sexual organs of the male shall know neither rest nor peace until they have entered those of the female.

On this point, though, there are some dissenting voices. In nineteenth-century Turkey there was a band of fanatical sodomists known as the Lewwautee, whose motto was:

> The penis, smooth and round, was formed with anus best to match it;
> Had it been made for vulva's sake, it'd be shaped like a hatchet.

As the sexual organs themselves are hidden from view, in many cultures, it is thought that

Opposite: In *The Italian* Ignacio Zuloaga Y. Zabaleta concentrates the eye on the pubic region

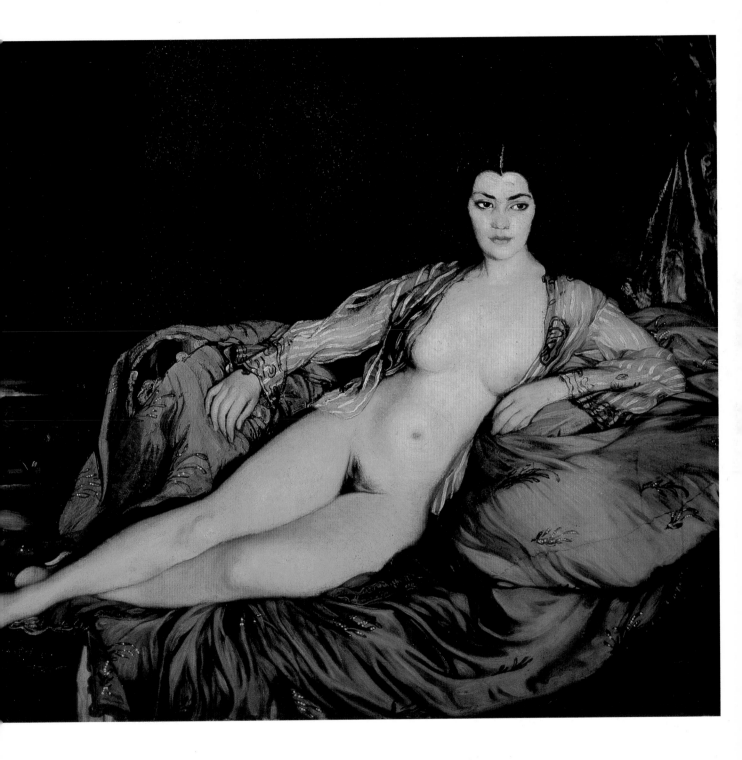

Jules Verdier's *Luxuriance* captures the opulence of the breasts.

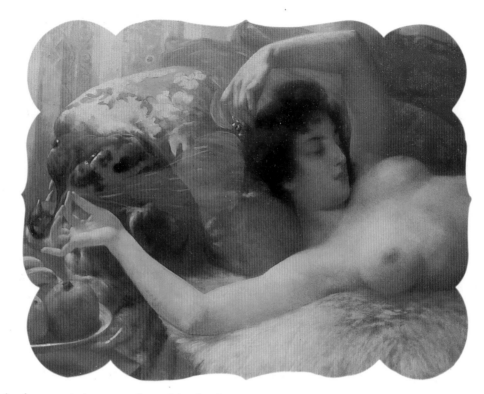

their characteristics are reflected in the face. An Arab proverb probably best sums up this idea:

> A maiden's mouth shows what's the make of her chose;
> Man's mentule one knows by the length of his nose;
> And the eyebrows disclose how the lower bush grows.

Literature, however, usually looks beyond the face, and in Sir Richard Burton's translation of *The Book of the Thousand Nights and One Night* we find a description of the erogenous attributes of the perfect woman:

> She hath breasts like two globes of ivory, like golden pomegranates – beautifully upright, arched and rounded, firm as stone to the touch – with nipple erect and outward jutting.

Moving downwards, below her slim waist, the three creases on her belly, her hips, which are heavy and wide, and her buttocks, which are rounded like revolving heavens:

> ...She hath thighs like unto pillars of alabaster and between them, there vaunts a secret place, a sachet of musk, that swells, that throbs, that is moist and avid...Oh hail, the jewel in the lotus.

Sexual encounters often begin with the breasts and move downwards. The young Fanny Hill found her breasts being admired, and fondled, by Phoebe, an older woman:

> My breasts, if it is not too bold a figure to call so two hard, firm, rising hillocks that just began to show themselves or signifying anything to the touch, employed and amused her hands awhile, till slipping down lower over a smooth track, she could just feel the soft silky down that had but a few months before put forth and garnished the mount-pleasant of those parts and promised to spread a grateful shelter over the sweet seat of the most exquisite sensation, and which had been, till that instant, the seat of the most insensible innocence.

The virginal Fanny tries to hide the delights of her young flesh:

> 'No!' says Phoebe, 'you must not, my sweet girl, think to hide all these treasures from me, my sight must be feasted as well as my touch – I must devour with my eyes this springing bosom. Suffer me to kiss it. I have not seen it enough. Let me kiss it once more. What firm, smooth, white flesh is here. How delicately shaped! Then this delicious down! Oh! let me view the small, dear, tender cleft! This is too much, I cannot bear it, I must, I must...'
>
> Here she took my hand and in a transport carried it where you will easily guess.

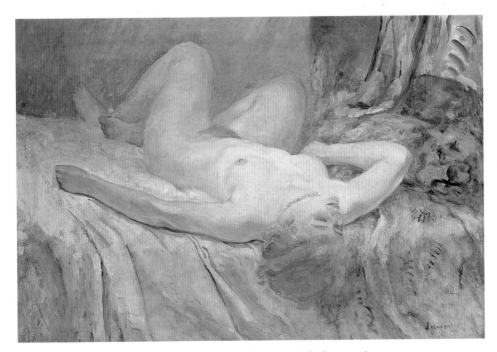

Femme nue endormie is modest, yet completely exposed.

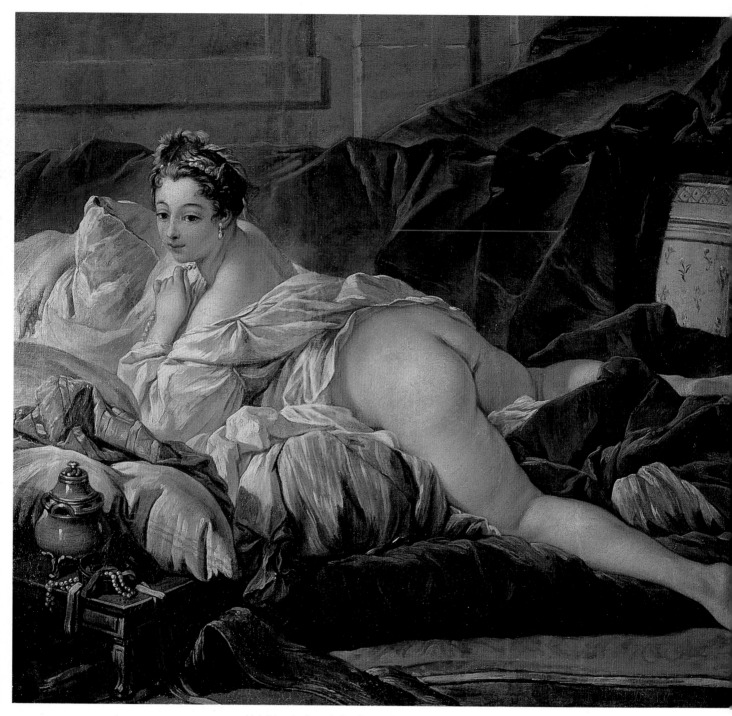

L'odalisque, by François Boucher, exalts the female buttocks.

Some sexual encounters do not move beyond the breasts. In the *Satyra Sotadica*, which first appeared in 1660, author Nicholas Chorier describes what is now known as 'Spanish sex' between Octavia and her lover Caviceo:

> You know there is in our house a gallery giving on to the garden, which is full of flowers. There Caviceo and I were promenading: he embraced me, kissed me, nibbled my lips and then thrust his hand in my bosom.
>
> 'I have a whim,' he said, 'bare your breasts, my darling.'
>
> What was I to do? His hot eyes rested on my bare bosom.
>
> 'I see Venus sleeping between your breasts,' he said. 'May I awaken her?'
>
> He then revealed himself, fiercely erect, and slides his hot, burning member between my breasts. How could I escape his blind passion? I had no choice but to bear it. His hands softly pressed my breasts together, so as to narrow the space in which his manhood had to travel towards a new experience. Why make a long story? Stupefied as I was at this vain ridiculous imitation of love, he inundated me with a burning libation: he had his will.

Sir William Russell Flint's *Clara Sprott* shows that breasts do not have to be large to be appealing.

In ancient Greece more attention was paid to the buttocks. The Greeks set up temples and statues to Aphrodite Kallipygos – the goddess with the beautiful buttocks. The third-century author Athenaeus explained how this came about:

> There once was a farmer who had two beautiful daughters. They had an argument about who had the most beautiful behind. To settle the dispute they went out on the highway. One day the son of a rich man came by and they displayed themselves to him. After gazing at them, he decided in favour of the older girl. In fact, he fell so deeply in love with her that, when he got back to the town, he went to bed, ill. He told his younger brother about what had happened to him. So he too went out into the country to look at the girls. And he too fell in love, but with the younger girl. The boys' father told them that it was no good falling in love with two farm girls and they should contract more respectable marriages. But when he failed to persuade them, he went out into the country and brought the girls home. With the consent of their father, he joined his sons in marriage to them. The girls became known as the 'fair-buttocked ones' by the townspeople, as Cercides of Megalopolis relates in his iambic verse. He says: 'There was a pair of fair-buttocked sisters in Syracuse.' Having come into wealth by marriage, it was said they founded the temple of Aphrodite called the 'fair-buttocked' as related also by Archaleus.

Fanny Hill's behind was also greatly admired:

> Her spark then endeavoured, as she stood, by disclosing her thighs, to gain us a completer sight of that central charm of attraction, but not obtaining it so conventionally in that attitude, he led her to the foot of the couch, and bringing to it one of the pillows, gently inclined her head down, so that she leaned with it over her crossed hands, straddled with her thighs wide spread, and jutting her body out, she presented a full back view of her person, naked to her waist. Her posteriors, plump, smooth and prominent, formed luxuriant tracks of animated snow, that splendidly filled the eye, till it was commanded down the parting or separation of those exquisite white cliffs, by their narrow vale, and was there stopped, and attracted by the embowered bottom cavity that terminated this delightful vista and stood moderately gaping from the influence of her bended posture, so that the agreeable interior red of the sides of the orifice came into view, and with respect to the white that dazzled round it, gave somewhat the idea of a pink slash in the glossiest white satin.

The Book of the Thousand Nights and One Night gives delightful descriptions of the vulva:

> When he beheld them stripped of their clothes, his chord stiffened for that looking at them mother-naked he saw what was between their thighs – and that of all kinds – soft and rounded, plump and cushioned – large-lipped, perfect, redundant and ample – and their faces were as moons and their hair as night upon day.
>
> He cast a glance, seeing her mother-naked; and there was manifest to him what was between her thighs: a goodly rounded dome on pillars borne, like a bowl of silver or crystal...part softer than silk, smoother than cream – pink, white – plumply rounded, protuberant – resembling for heat and moisture the hot-room of the bath.
>
> 'O my mistress: by God! thou has not grassed me by thy strength, but by the blandishments of thy back-parts; for I so love a full-formed thigh and crystal-mount, the delight of prickle thick and strong.'

The tight vagina of a young virgin was particularly prized. However, romantic men can easily be fooled:

> She was only a child, pulling up her robe in the garden,
> In it, there was no sin that a lover of love could not have pardoned.
> Her passage was as narrow as virtue, yet as easy as lying,
> But I was just halfway in when stopped by her sighing.
> 'Why?' I asked. And she said with a laugh:
> 'Oh moon of my eyes, I sigh for the other half.'

John Donne wrote a poem favourably comparing his lover's vulva with that of another woman:

> Thine's like the dread mouth of a fired gunne
> Or like hot liquid metalls newly runne
> In clay moulds, or like that Etna
> Where round about the grasse is burnt away.

How far the 'grasse is burnt away' has been an age-old question of debate. The Japanese *Pillow Book* recommends delipation:

> A woman may choose to remove all her pubic hair or
> she may leave an attractive crown at the front.
> Delipation is better if she likes to anoint her sex with
> honey and flower water to make licking more delicious.

The Italian humanist writer Pietro Aretino regularly wrote about the sexual organs of nuns:

> The General grabbed the youngest and prettiest
> nun. He threw her habit over her head and made
> her rest her forehead against the back of the bed.
> Then Missal deliberately pryed open the leaves of her arsehole and, deep in
> thought, contemplated her crotch. It was neither skinny and bony, or puffed out
> with fat, but somewhere in between – round, quivering, juicy, like a piece of ivory
> imbued with life.

This Tantric lesbian scene celebrates the cool beauty of the vulva.

The Chinese approach to the female sexual organs is altogether more delicate. In *The Golden Lotus* the protagonist Hsi-mên spends a great deal of time toying with the vulvas of his wives and various concubines:

> He took off his clothes, sat down on a stool and with his toes started playing
> around with the treasure of this beautiful flower. Then signs of her pleasure oozed
> out of her like the slime of a snail leaving its meandering white trail. Hsi-mên
> pulled off her ornate sandals and, having loosened the ribbons that bound her feet,
> tied her ankles to the lattice rails, so she was like a golden dragon baring its claws.
> The entrance of her womanhood was open, its guard was aroused, and a deep
> crimson valley appeared.
> Hsi-mên lay down and, taking his weapon in his hands prepared to storm the
> breach, resting one hand upon the pillow, and proceeding to the attack as he had

played 'Feathers through the Arch' then at the 'Flying Arrow' game. He strived with all his strength, until from the battlefield a mist arose, spiralling, like an eel rising from the mud.

Later he played 'Flying Arrows with a Living Target' and 'Striking the silver swan with a golden ball'. He took an iced plum from a bowl and threw it at her open vulva:

> Three times he threw it at the feminine entrance. Three times he hit the innermost flower. Once the plum stuck, but he did not remove it. Nor did he finish the work he had begun earlier.

Although Hsi-mên was interested in the vulva of his women, many Chinese would have been turned on by the slender bound feet that were tied to the lattice rails. Women's feet were erotic and were compared to fragrant lotuses. The Qing Dynasty essayist Fan Xan explains:

> Fragrant lotuses are noble in three ways. They are plump, soft and elegant. Fragrant lotuses have three 'ons', three 'withins' and three 'belows': on the palm of the hand, on the shoulder and on the seat of a swing; within the blankets, within the stirrup and within the snow; below the curtain, below the screen and below the fence.
> Fragrant lotuses have two 'good fortunes': an ugly woman enjoys good fortune if she has small feet, for she will attract the praise of others; a low prostitute has good fortune if she has small feet, for she will acquire everyone's love.

Another writer, Li Liweng, says of women's feet:

> When they are so slender as to seem without form, they incite more tenderness the more you view them. This is how to savour them during the day. When they are so soft they appear to be without bones, the closer you are to them the more you want to stroke them. This is how to savour them in the evening.

The second-century physician and birth-control pioneer Soranus of Ephesus took a rather more prosaic look at the female genitals in his *Gynaecology*:

> The visible outer part of the female genital system is called the 'wings' which are, so

to speak, the lips of the womb. They are thick and fleshy, stretching away on the lower side to either thigh, parting from each other as it were and on the upper side ending at what is *numphê* [clitoris]. This is the starting point of the wings, by nature a little fleshy thing and somewhat muscular and mouse-like.

Naturally, Sappho took a more poetic view of the *numphê*:

Like a sweet apple ripening to red on the topmost branch,
on the topmost branch, and the apple-pickers have overlooked it –
no they haven't overlooked it, but they could not reach it.

The English poet Robert Herrick (1591–1674) also took a lyrical view:

Show me those fleshy principalities; thy thighs
Show me those fleshy principalities;
Show me the hill where love doth sit,
Having a living fountain under it;
Show me thy waist, then let me therewithal,
By the assentation of thy lawn, see all.

And the nineteenth-century French poet-turned-gun-runner, Paul Verlaine, describes the vulva in 'The Anointed Vessel':

In a soft box of plushy fluff,
Black, but with glints of copper-red
And edges crinkled like a ruff,
Lies the great god of gems in bed.

Throbbing with sap and life, and sends
In wafts the best news ever sent,
A perfume his ecstatic friends
Think stolen from each element.

But contemplate this temple, cont-
template, then get your breathe and kiss
The jewel having fits in front,
The ruby grinning for its bliss,

Flowers of the inner court, kid brother
So mad about the taller one
It kisses till they both hay-smother
And puff, then pulse, in unison...

Gustave Courbet's aptly named *L'origine du monde* was painted for a private collector in 1866 and kept hidden. When first shown at the Louvre in 1995, it caused a sensation.

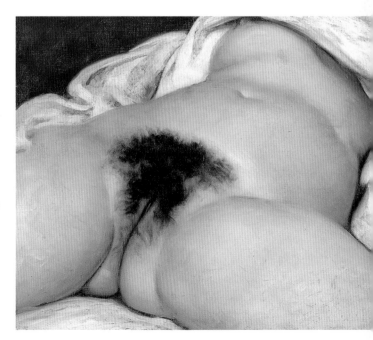

Verlaine was bisexual and described the penis in similarly glowing terms in 'Even Without Presenting Arms':

> It's plump, your little prick, and sleek
> As velvet, from the pubic mound
> To where the foreskin closes round
> The tip, and crowns the rosy peak.
>
> It swells a little at the end
> Under the soft skin, sketching out
> The gland, an inch long, with a pout
> Of red lips showing at the end.
>
> After I've bowed at length and kissed
> The rod with loving gratitude,
> Let my caressing hand grow rude
> And seize it in a daring fist
>
> And then suddenly doff its cap
> So that your tender violet bud
> Bursts out, not wanting for more blood,
> Joyfully beaming from your lap.

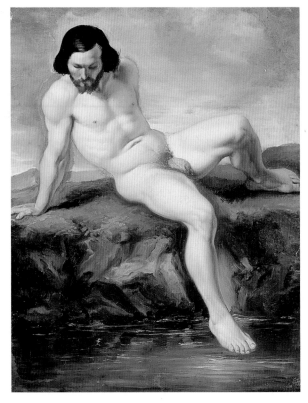

In this academy study by J. Ussi, the model may be looking at the river, but the viewer's eye is drawn to his penis.

Occasionally, the penis is depicted in a semi-aroused state, though the model must have had difficulty holding the pose.

The Perfumed Garden, also translated by Sir Richard Burton, contains descriptions of the perfect sexual organs. First, the vulva:

> God has given this object a mouth, a tongue, two lips and a shape like that of the footprint of a gazelle. When a desirable woman walks, her natural parts should stand out under her clothing; and when she is in heat, they should become turgid and moist – and grip and suck firmly up, the male organ.

Correspondingly:

> When a worthy man is in the company of a woman his member grows, becomes strong, vigorous and hard; he is slow to ejaculate and, after the spasm caused by the emission of semen, he is prompt at re-erection. His member must be well-developed; it should reach to the bottom of the vagina, in which it should be a snug fit. He should be slow to ejaculate but quick to erect.
>
> For a virile member to be pleasing to a woman, its length should be – at most – three hand-breadths and, at least, one hand-breadth and a half.

As noted above, the Indians were not too taken with large penises, associating them with low caste and vulgarity. An Indian poem says:

> Long penis, poverty;
> Thick penis, sadness;
> The man who is called to high things and good fortune has a thin short member, a smooth prepuce and hanging testicles.

However, in almost every other culture a large penis is prized. It was said, in ancient Rome, when you heard applause in the bath, that a moron with a large penis had arrived.

In the *Arabian Nights* it is written: 'In our world, nothing is so esteemed in a man as a good weighty penis, just as a jutting backside is the most excellent thing in a woman.' The great Islamic poet Abu Nowas wrote:

> Allah know, no-one has
> A penis the size
> Of mine; so measure it,
> Come take my prize
> Test it, hold it in your hands
> It's my nobility
> Whoever has a taste of it
> Feels both tenderness
> And a violent love for me.
> Its length is like a pillar
> Which I bear
> Come, seize it, hold it in your hands
> If you dare.
> Put it in your tent
> Between where the mountains stand
> Install it there yourself –
> Please take it in your hand.
> See how it holds its head up
> Like a lofty banner.
> And you'll never feel it give up,
> It's like a sturdy spanner.
> It will never droop
> Or slacken like a sail;
> As long as it is inside you,
> It will stand straight, like a nail.

The penis, as every man can testify, has a life of its own. Here it turns up on the handle of a Javanese kris dagger.

Strangely, in this illustration for John Cleland's *Fanny Hill* by Borel, the genitals and breasts are devoid of detail.

Women tend to have things more in proportion. The following poem accompanied an engraving called *The Wanton Frolic*, which shows a naked girl lying on the floor with her legs in the air, while a young man, clothed, kneels before her holding his erect penis:

Upon the carpet Cloe laid
Her heels toss'd higher than her head,
No more the clothes her beauties hide,
But all is seen in native pride
When Strephon kneeling smiles to see
A thing so fit for love and he
His amorous sword of pleasure draws,
Blest instrument in nature's cause.
The panting fair one waits its touch
And thinks it not a bit too much.

In the *Tale of the Vizier's Son and the Bathkeeper's Wife* the bathkeeper notices that the Vizier's son has only a small penis, the size of a peanut, hidden between his thick thighs. So he asks his wife to rub it, so that it will start growing again. She does as her husband asks:

Then the boy's prick stirred and swelled. Its smallness was only a first impression. It was one of those pricks which retracted almost entirely into the belly when at rest.

Suddenly it sprang up erect, rising up on end like that of an elephant or a jackass – a powerful sight to see. Then he mounted her with his huge penis and thrust it between her thighs. For three hours he rode her and fucked her ten full times, while she sobbed and sighed and writhed and wriggled over him.

But you can have too much of a good thing. There is another Arab tale called *The Man Who Had Three Wishes.* In it, Allah shows a man the power of the night and grants him three wishes. Unfortunately, he tells his wife about them:

She said: 'A man's pride and joy is his penis. So pray to Allah to increase the size of your member.'

So the man lifted up his hands to Heaven and said: 'Please Allah, increase the size of my penis.'

He had hardly finished speaking when his penis swelled to the size of a column. It was so big that he could neither sit, nor stand, nor move about. And when he tried to have sex with his wife, she ran away from him.

In primitive artefacts, it is common for the artist to exaggerate the sexual organs, reflecting the importance of sex in our lives.

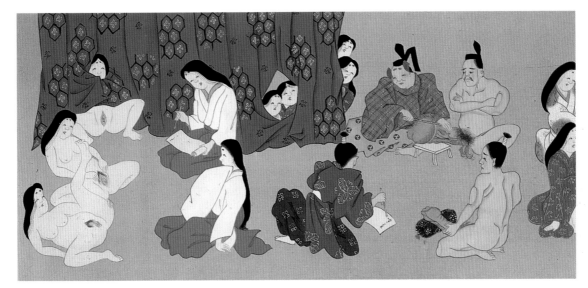

This Japanase 'shunga' scroll depicts the judging of a phallic contest.

He said to her: 'See what you have done, woman. This is all the fault of your lust.'

She replied: 'But I did not ask for it to be so big that it would not fit down the street. Pray to Allah to make it less.'

So he raised his eyes to Heaven and said: 'Please Allah, save me from this thing and rid me of it.'

Immediately his penis disappeared altogether and his pubis was smooth and clean. When his wife saw it, she said: 'Now you are pegless. I did not ask you to become a eunuch, shaved and shorn.'

He replied: 'All this comes from your stupid advice and your ill-thought-out judgment. I had three prayers that might have done me good in this world and the next. Now I have wasted two of them. What shall I do with the third?'

His wife said: 'Pray to Allah the Most Bountiful to restore your penis as it was.'

So he prayed to Allah and his penis was restored, exactly as it had been to start with. The man had wasted his three wishes by the poor judgment and stupidity of a woman.

Actually, he was just as stupid as his wife, both for following her advice and for wording his requests so badly.

Fanny Hill was equally impressed by a large penis:

I stole my hand upon his thighs, down one of which I could both see and feel a stiff hard body, confined to his breeches, that my fingers could discover no end to. Curious then, and eager to unfold so alarming a mystery, playing as it were, with

his buttons, which were bursting ripe from the active force within, those of his waistband and foreflap flew open to the touch, when out it started; and now, disengaged from the shirt, I saw with wonder and surprise, what? not the plaything of a boy, not the weapon of a man, but a maypole of so enormous a standard that, had proportions been observed, it must have belonged to a young giant.

However, one should remember that *Fanny Hill* was written by a man, John Cleland, and however true a psychological picture he painted of Fanny, he was still reflecting male prejudices.

The size of his penis is a matter of constant anxiety to a man. Even the legendary Yellow Emperor Huang Ti, said to have been born around 2704 BC and to have come to power in 2697 BC was concerned. But his principal female adviser Su Nü calmed his fears:

Emperor Huang Ti: Why do men's penises come in so many shapes and sizes?
Su Nü: Their penises are as individual as their faces. Whether it is small or large, long or thick, soft or hard, their characteristics have been fixed at birth. Sometimes a short man might have an impressively large penis and a tall man may have a small

Mihay von Zichy's *Study of Masturbation* shows loving attention to detail and a mastery of technique.

Opposite: *The Award of Love* shows that the heavenly reward, held by the cherubs, is much the same as its earthly counterpart.

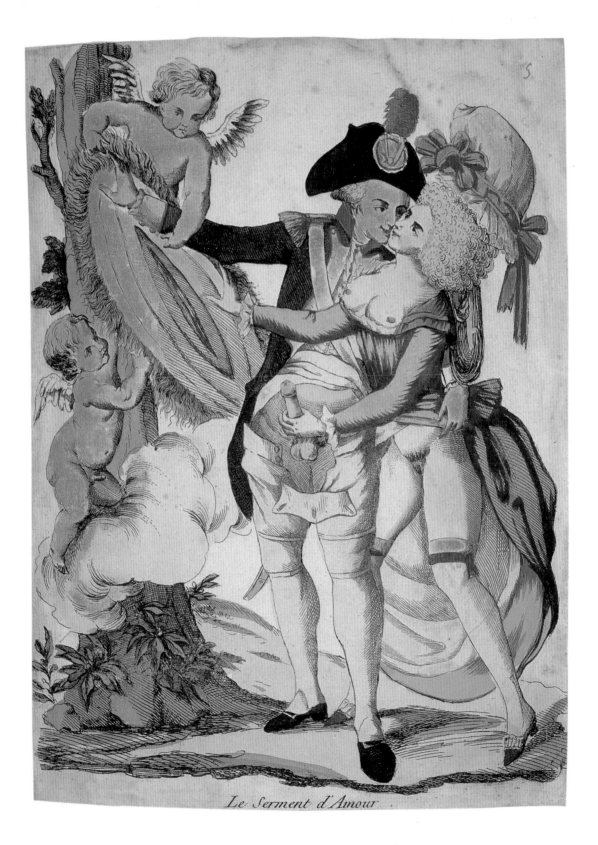

Le Serment d'Amour.

one. Some are straight and some are bent. Some look fierce. But these variations do not make much difference when they are inside a woman.

Emperor Huang Ti: So these differences do not affect the pleasure of sex?

Su Nü: The size and shape of the penis is only its outward appearance. The beauty and pleasure of love comes from inner feelings. If a man approaches the woman with love and respect, and shows true feeling, what difference could size and shape make?

Emperor Huang Ti: But what about hardness and softness?

Su Nü: Small but hard is better than long and soft. However, it is better to be soft but gentle than hard and violent. A middle course is best.

Emperor Huang Ti: There are doctors who can make small penises bigger and soft ones harder. But do these treatments have bad side-effects?

Su Nü: If a man and woman are in harmony with each other, this alone often makes a small penis become bigger and a soft one become harder. But when a man understands the Tao his penis will not weaken even after a hundred women. He will strengthen his yang with the woman's yin. Controlling his breathing will strengthen him. He will borrow water to feed his fire. And guarding his precious semen, he will not ejaculate all night. This way his deficiency is overcome and he will live a long life. But medicines and concoctions devised to heighten passion will only exhaust his yang and hasten the burning out of his fire.

The Taoist master Wu Hsien believed, however, that size did help:

If a man's jade stem is long enough and large enough to fill the woman's vagina completely, he will have to expend less effort to please her. So if a man wants to do a good job, first he must sharpen his tools.

Consequently, Wu Hsien developed a programme that a man could use to enlarge his penis:

Greek pottery painters delighted in depicting the genitals.

Every morning, after the hour of midnight and before noon, when the *yin* is in retreat and the *yang* is dominating, he should meditate in a quiet room facing east. He should leave his worries behind and concentrate on his inner being. His stomach should be neither full nor empty. He should breathe out all the air from his lungs and breath fresh air deep into his abdomen forty-nine times. Then he should rub his palms together until they are hot. He should hold his penis and testicles in his right hand, rub his abdomen with his left hand in a circular motion eighty-one times. Then he should changed hands and make a similar circular

motion with his right hand eighty-one times. Next he should hold his penis and swing it from left to right slapping it on each thigh numerous times.

When he embraces his woman and pushes his jade stem into her house of *yin*, he should leave it soaking in her vaginal secretions and breathe in her breath. Then he should rub his jade peak between his hands as if making a rope from countless strands. In time, he will notice his penis grow bigger and bigger.

The Chinese have numerous others ways of enlarging the penis. For some reason, they often seem to involve butchering dogs. This recipe is typical:

> Take three fen of prime jou ch'ung jung [a herb] and two fen of hai taso [a special seaweed] and grind them into a powder. Find a white dog born in the first moon of any year. Mix the secretions of its liver into the powder to make a paste. Apply this to your jade stem three times. The next day at dawn, draw water from the well and wash the paste off. Your jade stem will definitely have grown three inches.

In Somalia men strengthen their penises with cold-water applications and mutual masturbation, while women in East Africa extend their clitoris and labia by tugging on them. Large labia are particularly prized by men, as they are thought to give the vagina better suction. The extended labia more completely engulf a man's penis, giving greater pleasure to both parties.

Such enlarged labia were formerly known as Hottentot aprons. The name has now been dropped, though the practice of tugging the labia to extend them continues. An early explorer explains:

> Because it is considered unclean by them to touch the vulva with the hand, many Hamito-Negro girls masturbate with the skinned, unripe fruits of the banana. If they are surprised by the boys while at this pastime, they are copulated without further ado. But onanistic manipulations are indispensable in the very formation of the Hottentot apron. Let it not be thought that the Hottentot apron is the exception, produced only by women erotically free and loose.

Indonesian villagers carved such figures to boost fertility and ensure success in head hunting.

On the other side of the vase from the one shown opposite, the satyr masturbates.

Just as declitorization is a mark of every married woman, there is hardly a female to be found among the Swahili without a Hottentot apron since her youth. Men and women assured me: women without a Hottentot apron are simply boycotted by men; marriage itself would be annulled if the woman decided to retain her natural clitoris and refused to elongate her labia.

Even before the girl reaches the age of puberty, her mother says to her: 'Go make yourself a cock's crest.' Instructed by her older friends, the child busily plucks both labia minora. With regular treatment, the 'cock's crest' is ready inside of a week. It is considered ready when it has reached the length prescribed as standard (at least two inches, but preferably three). For this the girl takes a leaf, places it along her little finger, and tears off the part reaching above it. The measure is now ready. She then places the leaf against the lengthened lips to see whether the required length has been attained. If not, the plucking is continued.

Girls know another method of producing the Hottentot apron. They bind together the plucked labia with a string and have a small stone hang down as a sinker to stretch them properly. 'Then the lips become like the crop of a turkey,' added a woman who was unaffectedly telling me about the operation in the presence of other women.

The origin of the Hottentot apron is to be found in masturbation. It was noticed that the little labia became elongated (by repeated pulling and jerking); what had been a necessity became a virtue. A man was pleased with such a woman, especially since continual masturbation had intensified her sex instinct and her sensuousness. As a matter of fact, masturbation is very widespread among the Swahili women. Married women often find pleasure in it, repeatedly plucking the India-rubber bands of their elongated labia until the orgasm finally sets in. In fact, the woman with her Hottentot apron makes great demands of her husband's capabilities; she is hardly ever satisfied.

For a man, the loss of his penis is the worst of all possible fates. In the ancient world, men were castrated for many reasons – most commonly to turn them into eunuchs to guard the harem, or to initiate them into prostitution. But some were castrated by their concubines if they were found to be unfaithful, like the unfortunate one in the *Arabian Nights*, who had been foolish enough to marry another woman:

When it became known to me what they were planning to do, horror fluttered my scrotum. My very ballocks curdled with fear when I realized how trapped I was: that I could not cry out or escape, because of the eunuchs. By the eyes of the Prophet! I was in such confusion and dread, I piddled in my bag-trousers – and

Julius Klinger's
Salome wanted
more than John
the Baptist's
head.

even beshitted myself; whereupon, they unfastened the inkle of my drawers. Truly, my spittle was dried up for very incertitude.

Naked as I was, with prickle at point, she and her slave-girls pinioned me down. I begged her to reveal her intent; and finally, after I was well secured, she said unto me:

'I bear the intention of removing thy precious stones, the honours of thy yard. I must also apply the blade to thy pizzle, if only to prevent thee from enjoying the two million orgasms in Paradise. But there is a slower, more impressive, means of

making thee know of mine anger. Thou art of no further use to me, nor art thou any longer fit for my company; I care only for bachelors and not for married men. Thou hast sold me for the whore's heart ache for thee!'

God forbid! A cold fluttering in the cullions attested to my fear.

She tied a cord around my stones and, giving it to two of her women, bade them haul at it. They did so; and I swooned away and was, for excess of pain, in a world other than this. Then, she came with a razor of steel and cut off my member masculine; after which, she seared the wound with melted cheese and rubbed it with a powder – and I, the while, unconscious. Now when I came to myself, the blood has stopped; so she bade the slave girls to unbind me and made me drink a cup of wine. Then, she said to me:

'Go, now, to her whom thou hast married and who begrudged me a single night; for I needed nought of thee save what I have just cut off.'

And I weeped over myself, for that I was become even as a woman: without a manly tool like other men.

Impotence is almost as bad as castration. But, as usual, Su Nü had some comforting words. To sustain an erection, there were seven things a man must do, she said:

1. His five organs must be kept in good order.
2. He must learn to feel the woman's nine erogenous zones.
3. He must appreciate the woman's five beautiful qualities.
4. He must learn to arouse her so that he can drink in her yin essence.
5. He must drink in her salvia so that his semen and her breath are in harmony.
6. He must elude the seven injuries.
7. He must perform the eight worthwhile deeds.

 If he does these things, his body will be healthy and all disease will be banished. His penis will rise powerfully every time he enters a woman and his enemy will admire him. She will become his friend. Shame and embarrassment will be a thing of the past.

There are other problems a man can have with his penis. It can be over-active. In 1794 one 'Timothy Touchit' awoke to find he had trouble with his 'barometer':

I arose early in the morning, and found the barometer of health risen to its utmost elevation; and contrary to the Torricellian baroscope when at the highest, the bottom of the tube was greatly over-charged with mercury.

Finding, by its great and continued elevation, that, according to the *Anatomical cant*, the *Pyramidalia* had been to assiduous in supplying the *testiculi* with an

abundant stock of the vivifying fluid, I began to be alarmed for the consequence of such a repletion; for where there is irritation we are to expect inflammation, and where there is inflammation a conflagration generally succeeds.

I was contemplating on my situation, and had filled my mind with various apprehensions, just as the *Fille de chambre* knocked at my door to acquaint me it was time to rise. I did not tell her I had risen hours before, but went to the door, and unlocking it, desired her in a whisper, to run for *un Médecin*. She came into my room, and I wanted words, in her language, to tell my complaint; but it was too visible to be mistaken. She had been used to take care of sick guests, and knew something of the cure of diseases. – '*Ne craignez rien*,' said she, looking full at me, '*il ne fera plus de mal*.' – On this she prepared what I wanted, and collision effected a deliquidation three or four times, *pro re nata*, as physicians say, the elevation of the barometer fell down to 'changeable', and I became relieved and composed. It was a speedy, agreeable cure, I never knew a mouse-trap more serviceable than it was on this occasion.

You are a good doctor, and are used to these complaints, said I to the *Fille de chambre*. '*O qu'oui, Monsieur, tous les jours*,' said she, 'I must now go to a French gentleman in the next apartment, who is troubled with the same disorder, but not in so violent a degree. It is trifling; only a slight symptom.'

It is as well to remember, as the Japanese *Pillow Book* says:

> Few penises sleep so soundly they cannot be awakened with a kiss - but this kiss is not the peck of a bird. It is the tongue, palate and lips of a hungry calf noisily sucking at the teat.

To primitive people, the magical power of the penis to rise and fall makes it an object of veneration. And worship of the penis was widespread in early civilizations. Artemidoros, the second-century Ephesian soothsayer, spelt out the crucial significance of the penis:

From one side, this prehistoric carved stone figure found in North America looks like a nursing mother. From the other, it is a man with an erect penis.

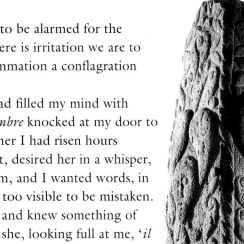

In early Celtic culture, phallic pillars are rare.

The penis is like a man's parents as it contains the generative code, but it is also like his children since it is the cause of them. It is like his wife and concubine as it is useful for sex. It is like his brothers and all his blood relatives, since the meaning of his whole household depends on it. It signifies strength and the body's manhood, as it is the origin of these – that is why it is called a manhood. It is like reason and education, as they too are generative...It also signifies excess and ownership as it sometimes opens out and sometimes is relaxed, and it can both produce and eject. It suggests plans [the word for plans and penis are similar in Greek]. It is also analogous to poverty, slavery and imprisonment as the penis is a symbol of constraint. It is also called reverence and respect.

Priapus, the god of fertility, shown on a fresco in the House of Vettil in Pompeii, weighs his phallus.

The Romans, of course, worshipped the phallus. When St Augustine visited Rome in the fourth century AD he recorded:

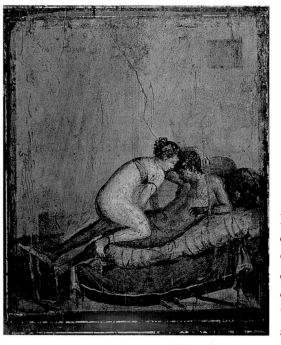

Another fresco from Pompeii shows that mere mortals sometimes need a helping hand.

That shameful part of the body was, during the festival of Liber, placed with great pomp on wagons and carried about the roads in the country and at last to the city. In the town of Lanuvium, a whole month was dedicated to Liber. During it, the citizens shouted obscenities until the phallus had been carried to the market place and erected there. The highest ranking lady of the town then had to put a wreath on it. The god Liber had to be propitiated to ensure the future of the crops, and the evil eye had to be driven from the fields by compelling a married woman to do in public, what not even a harlot would do under the eyes of married women in a theatre.

In China there were no gods to help a young married couple in their first exploration of sex. Despite the long Chinese tradition of erotic literature and art, there was often a problem of ignorance, especially among those of elevated status. This was overcome with the so-called 'Joyful Buddhas'. The Ming scholar Shen Te-fu wrote about them in the seventeenth century:

I have seen the Joyful Buddhas in the palace, which are said to have been sent as a tribute by foreign countries. Others say that these statues are remnants of the Mongol rule. They are pairs of richly adorned Buddhas, who embrace each other with their genitals linked. Some statues have movable sexual organs, plainly visible. The Head of the Eunuchs informed me that when a prince gets married, the couple is first led to the hall. After they have knelt and worshipped, both the bride and groom must feel the genitals of the statues with their fingers, so that they learn, without words, about sexual intercourse. Only after this ceremony may they drink the wedding cup. The reason is that it is feared that such persons may grow up ignorant of sex.

After that, presumably, they can practise on each other.

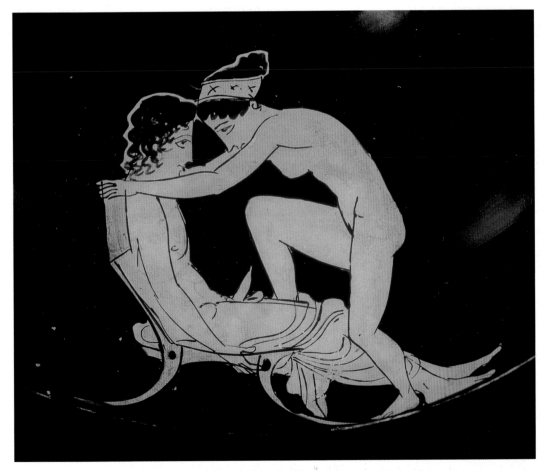

For this young Greek couple, depicted on a jug from the fifth century BC, everything is in full working order.

\intWEET SURRENDER

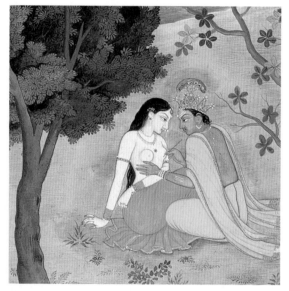

Krishna begins
by adorning
Radha's breasts.

Recline your cheek, with eager kisses press
Her balmy lips, and drinking from her eyes
Resistless love, the tender flame confess,
Ineffable but by the murmuring voice
Of genuine joy; then hug and kiss again
Stretch'd on the flow'ry turf, while joyful glows
Thy manly pride, and throbbing with desire
Pants earnest, felt thro' all the obstacles
That intervene: but love, whose fervid course
Mountains nor seas oppose, can soon remove
Barriers so slight...

J. ARMSTRONG IN *THE ECONOMY OF LOVE*

Seduction can be an innocent thing – two lovers surren-
dering sweetly to mutual attraction. It can be a delicate
dance with each partner circling the other, neither
explicitly stating their goal for fear of frightening off the other party. Or it can be the
defilement of innocence by a heartless adventure. Wang Shih-cheng wrote:

> There is a kind of lustful beast who cannot see a woman of even ordinary
> comeliness, without devising a hundred or a thousand plots to seduce her.

Men like this – which actually includes all of us – can take heart from the Arabic writer
Ibn Hebm, who declared:

> There is no woman who, if invited by man, will not surrender to him in the end. It
> is the absolute law and the inescapable decree of destiny.

The first step in seduction is usually a kiss. In the second century AD, in his romance
Leucippe and Cleitophon, the Greek author Achilles Tatius explained the significance of
osculation. His protagonist Cleitophon says:

Opposite: In Eleanor Fortesque-Brickdale's *The Pale Complexion of True Love*, this swain has a long way to go.

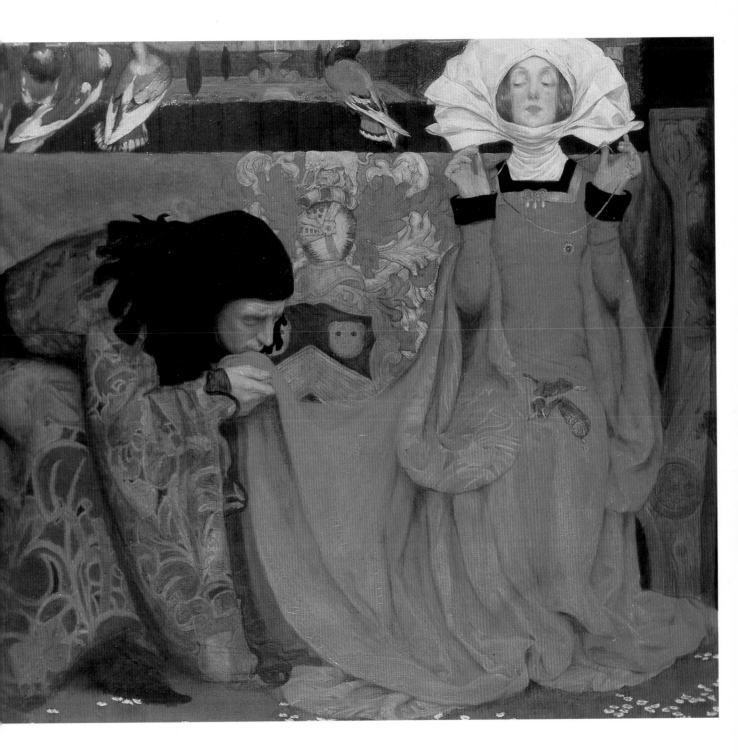

I could feel her kiss still resting on my lips like an alien thing, and I guarded it carefully as a secret source of pleasure. For a kiss is the greatest of pleasures. It is the love-child of the mouth. And the mouth is the loveliest organ of the body. It is the source of speech, and speech is the shadow of the soul itself. The union and commingling of two mouths radiates pleasure downwards into the body and draws the soul up towards the kissing lips.

Henry John Stock's *The Kiss* is the passionate prelude to an erotic encounter.

Kissing also has profound physical effects, Tatius points out:

A woman's body is moist in embrace and her lips are tender and soft for kissing. She holds a man's body totally and pleasantly wedged in her embraces, into her flesh, and the man is completely surrounded by pleasure. She plants kisses on your lips like a seal touching warm wax. She kisses with art and makes her kiss sweeter, for she wants to kiss not only with her lips but also with her teeth, grazing around the mouth of the kisser, nipping with her kiss. Her breasts too, when fondled, have their own special pleasure. And when the height of Aphrodite's act is reached, she is frenzied with pleasure. She kisses with her mouth wide open and goes frantic. Tongues caress each other fiercely, fighting to kiss as much as possible. The pleasure is heightened when you open your mouth to kiss. When a woman reaches the very peak of love making, she gasps with burning pleasure. The gasp reaches the lips with the breath of love. There it meets a wandering kiss looking for a way down. This kiss turns back with the gasp, follows it down and strikes at the very heart. Confused by the kiss, the heart throbs. If it were not firmly tethered in the chest, it could rip itself free and drag itself upwards towards the kisses.

For the Chinese, of course, a kiss is not just a kiss. Different types of kisses can be described, analysed and categorized. In his discourse *The Libation of the Twin Peaks* the master Wu Hsien shows how the man can drink in *yin* essence from the woman during kissing. And exactly where a man kisses a woman is all-important:

A kiss and gentle fondling is the universal opening, depicted here by Muhammad Zaman.

The 'Red Lotus Peak' – on the lips – is the highest kiss. The 'Jade Spring' gushes from two holes under the woman's tongue. The libation floods out when the man licks it with his own tongue. It is transparent and is very good for the man.

The 'Twin Peaks' – on the breasts – is the next highest kiss. 'White Snow' comes from the woman's nipples. It is sweet to taste and white in colour. Although it is good for the man, it helps the woman even more. It strengthens her circulation and regulates her menstruation, relaxing her body and putting her at ease. It also helps produce more libation in her 'Flowery Pool' – mouth – and 'Dark Gate' – vagina. Of the three libations, 'White Snow' is the best. If a woman has not borne a child and her breasts give no milk, the effect is even better.

The 'Purple Mushroom Peak' is the lowest of the three peaks. It is also known as the 'White Tiger's Cave' or the 'Dark Gate'. The lubricating libation which comes from it is called 'Moon Flower'. It is kept deep in the 'Palace of Yin', or womb. Only when a woman is excited to the point where her face is red and she starts murmuring does the libation flood out.

Jean Léon Gerome's *Pygmalion and Galatea* depicts many a sculptor's seduction fantasy.

Just a soft caressing of the face can attract Eros's arrows.

In a proper seduction, it is often difficult to make out who is seducing whom. Hsi-mên, the protagonist of *The Golden Lotus*, often finds himself with women who seem to have deliberately made themselves irresistible. So although he takes the active part, one senses that it is the woman who is really in control of the action:

Through the light silk shirt, Hsi-mên could see her crimson trousers. The sunlight made them transparent and he could clearly distinguish the cool flesh beneath them. The sight aroused him. They were alone, so he stopped dressing his hair and carried her to the couch. He pulled aside her silk skirt, took down the crimson trousers and played

with her the game called 'Carrying fire over the mountains'. They played it for a long time with him bringing the matter to a conclusion. Their pleasure was that of a love bird and his mate.

Of course, you must be in the right place at the right time. In his *Art of Love* Ovid recommends a visit to the games:

> Many are the opportunities that await you at the circus. No one will prevent you sitting next to a girl. Get as close to her as you can. That's easy enough, for the seating is cramped anyway. Find an excuse to talk to her...Ask here what horses are entering the ring and which ones she fancies. Approve her choices...If, as is likely, a speck of dust falls on her lap, brush it gently away; and, even if no dust falls, pretend it has done and brush her lap just the same. She will certainly let you have a glimpse of her legs...The deft arrangement of a cushion has often helped a lover...Such are the advantages which a circus offers to a man looking for an affair.

Ovid says that sometimes a man must be assertive, if he is to get what he wants:

> She will perhaps resist at first and say 'You naughty man'. But even while she is resisting she will show you that she desires to be overcome.

He then gives an example of his own seduction technique:

> Finally, I ripped off her tunic, which was so thin it hardly covered anything, but she still tried to cover herself with it. She struggled as if she did not wish for victory, betrayed herself and was overcome. When she stood naked in front of me, I could see that her body had not a single flaw. What shoulders and what arms I saw and felt! How well-formed her breasts were and how fit to be caressed! How firm her body was below her swelling breasts. Unspoilt by wrinkles, how beautifully formed it was. How wanton her buttocks! How slender and youthful her thighs! Why go on? Everything I saw was perfect. I pulled her naked body on to mine...May I often enjoy such happy hours of love.

This Roman sculpture shows Cupid and Psyche in the arms of love.

Today, this would not be considered assertive. It would be considered rape. But nudity, however achieved, does help if the action is to progress. In the sixth century AD Paulus Silentarius, a court official of the Emperor Justinian, wrote:

> Full nakedness! Strip off your linen white,
> And clinging closely, limb to limb, unite.
> Off with these flimsy veils, for while they're on
> Between us stand the walls of Babylon.

Many literary seductions take place in pastoral settings. In 'The Willing Mistress' of 1648, Aphra Behn wrote of being seduced by a youth named Amyntas, which at the time was a common sobriquet for a lover:

> Amyntas led me to a grove,
> Where all the trees did shade us;
> The Sun itself, though it has strove,
> It could not have betray'd us:
> The place secur'd from human eyes,
> No other fears allows,
> But when the wind that gently rise,
> Do kiss the yielding boughs.
>
> Down there we sat upon the moss,
> And did begin to play,
> A thousand amorous tricks, to pass
> The heat of all the day,
> A many kisses did he give
> And I return'd the same
> Which made me willing to receive
> That which I dare not name.
>
> His charming eyes no aid requir'd
> To tell their softening tale;
> On her that was already fir'd
> 'Twas easy to prevail.
> He did but kiss and clasp me round,
> Whilst those his thoughts expressed:
> And laid me gently on the ground
> Ah, who can guess the rest?

Otto Muller's *Gipsy Lovers* need no encouragement.

That notorious seventeenth-century rake Sir Charles Sedley, famous for causing a riot by pissing on a crowd in Covent Garden, stark naked, from the balcony of the Cock Tavern, was similarly coy when it came to verse:

Young Coridon and Phillis
 Sat in a lovely grove;
Contriving crowns of lilies;
 Repeat tales of love:
And something else, but what I dare not name.

But as they were playing,
 She ogled so the swain;
It saved her plainly saying,
 Let's kiss to ease our pain:
And something else, but what I dare not name.

A thousand times he kissed her,
 Laying her on the green;
But as he farther pressed her,
 Her pretty leg was seen:
And something else, but what I dare not name.

So many beauties removing,
 Her ardour still increased;
And greater joys pursuing,
 He wandered o'er her breast:
And something else, but what I dare not name.

The battle won, William Hogarth's lovers prepare to do it again.

A last effort she trying,
 His passion to withstand;
Cried, but it was faintly crying,
 Pray take away your hand:
And something else, but what I dare not name.

Young Coridon grown bolder
 The minute would approve;
This is the time he told her,
 To shew you how I love:
And something else, but what I dare not name.

Opposite: Modesto Faustini's *Lovers by a Fountain* relish sweet words.

The nymph seemed almost dying,
 Dissolved in amorous heat;
She kissed, and told him sighing,
 My dear, your love is great:
And something else, but what I dare not name.

But Phillis did recover
 Much sooner than the swain;
She blushing asked her lover,
 Shall we not kiss again:
And something else, but what I dare not name.

Thus love his revels keeping,
 Till nature at a stand;
From talk they fell to sleeping,
 Holding each other's hand:
And something else, but what I dare not name.

The Earl of Rochester was around at the same time and was involved in similar amorous activities, though with less success:

Fruition was the question in debate,
Which like so hot a casuist I state,
That she my freedom urged as my offence
To teach my reason to subdue my sense;
But yet this angry cloud, that did proclaim
Volleys of thunder, melted into rain;
And this adult'rate stamp of seeming nice,
Made feigned virtue but a bawd to vice;
For, by a compliment that seldom known,
She thrusts me out, and yet invites me home;
And these denials but advance delight,
As prohibition sharpens appetite;
For the kind curtain raising my esteem,
To wonder as the opening of the scene,
When of her breast her hands the guardians were,
Yet I salute each sullen officer:
Tho' like the flaming sword before my eyes,
They blocked the passage to my paradise;

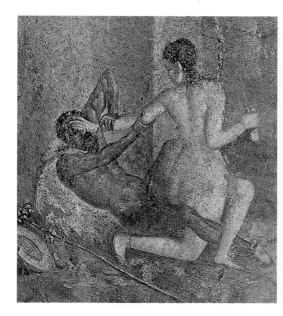

Nor could those tyrant hands so guard the coin,
But love, where't cannot be purchased, may purloin:
For tho' her breasts were hid, her lips were prize,
To make me rich beyond avarice;
Yet my ambition my affection fed,
To conquer both the white rose and the red.
The event proved true, for on the bed she sate
And seemed to court, what she had seemed to hate;
Heat of resistance had increased her fire,
And weak defense is turned to strong desire.
What unkind influence could interpose,
When two such stars in conjunction close?
Only to hasty zeal my hopes did foil,
Pressing to feed her lamp, I spilt my oil...
For love turns impotent, when strained too high;
His very cordials make him sooner die,
Evaporates in fume, the fire too great;
Love's chemistry thrives best in equal heat.

During the Restoration period, all England seemed to be on heat. In literature, at least, most seductions were brief, as in 'Riding to London, on Dunstable Way', written in 1661:

When I came to Hockley at the sign of the Cock
By a lightning I chanced to see her white smock,
It lay so alluring upon her round knee,
I called for a Chamber immediately;
I hugged her, I tugged her, I kissed her, I smugged her,
And gently I laid her down on a bed,
With nodding and pinking, with sighing and winking,
She told me a tale of her Maidenhead.

While she to me this story did tell,
I could not forebear, but on her I fell;
I tasted the pleasures of sweetest delight,
We took up our lodging, and lay there all night;
With soft arms she rouled me, and oft times told me,
She loved me dearly, even as her own soul:
But on the next morrow we parted in sorrow,
And so I lay with her at Hockley-i'th'-hole.

In Pierre Bonnard's *Nu aux bas noirs*, seduction is simply a matter of fixing a price.

Poetry itself has always played an important part in seduction. It started in Egypt in the New Kingdom (1580–1085 BC). One of the simplest and most beautiful of love poems was written on a large ostrakon – a flake of limestone – now in the Cairo Museum:

> When I embrace her
> and her arms are open,
> I feel like a man in the land of incense
> who is drowning in its scent.
> When I kiss her
> and her lips are open,
> I am joyful,
> even without having drunk beer.

The woman's reply is more erotic:

> I love to bathe before you.
> I let you see my beauty,
> through a dress of transparent linen,
> drenched with a fragrant perfume.
> I go down to the water to be with you
> and come up with a red fish,
> looking splendid in my fingers.

Johann Heinrich Füssli depicts the seduction of a willing participant.

For the ancient Egyptians, nudity was commonplace – and therefore not much of turn-on. But a woman's body glimpsed through sheer fabric was thought to be highly erotic. And the red fish plainly had phallic connotations.

Some Egyptian poems were translated into Greek. This one is taken from a collection made in Anakreon in the sixth century BC:

> I wish I were your looking glass
> so you always looked at me.
> I wish I were your favourite dress
> so you would always wear me.
> I wish I were the water
> that washes your body
> I wish I were the perfume, oh woman,
> that I could anoint you.
> And the band around your breasts,
> and the beads around your neck.
> I wish I were your sandal
> so you would step on me.

Clara Rice's blissful seduction, an illustration from Pierre Louÿs's erotic classic *Aphrodite*.

But the direct approach works just as well. In the second century AD, Lucius Apuleius describes his seduction of a young slavegirl called Fotis in *The Golden Ass*:

I said: 'Behold, Fotis, I am yours, and shall presently die unless you take pity on me.' Which when I had said she eftsoons kissed me, and bid me be of good courage, and 'I will,' quoth she, 'satisfy your whole desire, and it shall be no longer delayed than until night, when assure yourself I will come and lie with you; wherefore go your ways and prepare yourself, for I intend valiantly and courageously to encounter with you this night.'

And when I was entering into the bed, behold my Fotis came in and gave me roses and flowers which she had in her apron, and tied a garland about my head, and bespread the chamber with the residue. Which when she had done, she took a cup of wine and delayed it with hot water, and proffered it to me to drink; and before I had drunk it all, she pulled it from my mouth, and then gave it to me again, and in this manner we emptied the pot twice or thrice together.

Thus when I had well replenished myself with wine, and was now ready unto venery not only in my mind but also in body, I removed my clothes, and showing to Fotus my great impatience I said, 'O my sweet heart, take pity on me and help me, for as you see I am now prepared unto the battle which you yourself did appoint – for after that I felt the first arrow of cruel Cupid within my breast, I bent my bow very strong, and now fear (because it is bended so hard) lest my string should break; but thou mayest the better please me, undress thy hair and come and embrace me lovingly.'

Whereupon she made no long delay, but set aside all the meat and wine, and then she unapparelled herself, and unattired her hair, presenting her amiable body unto me in the manner of fair Venus when she goeth under the waves of the sea.

'Now,' quoth she, 'is come the hour of jousting; now is come the time of war; wherefore show thyself like unto a man, for I will not retire, I will not fly the field. See then thou be valiant, see thou be courageous, since there is no time appointed when our skirmish shall cease.'

In saying these words, she came to me to bed, and embraced me sweetly, and so we passed all the night in pastime and pleasure, and never slept until it was the day; but we would eftsoons refresh our weariness and provoke our pleasure, and renew our venery by drinking wine. In which sort we pleasantly passed away many other nights following.

Of course, a man does always have to wait for consent. When Hsi-mên saw Golden Lotus asleep, naked except for a light scarlet vest, he took off his clothes and told her maid, Plum Blossom, to close the door:

Then, indulging in a jest, he moved her legs apart, took his penis in his hands and put it in. She opened her eyes, but he had already gone up and down, in and out, ten times.

And he did not even apologize. When she told him that he was a rude man for creeping into her bedroom, he told her that no harm had been done and, besides, if he had been a stranger she would have pretended not to know the difference.

In the seventeenth-century poem 'I Dreamed My Love', again the victim is sleeping:

I dreamed my love lay in her bed:
 It was my chance to take her:
Her legs and arms abroad were spread;
 She slept; I durst not wake her.
O pity it were, that one so fair
 Should crown her love with willow;
The tresses of her golden hair
 Did kiss her lovely pillow.

Methought her belly was a hill
 Much like a mount of pleasure
Under whose height there grows a well;
 The depth no man can measure.
About the pleasant mountain's top
 There grows a lovely thicket,
Wherein two beagles trampled
 And raised a lively pricket.

They hunted there with pleasant noise
 About the pleasant mountain,
Till he by heat was forced to fly,
 And skip into the fountain.
The beagles followed to the brink,
 And there at him they barked;
He plunged about, but would not shrink;
 His coming forth they waited.

Then forth he came as one half lame,
 Were weary, faint, and tired;
And laid him down betwixt her legs,
 As help he had required.

For John Tobias Sergel's lovers, the seduction is over.

The beagles being refreshed again,
 My love from sleep bereaved;
She dreamed she had me in her arms,
 And she was not deceived.

As the narrator is also asleep and dreams the whole incident, this does not count as rape.

Rape is widely discussed in Arab culture, where forcibly taking a woman is thought to be unnecessary and vulgar:

> To rape a woman who resists is like trying to sheath a sword with an unsteady hand. If she faints, there is no life in her body. The art lies in arousing her directly by friction. Clutch her firmly but tenderly. Take your penis in your hand and rub its head against her slit until it becomes moist and ready for penetration. Only the brutish and ignorant man cries: 'I will piss my tallow into your womb unrelenting. Your ripe fruit will be impaled on a vigorous thorn.' Rape should be a glorious and guileful conquest. It is a difficult seduction, a subtle ravishing – not the gross action of a brutish beast. Be brave, be cunning – be all-powerful.

If all this guile and cunning is too much trouble, a man can always pay for what he wants. And to judge from the description in the *Arabian Nights*, a visit to a courtesan can yield many pleasures:

> The lady was crowned with a diadem of pearls and jewels, her face dotted with artificial moles in indigo, her eyebrows penciled with khol and her hands and feet reddened with henna. When I looked at her, I well-nigh bepissed my bag-trousers for the excess of her beauty and loveliness.
>
> When she saw me, she smiled and took me into her embrace and clasped me to her breast. Then, she put her mouth to mine and sucked my tongue; and I did likewise. Then, we fell to toying and groping and kissing and dallying.
>
> Straining me to her bosom, she threw me to the floor; then, she sat astraddle upon my breast and kneaded my belly with her fingers, till I well-nigh lost my senses. And she said to me: 'My life on thee! Harken to me: look upon the narcissus and the tender down thereon, and enjoy the sight of naked waist and navel, and touzle me and tumble me, from this moment till the break of day.'
>
> She opened the bosom of my shirt and bent over me and kissed me, and put forth

Ruben's *Embracing Couple* are already entwined.

her hand to me pressing my breast. And, because of the smoothness of my body, it slipped down to my waist, and thence to my navel, and thence to my yard; whereupon, her heart ached and her vitals quivered and lust was sore upon her. And mad for me, she stripped my body and left none of me unkissed and unfondled.

'By God! No male hast even filled my eyes but thyself,' she whispered; and she gripped me with supple limbs. And taking in hand my prickle, firm to the utmost of its height, she nailed it into her coynte.

Another Arab relates a similar experience with a prostitute:

Clasping her to my bosom, I suck her upper lip and then her under lip, and slid my tongue between the twain, into her mouth. Then I rose to her, and had of her amorous delight. I rained upon her cheeks kisses like the falling of pebbles into water, and struck with stroke upon stroke, like the thrusting of spears in battle brunt, for that she still yearned after clipping of necks and sucking of lips and gripping of tress and pressing of waist and biting of cheek and cavalcading on breasts with Cairene buckings and Abyssinian wrigglings and Persian sobbings and Syrian nibblings and Nubian lasciviousness and Hindoo leg-lifting and Bedeween moanings and Turkish hotness and Alexandrian languishment.

Visiting a prostitute was a more sordid business in eighteenth-century London, as James Boswell recorded in his diaries. By the time he was twenty-three in 1763 he had had eleven mistresses and more than sixty prostitutes in seven countries. And despite his moral qualms, he had no real thought of giving up. On 25 March 1763 he records:

As I was coming home this night, I felt carnal inclinations raging through my frame. I determined to gratify them. I went to St James's Park and picked up a whore. For the first time I did engage in armour, which I found but a dull satisfaction. She who submitted to my lusty embraces was a young Shropshire girl, only seventeen, very well-looked, her name Elizabeth Parker. Poor being, she has a sad time of it!

Five days later he went to the park again and grabbed the first prostitute he saw, 'whom I without many words copulated with, free from danger being safely sheathed'. Then on 13 April:

I should have mentioned last night that I met with a monstrous big whore in the Strand, who I had a great curiosity to lubricate, as the saying is. I went into a tavern with her, where she displayed to me all the parts of her enormous carcass; but I found that her avarice was as large as her a—, for she would by no means take

Opposite: A Hindu couple passionately aroused, depicted by the Bundi School in the late eighteenth century.

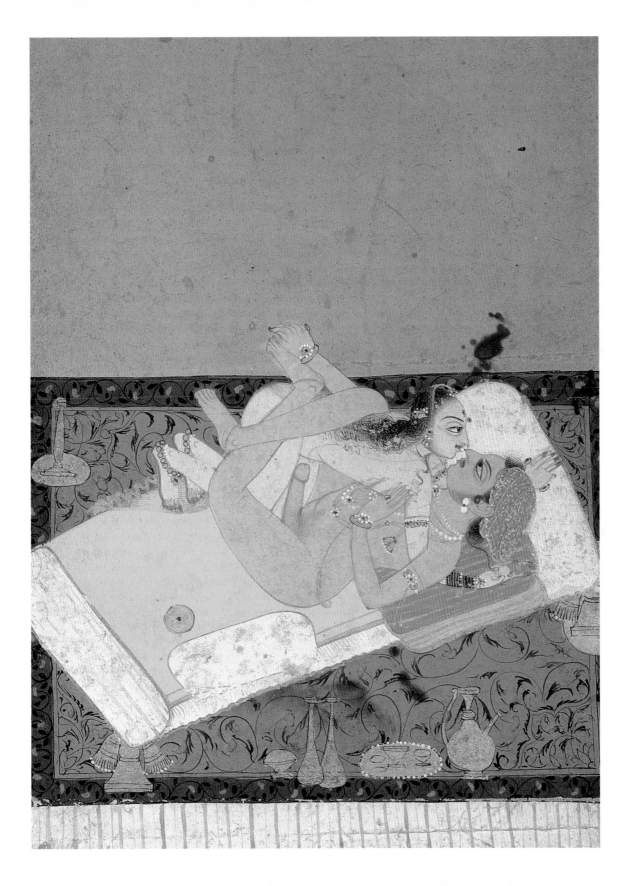

Although this French nineteenth-century engraving is called *The Conversation*, the woman mutely shows the man what she desires.

what I offered her. I therefore with all coolness pulled the bell and discharged the reckoning, to her no small surprise and mortification, who would fain have provoked me to talk harshly to her and so make a disturbance. But I walked off with the gravity of a Barcelonian bishop. I had an opportunity tonight of observing the rascility of the waiters in these infamous sort of tavern. They connive with the whores, and do what they can to fleece the gentlemen. I was on my guard, and got off pretty well. I was so much in lewd humour that I felt restless and took a little girl into a court; but wanted vigour. So I went home, resolved against low street debauchery.

Nevertheless, Boswell was at it again on 10 May:

> At the bottom of Haymarket I picked up a strong, jolly young damsel, and taking her under the arm I conducted her to Westminster bridge and there in armour complete did I engage her upon this noble edifice. The whim of doing so there with the Thames rolling below us amused me so much. Yet after the brutish appetite was sated, I could not but despise myself for being so closely united with such a low wretch.

But a week later:

> I picked up a fresh, agreeable young girl called Alice Gibbs. We went down a lane to a snug place, and I took out my armour, but she begged that I might not put it on, as the sport was much pleasanter without it, and as she was quite safe. I was so rash as to trust her and had a very agreeable congress.

Apart from the pox, there were other dangers. On 4 June:

> I went to the Park, picked up a low brimstone virago, called myself a barber and agreed with her for sixpence, went to the bottom of the Park, arm-in-arm, and dipped my machine in the Canal and performed most manfully. I then went as far as St Paul's Churchyard, roaring along, and then came to Ashley's Punch-house and drank three threepenny bowls. In the Strand, I picked up a little profligate wretch

and gave her sixpence. She allowed me entrance. But the miscreant refused me performance. I was much stronger than her, and *volens nolens* pushed her up against a wall. She, however, gave a sudden spring from me; and screaming out, a parcel of whores and soldiers came to her relief.

'Brother soldiers,' said I, 'should not a half-pay officer roger for sixpence? And here has she used me so and so.'

I got them on my side, and I abused in blackguard style, and then left them. At Whitehall, I picked up another girl to whom I called myself a highwayman and told her I had no money and begged she would trust me. But she would not.

On the night of 18 June:

I took a street-walker into Privy Garden and indulged sensuality. The wretch picked my pocket of my handkerchief, and then she swore she had not. When I got home I was shocked to think I had been intimately united with a low abandoned, perjured, pilfering creature. I determined to do so no more, but if the Cyprian fancy should seize me, to participate my amorous flame with a genteel girl.

In *The Landscape Lesson*, the artist is seduced by a lady – or it could be the other way around.

But on 13 July his amorous flame gets the better of him:

This afternoon I had some low debauchery with girls who patrol the courts in the Temple.

However, Boswell's conscience was beginning to trouble him:

Since my being honoured with the friendship of Mr Johnson I have more seriously considered the duties of morality...I have considered that promiscuous concubinage is certainly wrong...Sure that it is that if all the men and women in Britain were merely to consult an animal gratification, society would be a shocking scene. Nay, it would cease altogether. Notwithstanding of these reflections, I have stooped to mean profligacy. Heavens, I am resolved to guard against it.

But it happens again on 3 August:

> I should mention that on Monday night, coming up the Strand, I was tapped on the shoulder by a fine fresh lass. I went home with her. She was an officer's daughter and born at Gibraltar. I could not resist indulging myself with the enjoyment of her. Surely, in such a situation, when the woman is already abandoned, the crime must be alleviated, though in strict morality, illicit love is always wrong.

The notorious Giacomo Casanova, who was womanizing his way across Europe at that time, also used 'armour'. This was 'a little article of transparent skin, about eight inches long, with one opening, which was ornamented with a red rose'. On one occasion he was lucky enough to get a hot-blooded nun to put it on for him. When she had secured it, she said:

> 'There you are, hooded like a mother superior, but despite the fineness of the sheath I like the little chap better naked. I think this covering degrades both of us.'

No sign of resistance here. A woman admires her own breasts while her lover admires her buttocks – an illustration by Berthommé St André for 'La Vie des Courtisanes' from Aretino's *Ragionamente*.

'You are right, but let's not dwell on things that will spoil our pleasure.'

'We will have our pleasure soon enough. But for the moment, let me think about these things. Love must have invented these things, but first it must have listened to the voice of prudence. Love and prudence do not lie well together.'

'You are right, of course. But could we talk about it another time.'

'Hold hard. I have never seen a man before and I wish to enjoy the sight as much as I can now. Ten months ago, I would have called this thing the work of the devil, but now I see that its inventor is a benefactor...Dear me, the maker of this one must have measured you badly. Look, it is too big here and too small here, and it makes what should be straight, curved.'

Although Casanova liked the idea of seducing women by stratagem, charm and personal

attraction, he actually preferred buying their favours. What he hated most of all was to be turned down. When one woman, La Charpillon, refused him, he attacked her violently. Later, he toyed with the idea of taking her by force, using a device called 'Goudar's chair', which he thought of buying. This looked like an ordinary chair. But when someone sat in it, spring-loaded catches seized their arms and legs. Then their legs were forced apart. The seat raised and tilted until the victim was in the position of a woman in labour and could offer no resistance.

In the end, however, Casanova thought better of this plan. Resorting to such methods, he reasoned, would ruin his reputation.

The course of a proper seduction – like the course of true love itself – rarely runs smooth. The lawyer Agathias of Myrina, writing in the second half of the sixth century AD, found he had problems on his hands:

> I was once reclining at dinner between two women - one I desired but I gratified the other. One attracted me with her kisses, while like a thief I stole kisses from the other's grudging lips, invoking jealously in the first who made fearful and love-breaking messages. And I said with a sigh: 'It is a great misfortune for me to love and be loved, as I am doubly punished.'

The seduction of the younger, more reticent of the two then became something akin to a battle:

> The jealous old woman lay across the bed between me and the girl like a battlement. Behind her the girl lay covered by a single blanket. But the grim maidservant, having locked the door, fell back drunk from undiluted wine. I was not afraid. I silently lifted the latch of the door and put out the burning firebrand by waving my cloak. Penetrating slantwise across the chamber, I eluded the sleeping guard. Then I dragged myself on my stomach under the bed and came up by the wall on the other side. Pressing close to the girl's bosom, I grabbed her breasts, ravishing her face with my kisses, feeding myself on the softness of her mouth.
>
> My reward was a beautiful mouth and I took her kiss as the promise of a nightly contest. Until now, I have not destroyed the fortress of her maidenhead, since I am avoiding a fight. But if the war begins again, I shall knock down the walls of her virginity. No battlement will hold me back. And if I win it, I shall weave a garland for you, oh Cypris, bearing the badge of victory.

Women trick men into sex too. Pietro Aretino tells of an old woman who is too old to attract lovers, but manages to seduce a man by telling him about the tasks she performs for his intended mistress:

Lucas Cranach's *Infatuated Old Woman* must pay for her pleasure.

'I tell your lordship truly, I washed her with these very hands, not with ordinary water but rose-water, and while I was washing her nipples, breasts, thighs and neck, I was struck by the amazing softness and whiteness of her flesh. The bathwater was tepid, but though the fire was lit, I was to blame for what happened. As I cleaned her loins, her melons and her pretty little slit, I almost swooned from the unbearable sweetness of pleasure. What tantalizing flesh! What delicate limbs! What a beauteous body! Nobody can afford such flesh. I touched it, kissed it and fondled it, all the time talking about you.'

To cut a long story short, I got him so worked up that he raised his third leg, fell on top of me and gave me, not just an ordinary one, but what you could call a super-screw.

An experienced woman might easily seduce herself, as in the Japanese Legend of *Ame-No Uzume*:

The dance of the goddess Ame-No-Uzume grew wilder as she recalled a thousand orgasms she had enjoyed. Her nipples stiffened and she felt her sex open when she remembered the penises of the countless lovers that had penetrated her. When at last she brought herself to the crisis, she opened her clothes to reveal herself to the kami: wet to the knees, her sex throbbing with joy.

Once a couple have already made love one or more times, the woman often feels freer to use her seductive skills to excite her lover once again:

Inflamed by wine, her graceful fingers played with the warrior between his thighs. But he was weary after battle, yet not quite spent.

'Why don't you leave him alone,' he said. 'It is all your fault. You have terrified him so much that he can hardly move.'

'It can hardly move? What are you saying?' replied the woman.

'If it could move it would not be lying there like a withered flower. Why do you not ask his pardon, prostrate, on your knees?'

She looked down at it and laughed. Then she knelt, put her head against his leg, undid his trousers and seized hold of the wilting warrior.

'You are he who raised his head so proudly, and whose eye was so fierce it terrified me. Now you simulate fatigue and lie there as if you were dead.'

Meanwhile she was playing with him, pressing him against her soft cheeks,

cherishing him with her hands and, lastly, kissing the bone of the frog. Suddenly the warrior arose, burning with anger. His head was as stiff as a nail, his eye on fire, his jawbone bristling with hairs, his body standing rigid.

Any woman may use her wiles simply to put a man into the mood for love. In the ancient Chinese erotic novel *The Prayer Mat of the Flesh* an experienced woman, Hua Chen, explains one method of getting into the right frame of mind for sexual relations:

> You should look at spring [erotic] pictures before you start to act, while both parties are fully dressed. While still treating each other as host and guest, look at one picture, for when discussing its finer points the feelings will naturally be aroused, and before any action has been taken the male member will have raised itself, and the fluid of desire will have started to flow. But one should ignore these things, and wait instead until after you have seen more than ten, and absolutely prohibit doing anything even then, but wait for one to be fully aroused, for only then does one feel the full power of the spring palace.

The protagonist in *The Prayer Mat of the Flesh*, Wei-yang-sheng, uses this technique on his principal wife Jade Perfume. The daughter of a professor of literature, she was beautiful and had a good literary education, but knew little of the world. And when it came to sexual matters, she was completely ignorant:

> As soon as he made some passionate remark, her face would grow red and she would run off. Wei-yang-sheng had a great preference for engaging in sexual congress during the day time, he loved to let the sight of a woman's private parts excite his lust. Several times he tried to loosen Jade Perfume's trousers during the day, but then she would start to protest loudly and make as if she were going to be raped, so he had to give up. In the night, she submitted to his embraces, but only because she felt that it could not be helped. And as to the position, she clung to conventional positions, refusing to try any variation. When he wanted 'to catch the fire across the mountain', she protested that this must not be done because a wife was not supposed to turn her back on her husband and when he wanted her to practise 'moistening the inverted candle' she said that this was impossible because it inverted the correct position of the male and female positions. It was only by assiduous efforts that he could being her to place her feet on his shoulders. When reaching orgasm she did not cry out 'You kill me!' or 'My life' or similar exclamations that flatter a man's prestige in battle, and even when he called her 'My dearest one' or 'My very life' she did not respond and acted as if she were dumb.
> Wei-yang-sheng was greatly vexed at seeing Jade Perfume so unresponsive. He

reflected that there was only one thing to do, namely set to work to educate her and thus effect the desired change. So the next day he went to an antique shop and he purchased an album of very cleverly painted erotic pictures. They were authentic specimens of the brush of Chao Meng-fu [a famous Mongol painter]. There were thirty-six pictures in all, corresponding to the line in the T'ang poem 'Spring reigns in all the thirty-six palaces'. He thought if he took this album home and leafed through it together with Jade Perfume, she would see the various methods of sexual intercourse and realize that these were not an invention of her husband, but practised already by people of antiquity. He could prove the point by using the album as guide. When he brought her the album, Jade Perfume had no idea what its contents were. She took the book and opened it... She saw that the first two pages were inscribed with four large characters which read: 'Lingering Glory of the Han Palace.' She reflected that in the Imperial Palace of the Han Dynasty there had been many sage Empresses and chaste ladies and she thought that this album would contain their portraits. She wanted to see what they looked like. But when she turned the page she saw a man embracing a woman, both stark naked and engaged in the sexual act on an artificial rock. Her face grew red with embarrassment.

'Where did you get these terrible things?' she asked. 'They defile the women's quarters. Call a maid quickly and let her burn this.'

Wei-yang-sheng held her back, saying: 'This album is an antique worth a hundred silver pieces. I borrowed it from a friend to have a look at. If you are prepared to compensate him a hundred silver pieces, go ahead and burn it. But if you cannot pay that price, you had better put it down. I shall return it in a day or two when I have finished with it.'

Jade Perfume replied: 'What is the use of looking at such outlandish things?'

He answered: 'If they were really outlandish things, why would an artist have painted them. And why would the owner be willing to pay so much for them? On the contrary, this album represents the most normal things which have existed since the creation of the universe... Today I have borrowed this album not only for my own inspection, but also to acquaint you with these things. Learning how to conceive and become pregnant and give birth to sons and daughters, this certainly belongs to the study of the Right Way. Your father's only worry is that our marriage will not be fruitful. You would certainly not wish to bring him sorrow.'

Jade Perfume asked: 'I refuse to believe that these antics are a proper thing to do. If they were, then why did not the great sages of antiquity, in the beginning when they instituted social order, teach us to do these things openly during the day-time and in the presence of others? Why does one do it only in the depth of night and

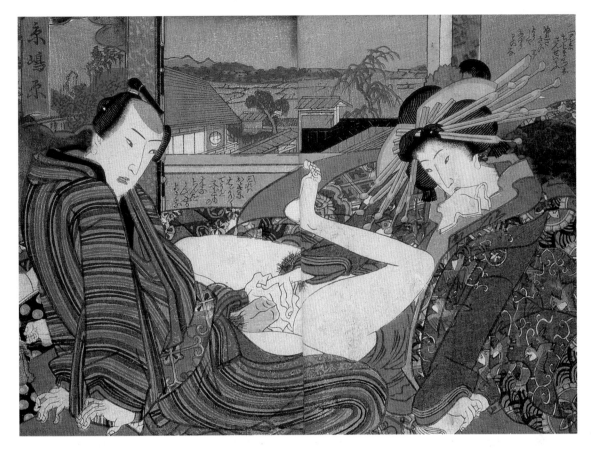

Eizan's erotic print is delightfully entitled *With Many Combs.*

conceal it from others, acting like a couple of thieves? From this you can clearly see that these things are improper.'

Wei-yang-sheng laughed and said: 'All this proves clearly that your father fell short in your education. He always kept you confined to the house, and without girl friends who could have told you a little about passion and love. Since you were always alone, you learned little of life, and remained ignorant of human affairs.'

Gradually Wei-yang-sheng cajoles Jade Perfume to sit on his lap, so that they can look at the erotic pictures together:

This album differed from the usual collections of erotic pictures. The right-hand side of every double page was taken up by the picture, while on the left there was a colophon. The first half of each colophon explained the erotic scene represented, the second half pointed out the artistic merits. Wei-yang-sheng read out the colophons to Jade Perfume to teach her the spirit of the picture, so that they would

later be able to put what she had learnt into practice.

The first picture was called 'The butterfly flutters about, searching for flowery scents'.

The colophon read: 'She sits waiting with parted legs on a rock by the shore of a garden pond. He, first carefully feeling out the terrain, takes pain to insert his nephrite proboscis into the depths of her calyx. Because the battle has only begun and the region of bliss is still far off, both still show a relatively normal expression, their eyes are wide open.'

The second picture showed 'The queen bee making honey'.

The colophon read: 'She lies on her back, cushioned in pillows, her parted legs raised as though hanging in mid-air, her hands pressed against "the fruit", guiding his nephrite proboscis to the entrance of her calyx, helping it to find the right path and not to stray. At this moment her face shows an expression of hunger and thirst, while his features reveal the most intense excitement, with which the viewer becomes infected. All this is brought out by the artist with remarkable subtlety.'

The third picture was 'The little bird that had gone astray finds its way back to its nest in the thicket'.

The colophon read: 'She lies slightly to one side, dug into the thicket of cushions, one leg stretched high, and clutches his thigh with both hands as though his obedient vassal had finally found its way to the right place, to her most sensitive spot, and she feared it might go off and get lost again. This accounts for the shadow of anxiety on her otherwise happy face. Both parties are in full swing, quite preoccupied by the spasmodic thrill of the "flying brush" and the "dancing ink".'

The fourth picture showed 'The hungry steed galloping to the feed crib'.

The colophon read: 'She, flat on her back, presses his body to her breast with both hands. Her feet propped up on his shoulders, he has sunk his yak whisk into her calyx to the shaft. Both of them are approaching ecstasy. The way in which the artist pictures their physical and mental state at this moment, their eyes veiled beneath half-closed lids, their tongues enlaced, reveals the master of the brush.'

The fifth picture showed the position called 'Two Dragons Tired of Flight'.

And the colophon read: 'The woman's head rests on the pillow. Her arms lie by her side, limp like a string of silk. The man is resting his head on the side of the woman's neck, his entire body limp, as numb as cotton. After the orgasm their souls seem to have left their bodies and now they are on their way to beautiful dreams. After the violent passion they have come to rest. The barest thread of life is discernible. If the artist had not added this subtle touch, the couple would seem to be dead, two lovers in one coffin and one grave. The picture brings home to us the

sublimity of bliss savoured to the very end.'

Up to this point Jade Perfume had obediently studied the pictures and patiently listened to the commentary. But as he turned the next page and began to show her the sixth picture, she pushed the book away, visibly agitated.

'Enough!' she cried. 'What's the good of all these pictures? They are just upsetting. You look at them by yourself. I'm going to bed.'

'Just a little patience, we'll run through the rest quickly. The best is still to come. Then we'll both go to bed.'

'As if there weren't time enough tomorrow for looking at books. For my part, I've had quite enough.'

He embraced her and closed her mouth with a kiss. And as he kissed her, he noticed something new. They had been married for a whole month. In all that time, she had held the gates of her teeth closed when he kissed her. His tongue had never succeeded in forcing or wiggling its way through the solid fence. Until today, he had never made contact with her tongue; he hadn't so much as an idea what it was like. But now when he pressed his lips to hers – what a wonderful surprise! – the tip of his tongue encountered the tip of her tongue. For the first time she opened up the gate.

'My heart, my liver!' he sighed with delight. 'At last! And now – why bother moving to the bed. This chair will do. It will take the place of the rock by the pond and we shall imitate the lovers in the first picture. What do you say?'

Jade Perfume pretended to be angry.

'Impossible,' she said. 'This is not a fit occupation for human beings...'

'You are perfectly right,' he said. 'It is an occupation more fit for the gods. Come let us play at being gods.'

So saying, he stretched out his hand and began to fiddle with the knot of her sash. And despite her grimace of disapproval, she co-operated, letting him draw her close and permitting him to strip off her underclothes. This fanned the flame of his excitement. Aha, he observed, just looking at those pictures had sprinkled her little meadow with the dew of desire. He undid himself and set her down in the chair in such a way that her legs hung over his shoulders. Cautiously, he guided his bellwether through the gates of her pleasure house, and then began removing the rest of her clothing.

Sadly, the pictures do their job too well. Soon Jade Perfume becomes insatiable and Wei-yang-sheng begins to look for lovers elsewhere. Eventually, worn out by his excesses, he enters a monastery, where the abbot explains that his debauches were necessary. He had reached enlightenment on 'the prayer mat of the flesh'.

THE ACT OF LOVE

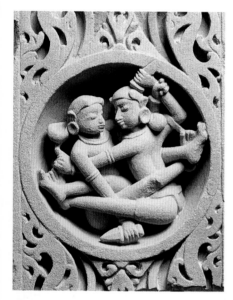

A central Indian pale pink sandstone panel depicting a man and a woman enjoying the secrets of love.

The heavens turn to the left; the earth to the right. Man sings; woman echoes. This the law of natural. If a man stirs and a woman does not respond, or a woman initiates and a man refuses, both will be harmed. So the man must turn to the left and the woman to the right. He descends from above; she receives from below. This is the union of heaven and earth.

TUNG HSUAN TZU

Many ancient civilizations dwelt on the spiritual aspect of sex. After all, coition is the single most important experience in life, after birth and death. It is central to the human experience. In the *Arabian Nights* we read:

> Women and girls were created by Allah for no other purpose than to unite their delicate organs with man. The Prophet has said: 'No woman of Islam shall grow old in virginity.'

Writers in all cultures have pointed out the similarity between death and the transcendent feelings experienced during orgasm. But it is possible to get too strait-laced about sex. The straightforward human – fun – aspect of lovemaking should never be overlooked:

> When the act of carnal copulation is enacted, a lively encounter rages between the two amorous actors, who engage in the heated and frisky combats of kissing and frolicking and interlocking of legs and belly-bumping. And by the sudden impact of the two pubes, the meeting of man and woman in wondrous collision, the enjoyment is not long in coming. For man, in the pride of his potency, works like a pounding pestle in a mixing mortar; and woman, with erotic wrigglings and rapturous writhings, comes artfully to his aid. At last, the climax of their clash comes and the orgasms arrive in mutual bliss.

Opposite: A rare Islamic erotic scene from Turkey.

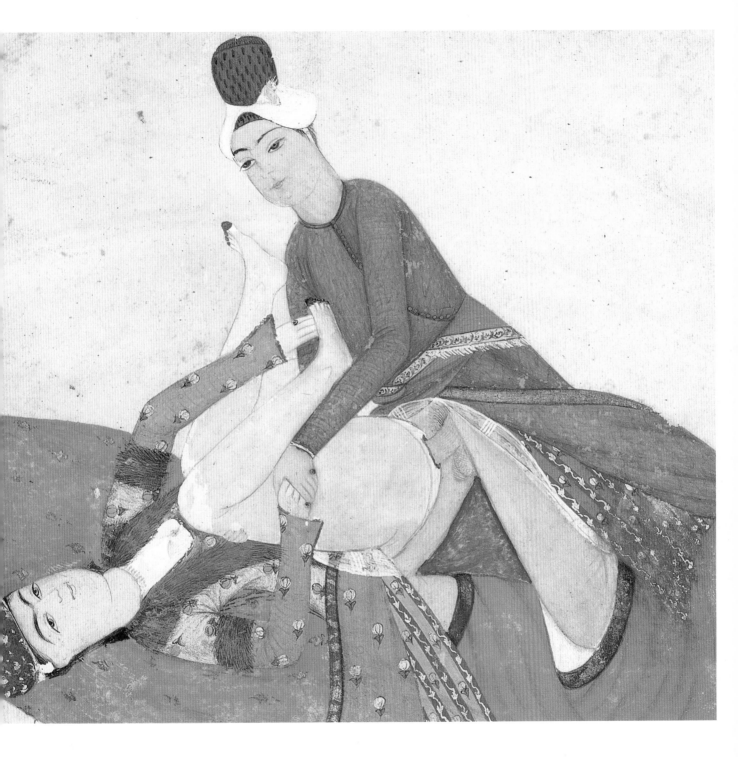

Around AD 100 the Chinese poet Chang Hêng wrote a poem about the joys of the wedding night:

> Let us now lock the door with its lock of gold
> And light the lamp to fill the bedroom with illumination.
> I will take off my clothes and my make-up
> And roll out the book by my pillow.
> Let the Plain Girl be my teacher.
> We will practise all the various positions
> That ordinary husbands rarely see,
> Like those taught to the Yellow Emperor by T'ion-lao
> No pleasure shall rival those of this first night.
> We will never forget them, no matter how old we grow.

A practice sketch of a couple making love, by an early Egyptian artist from the eighteenth dynasty, 1550–1295 BC.

The Plain Girl was Su Nü. She wrote an ancient sex manual called *The Plain Girl's Secret Way*, which Mao Tse-tung used to give to his myriad lovers.

Su Nü outlined the Taoist way of sex, in which the man must retain his masculine *yang* essence. This means that he must learn to control his ejaculation, separating it from his orgasm. According to the seventh-century physician, Li Tung Hsüan:

> A man should develop the art of holding back his ejaculation until his partner is completely satisfied. He must find out and regulate his perfect rate of ejaculation. It should be no more than two or three times in ten coitions.

At the same time, he must drink in as much of the female *yin* essence as possible. This he can get from the woman's lips, her breasts and her vaginal secretion. To obtain the greatest advantage from these he must give the woman full satisfaction.

To do that, the man must put aside his own needs desires and concentrate all his attention on the woman. According to Su Nü, there are five signs he must look for:

Terracotta lovers from pre-Columbian Mexico.

1. The woman's face is flush and her ears are hot. This means that love-making is on her mind. The man can enter her, teasingly thrusting, keeping his penetration shallow while watching for further reactions.

2. Her nipples become hard and there is sweat on her nose. Her desire is now heightened. He can now enter to the depth of five inches.

3. Her voice is lowered and the sound becomes hoarse. Her throat is dry, her eyes are closed, her tongue hangs out and she pants audibly. The man can now penetrate her freely, driving her to the edge of ecstasy.

4. Her vulva is richly lubricated and each thrust causes the juices to overflow. The man should now withdraw to the Valley of the Water-chestnut Teeth which is at about two inches. Then he should vary the timing and direction of his thrusting.

5. The woman wraps her legs tightly around the man and clutches him around the shoulders and back. The man should then thrust deeply into the Valley of the Deep Chamber at six inches. These deep thrusts will send ecstasy through her body.

There are another ten indicators that Su Nü says a man should look for:

1. Her hand holds his back. The lower part of her body is moving. She licks him. This indicates that she is aroused.

2. Her delicate body is supine. Her limbs lie straight and still, but she is breathing heavily through the nose. This indicates that he should resume his thrusting.

3. She plays with the sleeping man's jade hammer with her hands. This indicates that she wants him.

4. Her eyes flicker. Her throat makes guttural sounds or she whispers terms of endearment. This means she is greatly aroused.

5. She holds her feet and opens her jade gate widely. She is enjoying him greatly.

6. Her tongue hangs out as if she is half-drunk or half-asleep. This means her vulva is ready for a succession of shallow and deep thrusts at great frequency.

7. She stretches out her feet and toes and tries to hold his jade hammer inside her, though she does not know which way she wants him to thrust. Meanwhile, she murmurs in a low voice. The tide of yin about to come.

8. Although she has come, she turns her waist, sweats slightly and smiles. This means that she is not ready for him to ejaculate because she wants more.

9. The tide of *yin* has arrived, but she still holds on tightly. This means that her satisfaction is not yet complete.

10. Her body is hot and wet with sweat. Her limbs are relaxed. She is now thoroughly satisfied.

This Tibetan Buddhist bronze shows Vajrasattva in union with the Supreme Wisdom Visvatara.

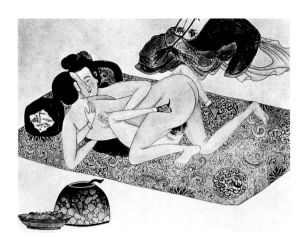

A Chinese painting showing a couple making love, their clothes hurriedly discarded.

Another female adviser, Lady Purity, told the Yellow Emperor:

> When a woman's face flushes, approach her gently. When her nose sweats and her breasts swell, enter her slowly. When her voice is husky and she swallows her saliva, shake your jade stem gently. When she gets wet inside, push your jade stem in as deeply as it will go. When her fluids overflow and run down her backside, guide them back to her jade gate.

The man must constantly monitor the woman's response:

> When the woman is ready, she gets short of breath and inhales hard. When she wants it, her mouth opens and the nostrils flare. When she wants more, she flings her arms around you. When she is within sight of contentment, she sweats all over. When she reaches contentment, her body stretches and her eyes become fixed.

There is always more to learn:

> When a woman embraces you and rubs her body against you, she is ready. When she stretches out her legs, she wants you to lie on top of her. When she moves her belly, she wants you to come. When her hips shake, she is enjoying the sheer pleasure of it. When she squeezes her thighs, she feels a deep itch inside. When she wriggles from side to side and quivers, she wants you to probe both sides of her flowery pathway. When she raises her body up and pushes against you, she has reached contentment. When her body jerks, she is feeling pleasure to the tips of her limbs. When her fluids overflow, she has come. If you watch carefully, you will enjoy all the sights of her pleasure.

In *The Perfumed Garden*, Shaykh Nefawi had the good sense to ask a woman's advice on these matters:

> O you who question me, those things which develop the taste for coition are the toyings and touches which precede it, and then the close embrace at the moment of ejaculation.
>
> Believe me, the kisses, the nibblings, suction of the lips, the close embrace, the visits of the mouth to the nipples of the bosom, and the sipping of the fresh saliva, these are the things to render lasting affection.

In acting thus, the two orgasms take place simultaneously, and enjoyment comes to the man and the woman at the same moment. Then the man feels the womb grasping his member, which gives to each of them the most exquisite pleasure.

This is what gives birth to love, and if matters have not been managed this way the woman has not had her full share of pleasure, and the delights of the womb are wanting. Know that the woman will not feel her desires satisfied, and will not love her rider unless she is able to act up to her womb; but when the womb is made to enter into action she will feel the most valiant love for her cavalier, even if he be unsightly in appearance.

Then do all you can to provoke a simultaneous discharge of the two spermal fluids; herein lies the secret of love.

The Perfumed Garden also spells out the signs to look for:

When, therefore, you see a woman's lips tremble and redden, and her eyes become languishing and her sighs profound, know that she desires coition; then is the time to penetrate her. If you have followed my advice you will both enjoy a delightful copulation which will leave a delicious memory. Some have said: 'If you desire to copulate, place the woman on the ground, embrace her closely and put your lips on hers; then clasp her, suck her, bite her; kiss her neck, her breasts, her belly and her flanks; strain her to you until she lies limp with desire. When you see her in this state, introduce your member. If you act thus your enjoyment will be simultaneous, and that is the secret of pleasure. But if you neglect this plan the woman will not satisfy your desires, and she herself will gain not enjoyment.

The more a woman showeth herself rebellious and recalcitrant, so much the more doth a man wax ardent and push home the attack; and so having forced the breach, he doth use his victory more fiercely and savagely, and thereby giveth more pleasure to the woman.

However, while the Arab man has come, the Chinese Taoist should try and contain his *yang* essence. In *The Secrets of the Jade Chamber* Su Nü says:

When a man makes love once without ejaculating, he strengthens his body. Twice and his sight and hearing become more acute. Three times and all his diseases will be cured. Four times, his soul will be at peace. Five times, his heart and circulation with be rejuvenated. Six times, his loins will be strengthened. Seven times, his buttocks and thighs will become stronger. Eight times, his skin will become smoother. Nine times, he will increase his life span. Ten times, he will become immortal.

The Tao master Liu Chang also believed that retaining the semen encouraged longevity:

> In the spring, a man should ejaculate just once in three days; in summer and autumn, twice a month. In a cold winter, a man should not ejaculate at all. The path of Heaven is to retain as much *yang* as possible in winter. This way a man will increase his lifespan. One ejaculation in winter is a hundred times more harmful than one in springtime.

Although ejaculation needs to be rationed, doing without sex simply is not an option. The seventh-century physician Sun S'su-Mo wrote:

> A woman cannot live happily without a man. A man cannot live long without a woman. He will crave a woman all the time and this will wear out his spirit. Of course, if he truly does not crave a woman, he may still live long. But such men are extremely rare. If a man tries to suppress his natural urge to ejaculate for long, it becomes hard to retain it. He may squander it in his sleep and when he pisses. He will dream that he is having sex with ghosts. Losing his semen this way is a hundred times more harmful.

So the Taoist way was to have plenty of sex while practising rigorous ejaculation control. Wu Hsien, a Tao master during the Han Dynasty, taught that this control did not come easily and that men must spend their time learning it. He spelt out the principles:

> 1. One must love one's partner to get the greatest pleasure. However, when practising ejaculation control, you must try to fain indifference.
> 2. The novice should thrust slowly and gently, first in one set of thrusts, then two and three. Between sets, he should stop and compose himself, before resuming again.
> 3. He must be kind and gentle with his partner to help her orgasm quickly. If he feels he is about to lose control, he should withdraw so that only the tip of his penis is inside the jade gate.

Wu Hsien also gave detailed practical advice on how this could be achieved:

> 1. A beginner should avoid getting too excited or too passionate.
> 2. He should start with a woman who is not very attractive and whose jade gate is fairly loose. That way it is easier for him to learn to control himself. If she is not very beautiful, he will not lose his head. And if her vagina is not too tight, he will not find it too stimulating.
> 3. The beginner should aim to go in soft and come out hard.
> 4. He should try to give three shallow thrusts, followed by one deep. This should be repeated eighty-one times.

Opposite: Shuncho Katsukawa's explicit *Making Love in Winter* is the Japanese equivalent of a modern-day pornographic movie's 'come shot'.

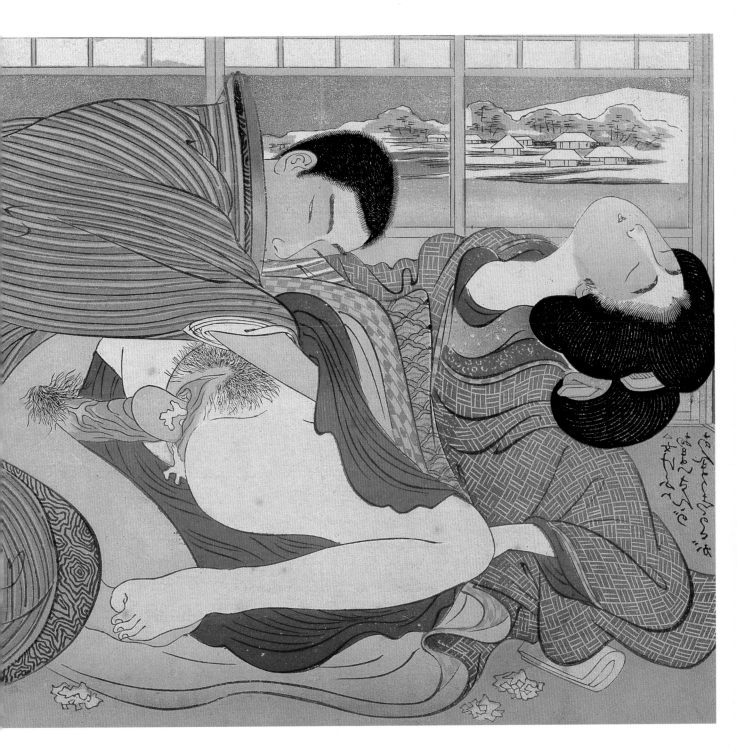

This ivory panel comes from a bed or swing. It shows a Hindu couple making love on a wooden bench.

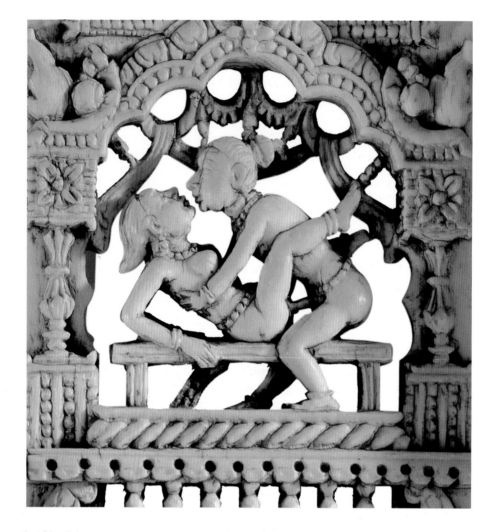

5. If he becomes too excited, he should withdraw his penis until there is only one inch of it inside the woman. He should wait there until this has calmed down, then resume his three shallow thrusts, followed by one deep.

6. Then he should try five shallow thrusts, followed by one deep.

7. Eventually, he should work up to nine shallow thrusts, followed by one deep.

8. A great deal of patience is required to learn ejaculation control.

The practice of using three deep thrusts to one shallow, followed by five deep thrusts to one shallow, followed by seven and then nine, was used by Chinese Buddhists. It appears in the *Yellow Book*, or the secret sex manuals of the Yellow Turbans:

When the dragon and tiger play together according to the rules of the 3-5-7-9 strokes, the heavenly and the earthly unite. Open the red gate, insert the jade stalk. The *yang* will imagine the mother of *yin* white like jade, the *yin* will imagine the father of *yang* fondling and encouraging her with his hands.

The Taoist Chen Luan wrote in AD 570:

> When I was twenty, I was fond of Taoist studies and enrolled in a Taoist monastery. We were taught sexual intercourse by the Yellow Book and to practise the 3-5-7-9. In pairs of 'four eyes and two tongues' we practised Tao in the cinnabar field [the body below the navel]. We were taught that this was the way to overcome obstacles and prolong life. Husbands exchanged wives of carnal pleasure. They were not ashamed to do these things even under the eyes of their fathers and elder brothers. They called this, 'the true art of obtaining vital essence'.

There are many ways a man can stop himself coming. Wu Hsien describes the 'locking method' to prevent imminent ejaculation:

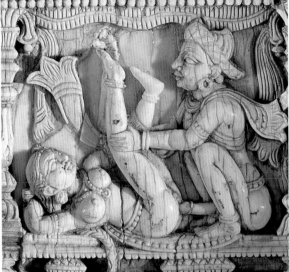

Another couple are depicted making love in a Tantric position with her legs being held aloft.

> 1. The locking method can be compared to stopping the Yellow River with one hand. An impatient man will take twenty days to learn it; a gentle man ten. After about a month of careful study the man's precious semen will be quite safe.
> 2. When the man is doing his pattern of three shallow thrusts and one deep one, he should close his eyes and mouth and breathe gently through the nose so that he does not start panting. When he fears he might lose control, he should raise his waist, withdrawing his jade stem, but staying in position without moving. Then he should breathe deeply from the diaphragm and contract his lower abdomen as if trying to control his bladder. He should think only on the importance of retaining his treasured sperm and that it must not be squandered. Breathing deeply, he will soon calm down. Then he can start again.
> 3. It is important to retreat immediately he becomes excited. If he leaves it too late and tries to force his semen back, it will leak into his bladder or his kidneys causing disease.
> 4. Practising this technique, the man can control his ejaculation without letting his

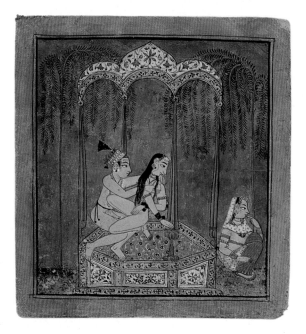

jade peak fall. He can save energy and remain relaxed. He should not emit his semen until he has made five thousand thrusts. If he also practises deep diaphragmatic breathing he can go on almost for ever and be able to satisfy ten women in one night without difficulty.

This was actually the aim. The Taoists of the Green Buffalo believed:

A man benefits greatly if he frequently changes the women he has sex with. It is best if he can have sex with more than ten women in a single night. If he always copulates with one woman, her vital essence will gradually grow weaker. Eventually she will be in no condition to benefit the man and she, herself, will become burnt out.

The master Peng Tsu agrees:

One cannot achieve one's aim of preserving health and prolonging life with just one woman. You have to make love to three, nine or eleven women a night – the more the better.

Consequently, these sexual secrets were for the man alone. The sixth-century Tao master Chung Ho Tzu wrote:

A man must not let the woman know about his technique if he wishes to nurture his *yang* essence. If the woman finds out, the technique would not only be useless, but quite harmful. It would be like giving your enemy your most deadly weapon.

Above: An Indian couple surprised while making love, depicted in a painting from the seventeenth century.

Opposite: An Indian prince could surround himself with lovers. Here one takes on five women.

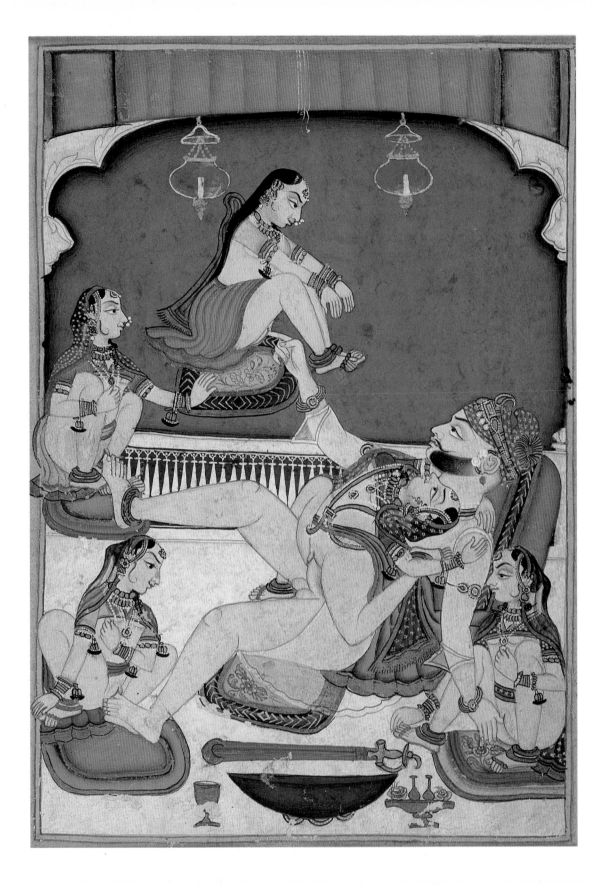

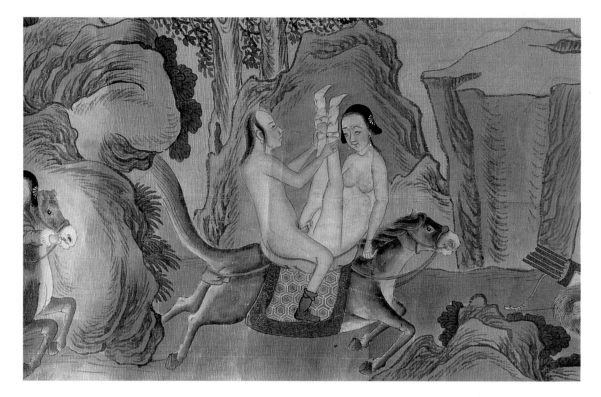

Even Su Nü acknowledges this danger:

> When facing the enemy, a man should consider her rock or slate, while his essence is precious like gold or jade. If he feels in danger of losing his semen, he must withdraw immediately. Sex with a woman is like galloping on a horse with reins that are rotten, or walking along the edge of a pit filled with sharp spikes. But a man who has learned to treasure his semen is quite safe with a woman.

Mastering the art of the bedchamber was especially important in later life:

> Until a man reaches his fortieth year he is full of fiery passion. But when he had passed forty he will notice his potency decreasing. Then diseases will swoop on him like a swarm of bees. If this is allowed to continue, he will find himself beyond cure. So at forty a man must learn the art of the bedchamber.
>
> The principle of the art of the bedchamber is very simple, yet few use it. A man must have sex with ten different women at night without emitting a single drop of semen. This is the essence of the art of the bedchamber.
>
> A man must not engage in sexual intercourse merely to satisfy his lust. He must

Above: The Mongols lived so intimately with their horses that they were even depicted
making love on the back of a galloping steed. Don't try this at home.

try to regulate his sexual desire and thus nurture his vital essence. He must not force himself to extravagant action during sex, giving free rein to his passion, just to enjoy carnal pleasure. Instead, he must think of how the sexual act will benefit his health and keep him free from disease. This is the subtle secret of the art of the bedchamber.

Sun S'su-Mo also believed that it was important for men not to force ejaculation, especially after the age of forty. He said:

> When a man squanders his semen, he will get ill and if he recklessly exhausts his semen he will die.

It was conceded that men got pleasure from ejaculation, but by denying themselves they could attain greater pleasure. According to *The Secrets of the Jade Chamber*:

> After ejaculation, a man is worn out. There is a buzzing in his ears. His eyes are heavy and he wants to go to sleep. His mouth is dry and his arms and legs are stiff and heavy. For the brief seconds of pleasure he experiences in ejaculation, he suffers long hours of weariness. However, if he learns to hold back and keep his emissions to an absolute minimum, his body retains its strength. His mind is set at ease, and his sight and hearing are improved. Although the man has denied himself the pleasure of ejaculation his love for his woman will greatly increase. He can never have enough of her. And that is a lasting pleasure.

Sun S'su-Mo recommended that a man should ideally ejaculate only once every hundred times he makes love. This he realized was impossible for most men, but if a man could keep his ejaculations down to twice a month, with good food and exercise he could still live a long life. Sun S'su-Mo laid out a formula related to age:

> A twenty-year-old man should ejaculate once every four days. A thirty-year-old once every eight days. A forty-year-old once every ten days. A fifty-year-old once every twenty days. A sixty-year-old should not ejaculate at all, unless he is particularly strong, when he can do it once a month.

If a man is particularly strong and fit, Sun S'su-Mo continued, too much restraint can be harmful, and boils and pimples would appear if he went without ejaculation for too long. However, spiritual people should avoid emission altogether, although they should not give up sex:

> When a couple are like immortals, they can unite deeply, without moving so that the semen will not be disturbed. They should imagine that they had a red ball the

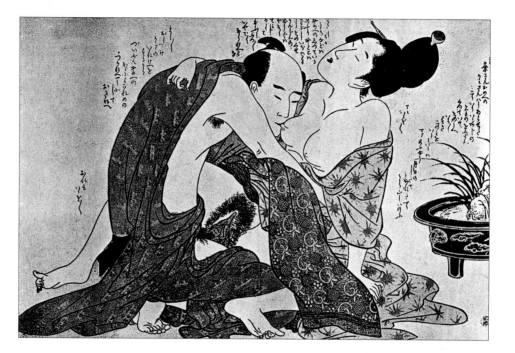

A print by Utamaro showing a courtesan and her lover. In these 'floating world' pictures, women are rarely shown naked – the courtesans modelled the latest kimonos and hairstyles.

size of a hen's egg between their navels. Then they can thrust very gently. But if they get excited, they should hold back. In one day, the couple can do this dozens of times. It will ensure a long life.

Another master, Tung Hsuan Tzu, takes a different approach:

Before intercourse, the woman should sit, then lie down to the left of the man. After resting, the man should ask the woman to lie flat on her back, open her legs wide and stretch out her arms. Then he should cover her body with his own, taking the weight on his knees which should be placed between her open thighs. He should rub his jade stem gently but unrelentingly against the outside of her jade gate, like a lone pin standing proudly at the mouth of a mountain cave. While he is rubbing her this way, he should open his mouth and suck in her tongue. He should fondle her breasts or private parts with his hands, looking at her face or her jade gate. Once her secretions begin to flood out, he should hurl his jade stem through her gate, coming immediately so that the seed and secretions mingle. Then he should continue thrusting unmercifully until the woman begs him to spare her. At this point, he should pull his jade stem out, wipe it with a piece of silk – then put it back in again, making nine shallow thrusts, followed by one deep one. He should vary his movements – sometimes fast, sometimes slow; sometimes vigorous,

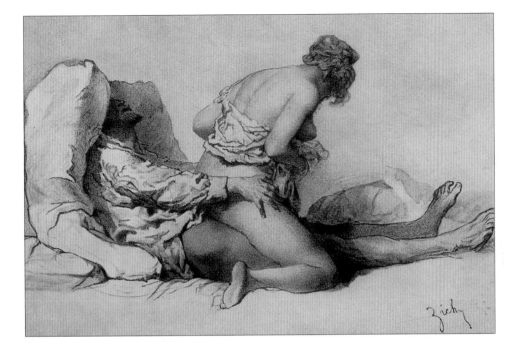

sometimes gentle. After inhaling and exhaling twenty-one times, the woman will be ready to climax. The man should then push his penis into the depth of five inches, stabbing quickly and rubbing both sides of her flowery path. She will get very wet and feel satisfied. Then he should pull out his jade stem before he comes a second time. Should he come a second time, it will be bad for his health and he must be very careful not to.

There are two ways for a man to stop himself ejaculating at this point. They were outlined in *Important Guidelines of the Jade Room*:

> The minute you feel the seed moving, put the index and second finger of your left hand on your groin and press hard. At the same time, open your mouth and breathe out heavily. Then grind your teeth together thirty or fifty times. This way, the seed will drain back to their source down the jade stem.

The other method is as follows:

> When trying to benefit *yang* from *yin* during sex, and you feel you are coming, quickly raise your head and open your eyes wide. Look left and right, up and down. At the same time, contract the muscles of your lower abdomen. This done, the discharge will cease.

In the ancient Chinese, Indian and Arabian cultures lovemaking was a legitimate topic of study and was subjected to intense analysis. Seventh-century Chinese physician Li T'ung Hsüan outlined the four basic positions for making love:

1. Close union – man on top.
2. Unicorn horn – woman on top.
3. Intimate attachment – side by side.
4. Sunning fish – rear entry.

Then he detailed the twenty-four variations on these basic positions, each of which has a poetic name, some of which do not bear translation. The variations on the 'close union' are:

1. Silkworm spinning a cocoon – The woman wraps her legs around the man's body and clasps his neck with her hands.
2. Turning dragon – With his left hand, the man holds the woman's feet up above her breasts. With his right hand, he guides his jade stem into her jade gate.
3. Loving swallows – The man lies flat on the woman's belly. She holds his waist. He holds her neck.
4. United kingfishers – With the woman on her back, the man kneels between her legs and supports her waist with his hands.
5. Dwarf pine tree – The woman crosses her legs around the man and they hold on to each other's waists.
6. Dance of the two phoenixes.
7. Phoenix holding her chicken.
8. Flying seagulls – The man stands beside the bed, holding the woman's legs while he enters her.
9. Leaping wild horses – The woman rests her feet on the man's shoulders while he penetrates her deeply.
10. Galloping steed – The man squats with one hand supporting the woman's neck, the other supporting her feet.
11. Horse's hooves – The woman puts one of her feet on the man's shoulder, letting the other dangle.
12. A giant bird soaring over a dark sea – The man holds the woman's waist and supports her legs on his upper arm.

The variations on the 'unicorn horn' are:

1. A pair of flying ducks – The woman turns around so that she is facing the man's feet.

Opposite: A nineteenth-century artist from Uttar Pradesh shows that the Indians are the masters of the exotic position.

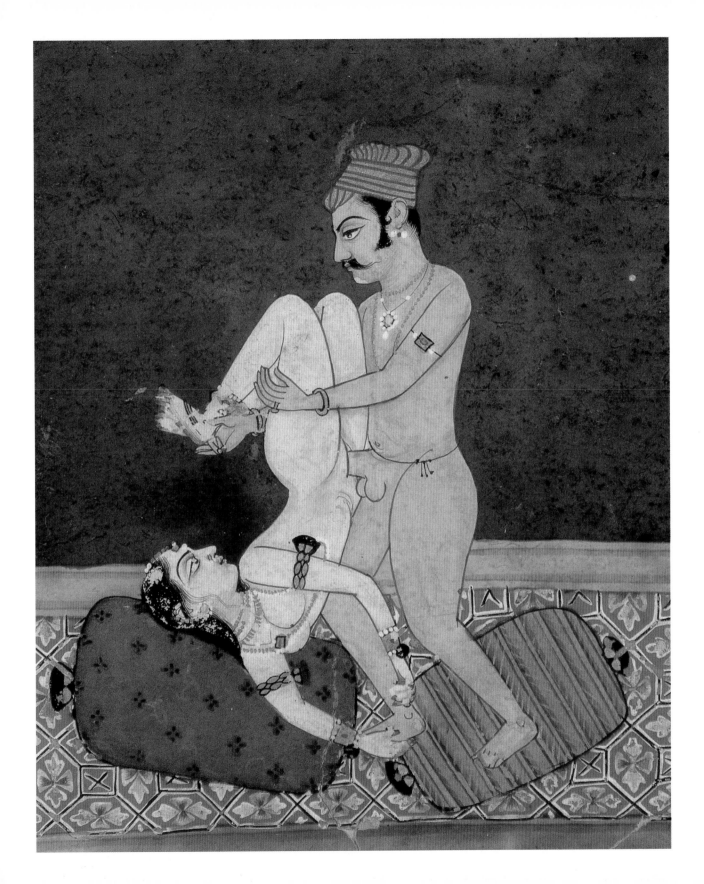

2. A singing monkey holding a tree – The man sits up with the woman on his lap, facing him. She holds him while he supports her buttocks with one hand. He supports himself with the other.
3. Cat and mice share a hole – The woman lies flat on top of the man, giving deep penetration.
4. Flying butterflies.

The 'dance of the two phoenixes' can also be performed with the woman on top, apparently.

The variations on 'intimate attachment' are:

1. Two fishes side by side – The man and woman lie face to face and kiss, while the man uses one hand to support the woman's feet.

And the variations on the 'sunning fish' are:

1. Mandarin ducks entwined – The couple lie on one side with the woman facing away from the man. She curls her legs so that he can enter her from the rear.
2. Flying white tiger – The woman kneels on the bed with her face on the pillow. The man kneels behind her and pulls her on to him by holding her waist.
3. Dark cicada clings to a branch – The woman lies flat on the bed with her legs spread. The man holds her shoulders.
4. Goat facing a tree – The man sits in a chair. The woman sits on his lap with her back towards him.
5. Late spring donkey – The standing woman bends over and supports herself on her hands. The man stands behind her and holds her waist.

Despite this detailed analysis, Li T'ung Hsüan admits that there are two other positions that do not really count as variations on the basic four:

1. Bamboos near the altar – The man and woman stand face to face.
2. Autumn dog – The woman and man kneel on all fours, pressing their buttocks against each other's. The man bobs down, takes his jade stem with one hand, bends it backwards and inserts into her jade gate.

Li T'ung Hsüan also spells out the six styles of penile thrust:

1. Pushing the jade stalk down then letting it move to and fro over the lute strings like a saw, as if you were prising open an oyster in the hope of finding a pearl inside.
2. Hitting the golden gully over the jade veins, as if cleaving a stone to find its jade kernel.

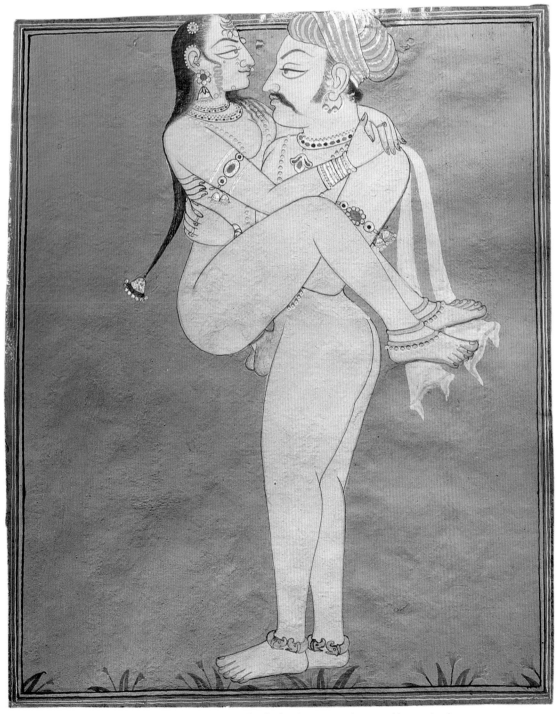

Shiva and Shakti, his wisdom embodied by the female, merge and transcend in sexual embrace.

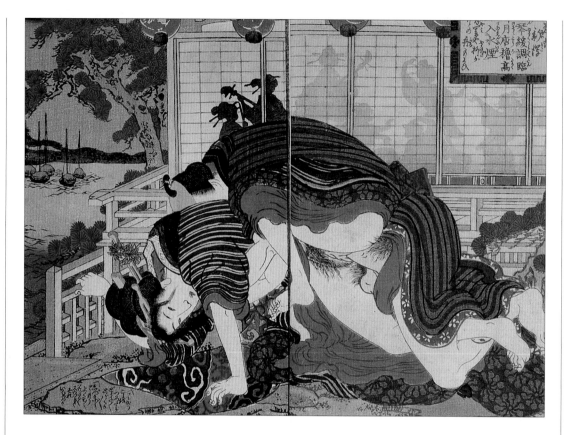

Eizan's *By A River* comes from a pillow book, given as a wedding gift to encourage young brides.

3. Letting the positive peak hit the jewel terrace, like a pestle against a mortar.

4. Letting the jade stalk go in and out, left and right, like a hammer shaping iron.

5. Letting the positive peak mill around the sacred field and deep vale, like a farmer hoeing his field in autumn.

6. Letting the two peaks inhabited by the gods rub against each other, until the two mighty mountains crumble into one.

Later he describes nine styles of movement in graphic detail:

1. Striking out to the left and right like a soldier trying to break through the enemy ranks.

2. Rearing up and down like a wild horse crossing a swift river.

3. Moving outwards and inwards like seagulls swooping among the waves.

4. Using shallow teasing thrusts, followed by deep ones, like a bird pecking leftover rice from a pot.

5. Making shallow strokes, then deeper ones, like a rock sinking in deep water.

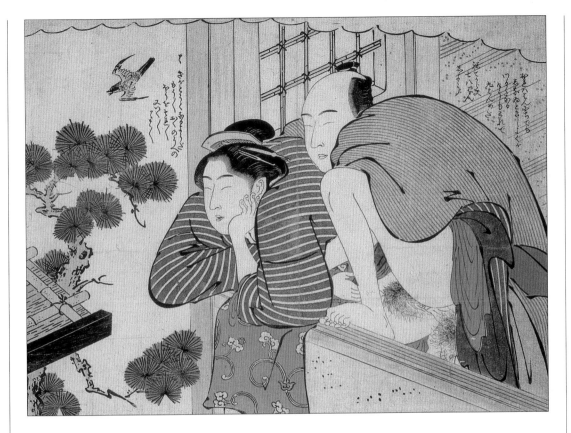

6. Pushing slowly, like a snake slithering into its burrow to hibernate.
7. Thrusting quickly like a scared rat running into a hole.
8. Circling high, then swooping, like an eagle catching a hare.
9. Rising high, then plunging, like a ship in a gale.

The best stratagem, Li T'ung Hsüan says, is to use a combination of these thrusts:

> Shallow and deep, fast and slow, straight and slanting. Each has its own special effect. A slow stroke should have the jerky movement of a carp on a hook. A fast stroke should have the movement of a flock of birds flying against the wind. Up and down, in and out, left and right, slowly or in rapid succession, these movements should be choreographed. At each moment one should use the movement most appropriate, rather than stubbornly stick to one style.

Su Nü believed that the depth of the thrust was all-important, and she divided the vagina into the eight valleys:

Shuncho Katsukawa's *Lovers on a Balcony*. Two thirds of Japanese art from the seventeenth, eighteenth and nineteenth centuries depicts the 'floating world' of prostitution.

1. The first one inch is called the Lute String Valley.
2. At a depth of two inches is the Water-chestnut Teeth Valley.
3. At a depth of three inches is the Little Stream Valley.
4. At four inches is the Black Pearl Valley.
5. At five inches is the Valley Proper.
6. At six inches is the Deep Chamber.
7. At seven inches is the Inner Door.
8. And at eight inches is the North Pole.

Thrusting between the Lute String Valley and the Black Pearl Valley is shallow. Thrusting between the Little Stream and the Valley Proper is deep. A stroke that is too shallow will not give the couple the maximum pleasure. But thrusting too deep can cause injury.

Su Nü's formula for successful intercourse was simple:

A man must notice what the woman's needs are and at the same time retain his precious semen. He should rub his hands together to make them warm and grip the jade stem firmly. Then he should use the method of 'shallow draw' and 'deep thrust'. The longer he does this, the more the couple will become aroused. The pace must be neither too fast, nor too slow. Nor should he thrust too deeply in case he injures the woman. First try several thrusts to the Lute String Valley, then strike energetically at the Water-chestnut Teeth. When the woman nears orgasm she will unconsciously clench her teeth. She will sweat and begin to pant. She will close her eyes and her face will flush. Her jade gate will open widely and her essence will flood out. The man can then see that she is enjoying it very much.

Indian writers also spent a good deal of time and energy on naming the various sexual positions:

If you lift the woman by passing your elbows under her knees and enjoy her as she hangs trembling with her arms garlanding your neck, this is called the Knee-Elbow.

If your lustful lover buries her face in the pillow and goes on all fours like an animal and you rut upon her from behind as though you were a wild beast, this is called the Deer.

When, straightening her legs, she grips and milks your penis with her vagina, as a mare holds a stallion, it is called the Mare, which cannot be learned without practice.

If, lying with her face turned away, the fawn-eyed girl offers you her buttocks and your penis enters the house of love, this is the coupling of the Cobra.

Followers of the cult of Tantra regarded sexual intercourse as an essential rite of initiation.

Tantric sex enabled the faithful to attain enlightenment.

The author of *The Perfumed Garden* is more prescriptive in his eleven positions for love-making:

1. Lay the woman on her back and raise her thighs. Get between her legs and introduce your penis. By gripping the ground with your toes, you will be able to make suitable movements. This is a good position for those who have a long penis.

2. If your penis is short, lay the woman on her back and raise her legs in the air so that her toes touch her ears. Her buttock will be raised and the vulva pushed forward. Now introduce your penis.

3. Lay the woman on the ground and get between her thighs. Then put one of her legs over your shoulder and the other under your arm, and penetrate her.

4. Stretch out the woman on the ground and put her legs on your shoulders; in that position your member will be exactly opposite her vulva which will be lifted off the ground. That is the moment for introducing your penis.

5. Let the woman lie on her side on the ground; then, lying down yourself and getting between her thighs, introduce your member. This position can give rise to rheumatism or sciatica.

6. Let the woman rest on her knees and elbows in the position for prayer. In this position, the vulva stands out behind. Attack her thus.

7. Lay the woman on her side, then sit on your heels and place her top leg on your shoulder and her other legs against your thigh. She will remain on her side and you will be between her legs. Introduce your penis and move her backwards and forwards with your hands.

8. Lay the woman on her back and kneel astride her.

9. Place the woman so that she leans, facing forwards or backwards, against a raised platform. Her feet should remain on the ground and her body projecting in front. This way she will present her vulva to you and you can enter her.

The Tantric cult flourished in the late eighteenth and early nineteenth centuries. These paintings are from an album of that period.

A pair of lovers show off a position not mentioned in the *Kama Sutra*. In this Bundi-style painting, the orange background symbolizes royal radiance and force.

Opposite: Sitting positions are popular in Indian erotic art. This painting is from central India, late eighteenth century.

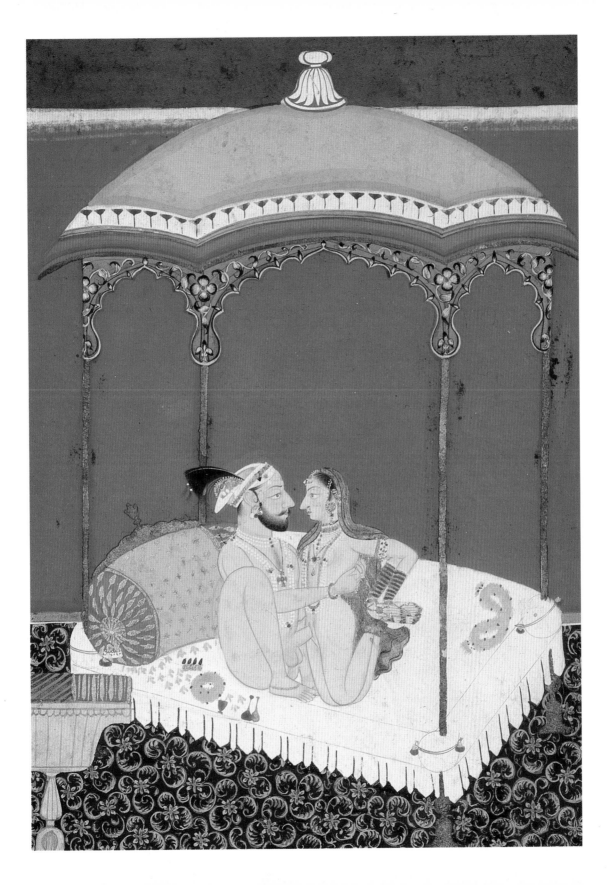

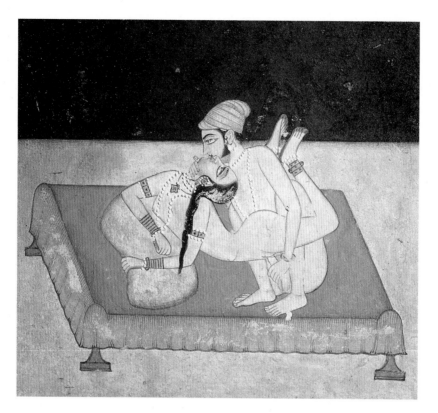

Tantric positions are always inventive – even if it is a strain to get a kiss.

10. Place the woman on a low divan and let her grasp the woodwork with her hands; then, placing her legs on your hips and telling her to grip you with them, you introduce your penis and grasp the divan. When you begin to work, let your movements keep time.

11. Lay the woman on her back and let her buttocks be raised by a cushion placed under them. Let her put the soles of her feet together; now get between her thighs.

Ovid's writings are also full of practical advice on the act of love. In his book on satisfying a mistress, he says: 'A woman does not have to be teased to be worked up into a frenzy.' He goes on:

> I do not want a woman who sees it as a duty,
> She should say, 'Don't come too soon', or 'Wait a while.'
> I want a woman whose eyes admit her excitement.
> And after she comes, let her want no more for a while.
> Young people know nothing of delight. These things should not be rushed.
> After thirty, lovers start learning how.

His advice to a woman is:

> If your face is pretty, lie on your back.
>> If your buttocks are cute, let him have you from behind.
>> Atalanta used to put her legs on Milanion's shoulders.
>> Do this if you have beautiful legs.
>> Small women should get on top, as if they are riding a horse.
>> Hector's Andromache did not do this because she was too tall.
>> Press against the bed with your knees and bend backwards slightly.
>> If your naked body is something a lover should crave to look at,
>> If your breast and things look lovely,
> Let the man stand while the woman lies at an angle on the bed.

Rear entry – or what is known vulgarly as 'doggy style' in English – is a sexual position that has long been prized by both men and women. Nicholas Chorier describes it with particular relish in *Satyra Sotadica*:

Rear entry was popular with the ancient Greeks.

Hindu temple art depicts sexual intercourse in all its facets.

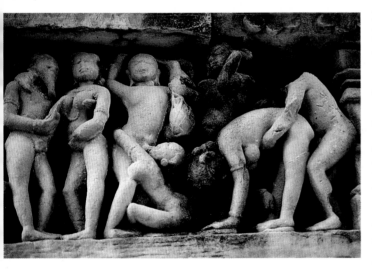

Fabrizio made ready for another attack. His member was swollen, red and threatening.

'I beg of you madam,' he said, 'turn over on your face.'

I did as he wished. When he saw my buttocks whiter than ivory and snow, he cried: 'How beautiful they are. But raise yourself on your knees, and bend your head down.'

I bowed my head and bosom, and lift my buttocks. He thrust his swift and fiery dart to the bottom of my vulva and took a nipple in either hand. Then he began to work in and out, and soon sent a sweet rivulet into the cavity of Venus. I also felt unspeakable delight, and nearly fainted with lust. A surprising quantity of seed secreted by Fabrizio's loins filled and delighted me; a similar flow of my own exhausted my forces.

As all the masters of the ancient world seem to agree that the object of the sex act is to satisfy the

Ancient Greeks were known for the enjoyment of anal sex, as well as vaginal sex 'doggy-style'.

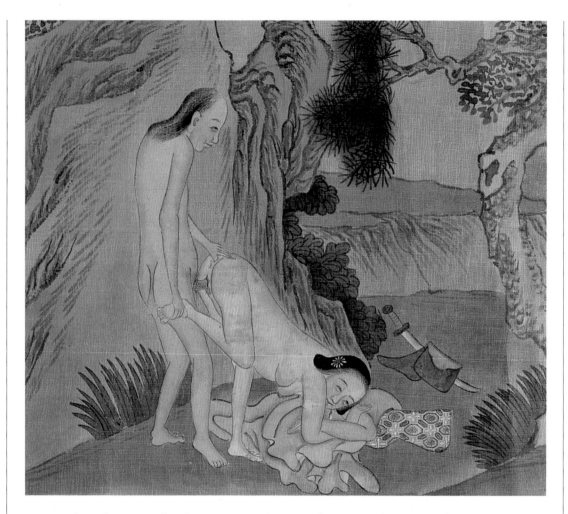

Mongol horsemen also enjoyed sex 'wheelbarrow' style.

woman, it makes sense for the woman to instruct the man in her particular requirements. The beneficial effects of this can be seen in the following tale from Islamic folklore:

> She now turned to him, bussing and bosoming, locking leg over leg, and said to him: 'Put your hand between my thighs, to the place of which you know, so that it may stand up as to prayer after prostration.'
>
> So he put forth his hand and felt about his fingers, and found her thighs cooler than cream and softer than satin. The touching of them pleasured him, and he moved his hand hither and thither till his fingers alighted upon a dome heated with moisture, and soon his fingertips touched upon her prayer nice and the tiny preacher therein.

Then she said: 'O 'Ali Shar! it is the custom of my clitoris that it stands not on end save it be rubbed with the hand; so come, rub it with your hand till it be at stand.'

So saying, she lay down on her back and, taking his hand, set it fast to her parts; and he found her cunt to be softer and smoother than satins and silks, white, plumply rounded and protuberant, likening for heat and steam the hot room of the bath or the heart of a lover whom love-longing has wasted.

Said 'Ali Shar to himself: 'Indeed, what wonder of wonders!'

The red-hot lust got hold of him, and his rod rose and stood upright on the end to the utmost of its heights.

Unusually for a Tantric album, a woman is shown taking a passive role.

When Zumurrud saw this, she burst out laughing and said: 'By Allah, O my lord, all this betides us and yet you know me not!'

So he kissed her and embraced her, and he threw himself upon her like the lion upon the lamb. Then he plunged his sword completely in her sheath, and he ceased not to play the porter at her portal and the preacher in her pulpit and the priest at her prayer niche; while she with him ceased not from inclination and prostration and rising up and sitting down, accompanying her canticles of praise and of 'Glory be to Allah' with passionate movements and wrigglings and claspings of his member and other amorous gestures and gyrations, till two little eunuchs heard the noise.

So they came and peeping out from behind the curtains saw the Queen lying upon her back and upon her 'Ali Shar, who was thrusting and thrashing and slashing away while she huffed and puffed and sighed and cried and wriggled and writhed.

In China, too, the woman often took the initiative:

The woman touched the warrior. It was very hard and frisky, and she felt excited and scared at the same time. They kissed each other and went to business. Hsi-mên Ch'ing took her by the legs and thrust into her violently. Heart's Delight gasped and her face went bright red.

He held her pale thighs firmly and threw himself forward again. She sighed softly and her eyes grew dim. He told her to open her legs and lie down like a mare, then he rode her like a powerful stallion. He drove his spear all the way home and fondled her buttocks which she raised to receive his lunge.

'Call me your sweetheart,' she said, 'and please don't stop. Give me all of it.'

Heart's Delight lifted her lovely bottom so that she could take his full length, and she called him darling with quavering voice. They toyed with each other for an hour before Hsi-mên was willing to withdraw his penis. At last, she pulled out his penis, wiped it off with a napkin, and took it in her mouth.

'I love you so much, I will suck it all night,' she said.

Chinese prostitutes were taught how to be in control of lovemaking, not only to flatter and satisfy their clients but also to minimize wear and tear on themselves. A nineteenth-century Master of the Plum Blossoms gave advice to what are now called 'commercial sex workers', in *Memoirs of The Plum Blossom Cottage*:

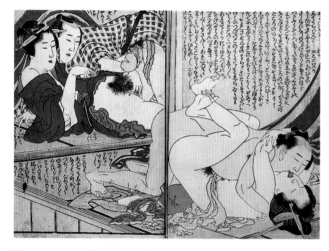

The great Japanese landscape artist Hokusai shows his mastery of the 'shunga' print with this depiction of two pairs of lovers.

Most men think that they are potent and virile. Your main aim is not to dent their ego. They are your customers, so your job is to satisfy their needs, not your own. Let them think that they are in control, though in fact they are in your hands. With someone who has no stamina, fake satisfaction even though he may come the moment he enters. Let his shrivelling member remain inside you while you embrace and caress him like he is the most wonderful man you have ever had. With a customer who has a small penis, press your legs tightly together once he is in you. Give him the feeling that every thrust hurts and thrills you. An older customer may have difficulty getting an erection. Fondle his penis tenderly and gently. Tell him erotic stories and give him time to get excited. If this fails, suck his penis. If sucking does not work, tell him to rest. Men are usually more virile after they have slept. Do not give him aphrodisiacs. They may damage his health. Besides, his inability is not your fault, if you have tried everything you know.

The real problem is with men who are virile and have endurance. This is when you must use your techniques the most. Do not let yourself get carried away, even if he makes you enjoy it. For your own good, make him come as quickly as you can. Do this without his knowledge. Move your hips like a millstone, holding his waist tightly and gently stroking his spine near the waist. At the same time, tickle the upper part of his mouth with the tip of your tongue. If you do these things skilfully, you can make him come at will. But let him have some fun first, or you will hurt his ego and lose a customer.

If a customer comes to you after taking aphrodisiacs make him drink a cup of chrysanthemum tea before taking him to bed. Some wines also counter the effects of aphrodisiacs.

Do not be afraid of a man with a big penis. It does not mean that he is especially virile. But for your own protect, go behind the bed curtains and anoint your private parts with rose-petal oil. Do this secretly for men like to show off their big penis and enjoy the pain it can cause you. Again make him come quickly using the millstone action. You can also bend your waist so his penis will not reach too far inside.

If you are lucky enough to have a virgin boy come to you, coach him patiently. He will be clumsy and will not be able to do it properly without your help. Help him overcome his natural shyness and lack of confidence. He may become more manly after his premature discharge. Teach him to find both physical and mental pleasure in having sex. Usually, you will find 'spring chickens' extremely enjoyable after you have coached them.

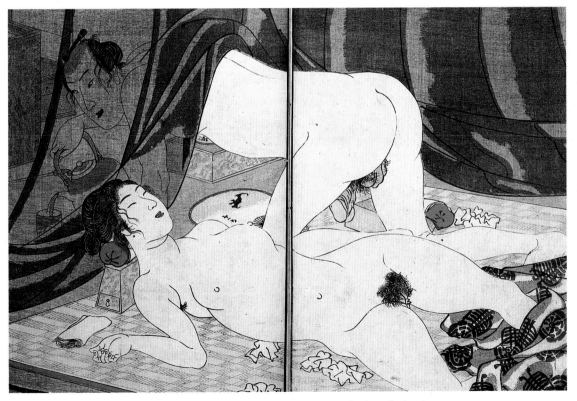

The Satisfied Woman by Kuniyoshi – all passion spent, her lover fetches the tea.

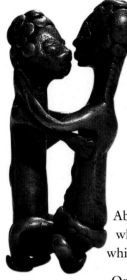

An Ashanti gold weight, from Ghana, depicting a man and woman making love.

In many cultures, women strive to learn a technique of selectively contracting the muscles of their vaginas to bring exquisite sensations to both partners. The *Anangaranga* of Kalyanamalla calls it the *samdhämsa* or 'pincers' technique:

> The woman must strive to constrict the muscles of her vagina until they hold the penis tightly, like the muscles of the anus hold a finger when it is inserted. She must learn to open and constrict the muscles at will, like the hand of a dairymaid milking a cow. The penis is the teat, while the vagina is the hand which extracts the vital essence by squeezing and pulling it. This can be learnt by diligent practice, though it requires a great deal of will-power.

Abyssinian women are particularly accomplished at this technique. Arabs call those who can perform it well 'holder women' or 'nutcrackers'. With its extended labia, which can even engulf the testicles, her vulva is known as a 'sucker'. And, it is said:

> Once the member is grasped by the sucker, a man can no longer prevent the emission of semen; and the member is held tightly until it is completely drained.

A woman should strive to obtain her own satisfaction, even if her lover is tired. According to the *Kama Sutra*:

> When a woman sees her lover is fatigued by constant congress, without having his desire satisfied, she should, with his permission, lay him down upon his back, and give him assistance by acting his part. She may also do this to satisfy the curiosity of her lover, or her own desire of novelty.
>
> There are two ways of doing this, the first is when during congress she turns round, and gets on top of her lover, in such manner as to continue the congress, without obstructing the pleasure of it; and the other is when she acts the man's part from the beginning. At such a time, with flowers in her hair hanging loose, and her smiles broken by hard breathings, she should press her lover's bosom with her own breasts and, lowering her head frequently, should do in return the same actions which he used to do before, returning his blows and chaffing him, and should say 'I was laid down by you, and fatigued with hard congress, I shall now therefore lay you down

A detail from the sarcophagus of Butehamun, scribe of the royal necropolis at Thebes, showing the union of the earth god Geb and sky goddess Nut, which led to the creation of the world.

Opposite: For the Mughal and his mistress, lovemaking is a leisurely affair.

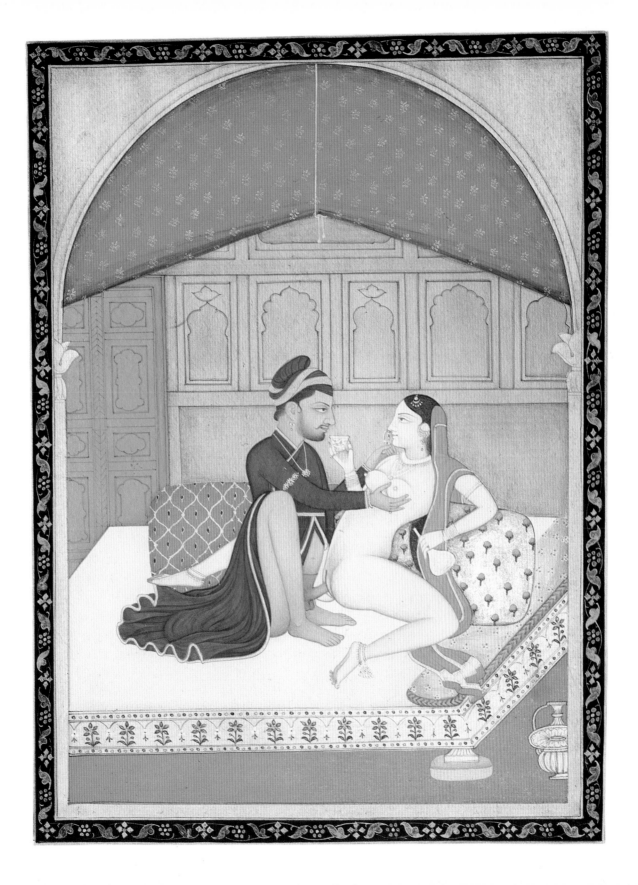

in return.' She should then again manifest her own bashfulness, her fatigue, and her desire of stopping congress.

The Yellow Emperor wanted to know why, during sexual intercourse, if a man was not enjoying himself, his jade stem did not stay aroused and strong. Lady Mystery told him:

> *Yin* and *yang* attract each other. Without the aid of yin, yang cannot be aroused. So, before intercourse, the man and the woman must both feel desire and anticipate the pleasures to come. Without mutual understanding and the caresses of foreplay, no spiritual harmony, which is the basis of love-making, can be achieved. This is what happens if you go ahead when one or other of the sexual partners is not quite ready.
>
> Soft caresses and the words of love will stimulate the woman to respond to the man's desire. Her jade gate will quiver and moisten, ready to welcome his jade stem. When his jade stem enters her jade gate, it must alternate slow movements with fast ones, gentle ones with vigorous ones. If Your Majesty follows this advice carefully, you will find both benefit and delight in intercourse, no matter how strong your partner is.

Lady Purity had more advice:

> Before you begin making love, you should ask the woman to lie flat on her back and bend her knees. As you enter her, press your open mouth to hers and suck her tongue. First let your jade stem knock at her doorway, then push it in slowly and steadily. If your jade-stem feels like it wants to burst, push it in one and a half inches. If it is not yet fully erect, push it in just one inch and do not shake. Then take it out and push it in more deeply a second time.
>
> When the jade stem enters the portal fully, the woman will feel its warmth inside her. She should respond by moving her body up and down in harmony with your thrusts, trembling slightly. When the jade stem reaches a depth of three and a half inches, you should close your mouth tightly while thrusting. Pause after every nine thrusts and do not thrust any more after you have done eighty-one strokes.

The master Peng Tsu also has some advice:

> The correct way of intercourse is, not surprisingly, difficult. You must be calm and relaxed, and remember to be as gentle as you can. Fondle her jade gate and ask for her tongue. Watch her response. Her ears will turn red, as if she has had a few drinks. Her breasts will swell until they are big enough to fill your open hand. She will move around on her behind and her legs will tremble. This is the moment you

Opposite: A couple make love on a four-poster bed, Rajasthan, *circa* 1800.

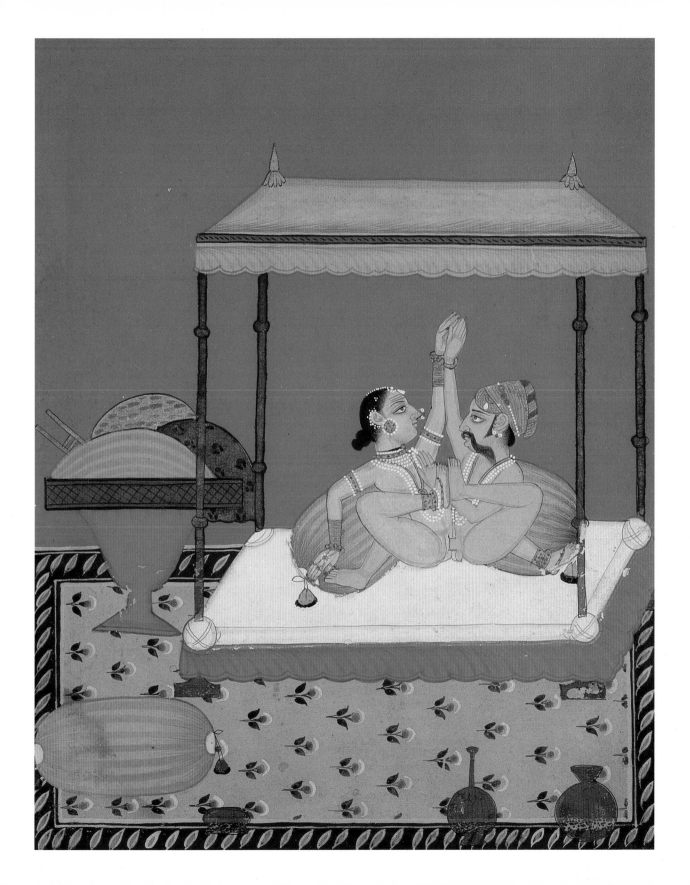

should enter her, slowly and steadily. Then, when she holds you tight, push your jade stem in all the way. Meanwhile keep your mouth clamped to hers. Lick her tongue and swallow her saliva. It is a natural tonic for your health. In this manner, she will have an orgasm without you having to discharge.

However, even in the Orient, sex can be quite cursory. There is even an example in *The Perfumed Garden*:

> He at once fell upon her and, with a single push, buried his member completely. Then he set to work like a pestle, and she to shake her croup; and thus they continued until the two ejaculations arrived. Then he got up, wiped his member, and went away.

This seems to have been quite satisfactory for both partners, but women unusually prefer something more prolonged. Two women discuss the problem in the *Arabian Nights*:

> How shall I spread-eagle myself under a boy who will emit long before I can go off, and forestall me in limpness of penis and clitoris; and leave a man who, when he taketh breath, clippeth close, and when he entereth, goeth leisurely, and, when he hath done, repeateth and, when he pusheth, poketh hard and, as often as he withdraweth, returneth?

A couple lost in the ecstasy of love, from Mihaly von Zichy's 1911 classic *Liebe*.

But sometimes things work out just dandy. In *The Golden Lotus*:

> His prick was so thick and long that it filled the whole of her organ. Moving backwards and forwards he made her innermost flower red like a parrot's tongue, now black like the wing of a bat. It was pleasant and wonderful to see. He held her legs, their bodies were pressed together, the penis penetrated right to the root. The woman's eyes were open and the erotic fluid came out. Hsi-mên reached the height of pleasure and poured forth his semen like a river.

In *Satyra Sotadica* Caviceo and Octavia achieve the most exquisite orgasm:

In passion, a man does not know his own strength.

> Caviceo despoils me of my chemise, and his libertine hand touches my parts. He tells me to sit down again as I was seated before, and places a chair under either foot in such a way that my legs were lifted high in the air, and the gate of my garden was wide open to the assaults I was expecting. He then slides his right hand under my buttocks and draws me a little closer to him. With his left hand he supported the weight of his spear. Then he laid himself upon me, put his battering ram to my gate, inserted the head of his member into the outermost fissure, opening the lips of it with his fingers. But there he stopped for a while making no further attack.
>
> 'Octavia sweetest,' he said, 'clasp me tightly, raise your right thigh and rest it on my side.'
>
> 'I do not know what you want,' I said.
>
> Hearing this, he lifted my thigh with his own hand and guided it round his loin,

as he wished; finally he forced his arrow into the target of Venus. In the beginning, he pushes in with gentle blows, then quicker, and at last with such force I could not doubt I was in great danger. His member was as hard as horn, and he forced it in so cruelly, that I cried out, 'You will tear me to pieces!'

He stopped a moment from his work.

'I implore you to be quiet, my dear,' he said. 'It can only be done this way; endure it without flinching.'

Again his hand slid under my buttocks, drawing me nearer, for I had made a feint to draw back, and without more delay plied me with such fast and furious blows that I was near fainting away. With violent effort he forced his spear right in, and

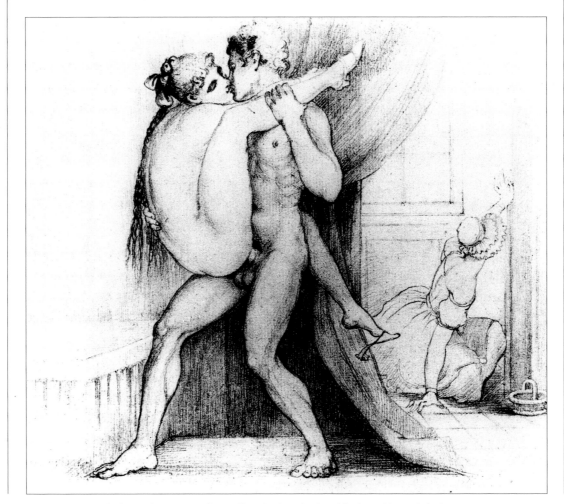

In the careless rapture of lovemaking, the shoe dangles while the maid secretly looks on.

the point fixed itself in the depths of my wound. I cry out. Caviceo spurted out his venerean exudation, and I felt irrigated by a burning rain. Just as Caviceo slackened, I experienced a sort of voluptuous itch as though I were making water; involuntarily I drew my buttocks back a little, and in an instant I felt with supreme pleasure something flowing from me which tickled me deliciously. My eyes failed me, my breath came thick, my face was on fire, and I felt my whole body melting.

'Ah! ah! ah! my Caviceo, I shall faint away,' I cried; 'hold my soul – it is escaping from my body.'

And Fanny Hill could not bring herself to describe it, the sensation was so delicious:

My thighs, now obedient to the intimations of love and nature, gladly disclose, and with a ready submission resign up the lost gateway to entrance at pleasure: I see! I feel! the delicious velvet tip! – he enters might and main with – oh! – my pen drops from me here in the ecstasy now present to my faithful memory! Description, too, deserts me and delivers over a task, above its strength of wing, to imagination; but it must be an imagination exalted by such a flame as mine, that can do justice to that sweetest, noblest of all sensations that hailed and accompanied the stiff insinuation all the way up, till it was at the end of its penetration, sending up, through my eyes, the sparks of the love-fire that ran all over me, and blazed in every vein and every pore of me: a system incarnate of joy all over.

Sometimes once is not enough. *The Arabian Nights* relates:

As soon as she was heated with wine, she put off her petticoat-trousers and lay down on her back; whereupon, the bear rose and came up to her, and mounted her and stroked her, and she gave him the best of what belongeth to the sons of Adam till he had made an end, when he sat down and rested. Presently, he sprang upon her and futtered her again and, when he ended, again sat down to rest; and he ceased not so doing till he futtered her ten times, and they both descended into a fainting-fit and lay without motion.

For some, all this passionate activity can become just too tiring. In that case, you may need some help. In the reign of Louis XV, a French architect called Monsieur du Borsage designed an apparatus called *une avantageuse*. In his *Les sociétés d'amour au 18ème siècle* Jean Hervé gives a description of it:

After gripping the two supports which are shaped like erect penises on either side of her, the woman lowers herself backward on a thick, firm, satin-covered cushion which supports her from the head to the buttocks. She opens her legs out like

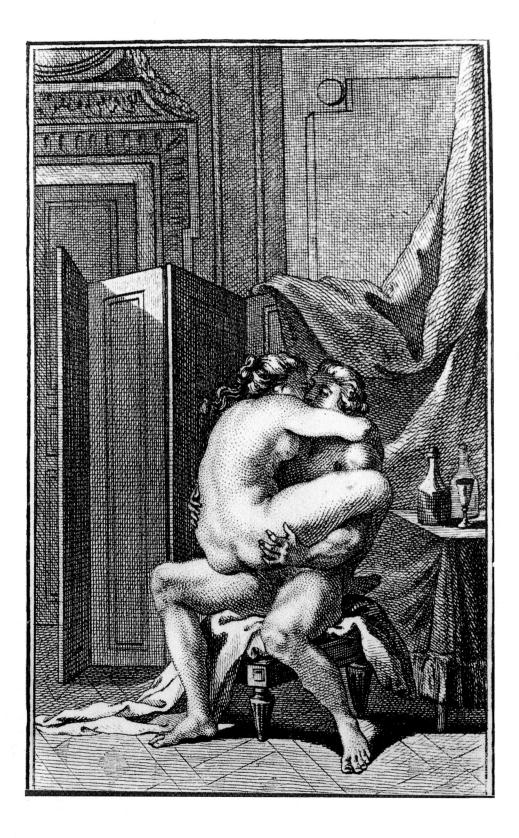

scissors at right angles and rests her feet in soft padded stirrups. Meanwhile the man positions himself above her with his knees resting on cross bars. His hands grasp two cylindrical supports on the outside of the device and he is now in easy reach of his goal.

Whether sex is achieved with artificial aids or naturally, the feeling of contentment enjoyed afterwards is universal. Ming Dynasty Chinese poets called the sexual act 'clouds and rain', and in a poem entitled 'Awakening from a Spring Slumber' the poet gives the most exquisite expression of what it feels like after orgasm:

The clouds have cleared from Wu Mountain,
The rain has passed in the fragrant women's quarters,
Who can understand the limitless passion of the game they have played?
She is as lovely as the Empress stepping from her bath,
Slowly she ties the cord of her embroidered skirt,
As if angry at having been woken from her slumber,
Her limbs are too tired to bear the weight of clothes,
She is too lazy to pick up her apricot dressing gown.
From under the delicately arching eyebrows she gazes at her lover,
She appears dazed as her thoughts linger on their passionate union.

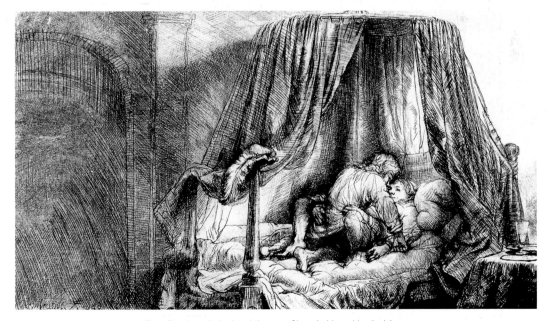

Even Rembrandt depicted the act of love in his etching *Ledekant*.

Opposite: A French book illustration from the era of Casanova.

FORBIDDEN FRUITS

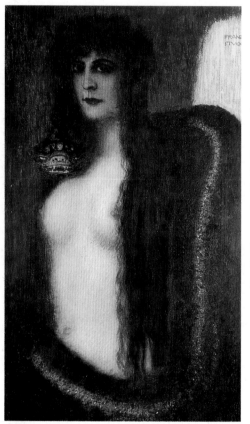

Franz von Stuck, *The Sin* – but which sin is she guilty of?

The world is based upon the interaction of the male and the female principles, and it is natural for men and women to be drawn together. One cannot say that anything we do is out of depravity and evil passion.

WANG SHIH-CHENG, *THE GOLDEN LOTUS*

The idea that there are any areas of sex that are forbidden is a Christian one, and the dividing line between what is allowed and what is prohibited has been hotly debated for nearly two millennia. For the Puritans, almost everything about sex was banned. This left them wide open to the ridicule of pamphleteers. In *A Merry Conversation which Lately Pas'ed Between a Very Noted Quaker and His Maid, Upon a Very Merry Occasion*, published in 1739, the master, John, is explaining a passage from the Bible to his maid, Mary, and his seduction takes on a religious tone as he shows her the secrets of carnal copulation:

> *John*: Let me feel thy breasts; for they are like two roses, which are twins feeding among the lilies.
> *Mary*: My brother! My spouse! How fair is thy love.
> *John*: ...Doest though feel nothing Mary?
> *Mary*: Yea, I feel something stiff against my belly, as it were the horn of a unicorn.
> *John*: My undefiled one, speak not of unicorns, for there

is nothing of the beast between these sheets: This is part of carnal man which riseth and falleth according to the spirit within. This is that which entereth into the secrets of woman, and filleth them with the blessings of posterity, so that their memories shall not perish.
Mary: May I not feel it too? Oh John! Where are the Chariots of Israel, and the horsemen thereof? For here are two of the great wheels!

Opposite: There are many references to fellatio in Indian erotic literature – but few to cunnilingus.

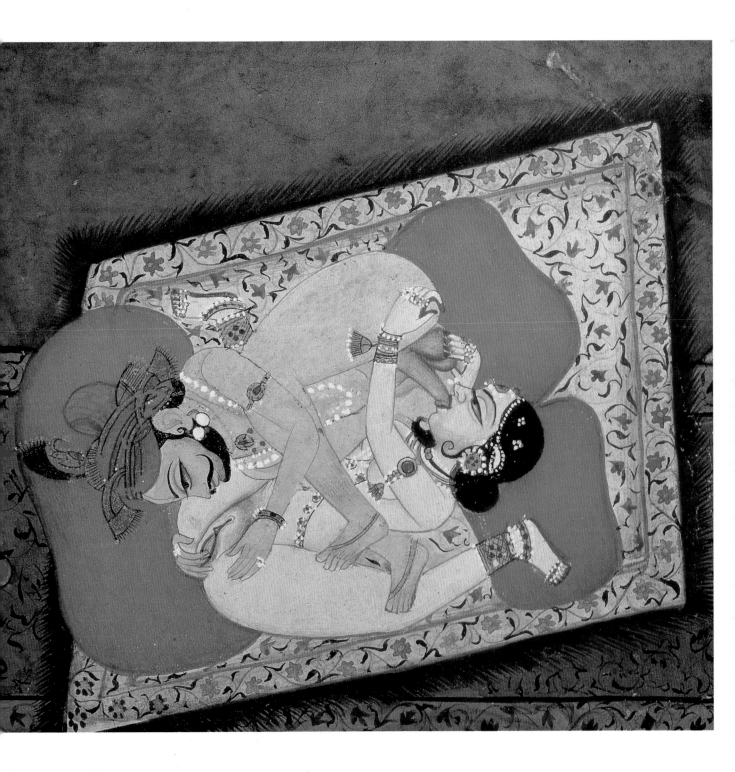

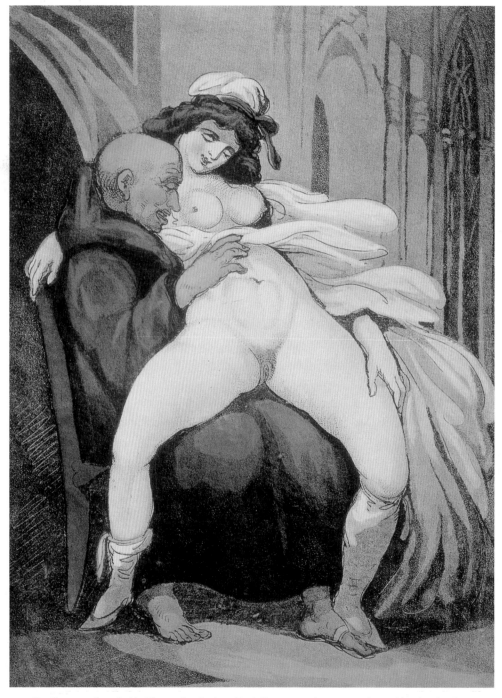

The Clergyman Quenched by Thomas Rowlandson. Erotic literature and art was used to satirize the church.

John: Now, in the fear of Heaven, will I take up thy lower linen, for time calleth me to feel thy belly and its secrets.

Mary: Thou seest I am free, yea, very free: do unto thy handmaid as seemeth good in thine eyes.

John: How beautiful is my beloved!

Mary: What hast thou found there John?

John: Thy belly, and thy secret parts of generation; thy belly is like a field of wheat, set about with lilies, and thy navel is as a round cup which wanteth liquor; embrace me, Mary; embrace me in thy arms.

Mary: I will, I do John, I will embrace thee; thou shalt lie between my breasts.

John: Yea, I will lie betwixt thy thighs: Give way to thy beloved; spread one thigh towards the north and the other towards the south! I will exalt my horn, I will enter with courage and resolution, and beat Satan down before me.

Mary: Oh! John, I have seen many go out of this world, but never knew how they came into this world before; oh! John, thou has filled me with the spirit of life, and with the dew of knowledge.

Throughout the Renaissance the ancient ideas of nudity and sex reasserted themselves in Europe. With the invention of the printing press around 1437, the distribution of books no longer depended on legions of monks transcribing them by hand, and the humanist writers of the period used erotic writing to attack the excesses of the priesthood. In 1561 the priest Pietro Leon of Valcamonica found himself in the firing line. He was said to be:

> ...living in abominable sin with the nuns committed to his care, who numbered about four hundred, and who for the greater part were young and beautiful. Inside the convent walls he laid aside the mask of hypocrisy and showed himself in his true colours as a lecherous tyrant. He made use of the confessional to seduce nuns and, if he met with resistance, had recourse to imprisonment and torture. In summer he made the fairest of the sisters strip and bathe in the boat-house while he played the role of the elders in the story of Susanna.

According to stories published at the time, monks and nuns were always at it. This account comes from *Memoirs of the Voluptuous Conduct of the Capuchins in Regard to the Fair Sex: Represented in a Variety of Curious Scenes, Exhibited to the Public View by a Brother of the Order* (1755):

> I went upstairs to the parlour of the prioress, where he usually conversed with one or other of the nuns. I opened the door without knocking, though the contrary is punctually observed by monks and nuns: But I had so raised the latch that I did not

Transvestism as practised in Persia in the early nineteenth century.

well know what I was about. I beheld, on opening the door, shall I say! our Reverend Father Provincial making preparations for conveying very luscious ideas to the imagination; he lay extended on his back upon the shelf that was placed before the grate. His eyes full fraught with glances of amorous passion were eagerly fixed on one of the nuns on the other side, who displayed charms not to be told and whose hand to avoid idleness went through the ceremonious parts of a certain office. This spectacle surprised me so much, that I drew the door after me with more precipitation than I opened it, and ran in quest of the Secretary, without knowing why, or wherefore. My head was so distempered with wine and what I had seen that I rushed suddenly into the parlour where he was and broke the bolts which he had the prudence to keep the door secure by, for fear of a surprise. But if my astonishment had been great on sight of the condition of the Father Provincial, that in which I found the Secretary was much worse. He was stretched on two chairs, his visage pale, his cord loose about him, his sandals at a distance, his gown carelessly raised, and a young lady held him by the hand across the grate. I ran to succour him, but the posture in which I saw the lady as I approached, convinced me that he was only dead to partake of the effects of a more pleasing resurrection. She assured me that his debility would be attended with no fatal consequences.

But it was not just the clergy who enjoyed being masturbated. The Comte de Mirabeau, the orator reputed to have begun the French Revolution, offers a description of being masturbated by a young Jewish girl skilled in the art in a brothel in Constantinople:

Imagine the two players naked lying on a gently sloping couch in a mirrored alcove. The artful girl takes great care to avoid touching the sexual parts. Her approach is slow, her embraces soft. Her kisses are more tender than wanton, the strokes of her tongue are delicate. Her expression is luxurious and her limbs lace around him gracefully. Gently she tickles the tips of his nipples. Soon she notices that the head of his penis has become moist. Once she knows that the erection is firmly

established, she touches her thumb on the tip of his glans, finding it bathed with clear liquid. From there, she runs her thumb smoothly down to the root of the frenum, returns to the top, redescends, then makes a tour of the corona.

Occasionally she stops if the pleasure is increasing too rapidly. She also makes use of more general stimulation. After the direct touching with her hand, then both hands and the approach of all her body, the erection becomes extremely violent. She now has to decide whether to aid nature in its course or deflect it. Eventually the spasms become so acute that the erection is in danger of falling into syncopation if she does not put an end to it. She does this by clasping the shaft firmly and rapidly manipulating it, producing a powerful climax.

In *Venus in India* Charles Devereux records a more amateur approach:

I might have kept up my acquaintance more vigorously with the Selwyns but for Mabel. That little girl, ever since I had tickled her mound at Nowshera, evidently looked forward to being had by me very soon, to make my yard stand, no matter whether her mother was beside her, and my embarrassment was simply enormous. Pretending to consider herself as a mere child, she would, in spite of her mother's feeble chidings, seat herself on my lap, and, hiding her hand under her, feel for and

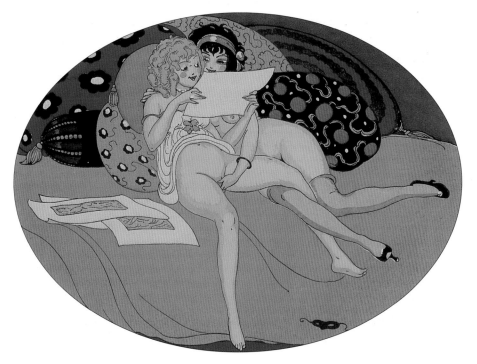

Gerda Wegener's *The Pastimes of Eros*, 1917, shows an attractive lesbian couple.

A young Japanese woman pleasures herself with a dildo attached to her heel, *circa* 1850.

clutch my infernal fool of an organ, which would stand furiously for her though I wished it cut off at such moments. If I happened to be spending an evening with her at her father's house, and to be engaged in a game of chess with one of the two girls, Mabel would find her opportunity, slip unnoticed under the table, crawl to my knees, and with her nimble fingers, unbutton my trousers, and putting in her little exciting hand take possession of all she found there. I should have laughed at it only that I was terrified lest this very forward play be discovered, I had to sit tight up against the table, and do my best to seem unconcerned, whilst Mabel's moving hand precious nearly made me spend! A catastrophe, I am thankful to say, she never quite succeeded in bringing about.

In *Memoirs of a Woman of Pleasure* the heroine Tonzénie also explores the delights of masturbation:

One of the middle-sized dildo-tribe was procured for her private amusement; through it her French maid, well skilled in such practices, would in the moment of rapture, dart a warm injection; nay, sometimes artfully gird it to her loins, and act the man with her young mistress.

Chinese women used dildos made from rubber, which were tied to their heels or ankles. They would a masturbate alone, simply by moving their foot.

Nuns seem to have been particularly drawn to mutual masturbation. In 1620 Benedetta Carlini was tried for immodest acts by an ecclesiastical court. The case was recounted in *The Life of a Lesbian Nun in Renaissance Italy*:

For two years, in the evening, two or three times a week, after undressing and going to bed, she would wait for the sister, who served her, to undress as well. Then she would force her to get into the bed, kissing her like a man and stirring herself on top of her so much that they both corrupted themselves. She would hold her there by force for two or three hours. She would do these things at the most devout hours, especially in the morning. Pretending she needed something, she would call her, then take her by

Anyone can have one – an anonymous drawing called *L'école des biches ou moeurs des petites dames de çe Temps*, Paris, 1939.

Leo Putz's *Morning* plainly depicts the morning after the night before.

force as described above. To increase her pleasure, Benedetta would put her face between the sister's breasts and kiss them, always wanting it to be like this. During the day she would pretend to be ill, grab the sister's hand and put it under herself, forcing her finger into her vagina and holding it there while she stirred herself so much that she corrupted herself. And she would kiss her and force her own hand under her sister, put her finger into her vagina and corrupt her. When the companion fled, she would do the same thing with her own hands. Many times she locked the sister in the study, make her sit down and, by forcing her hands under her, corrupt her. She wanted the sister to do the same, while she kissed her. She appeared to be in a trance while she was doing this.

In the *Arabian Nights* there is a description of the activities of a young female bath attendant:

> She used to compel the young male slaves to mount her, and she herself loved to mount the young female slaves. But above all things she loved to tickle and rub herself against these virgin bodies. She was especially adept at the titillating art and could suck the delicate parts of a girl voraciously while rubbing her nipples.

But masturbation is usually a solitary outlet. It gives us solace when we are alone, and even Fanny Hill could not always find a partner:

> It was yet worse when yielding at length to the insupportable irritations of the little fairy charm that tormented me; I search it with my fingers, teasing it to no end.
>
> Sometimes, in the furious excitations of desire, I threw myself on my bed, spread my thighs abroad, and lay, as it were, expecting the longed-for relief, till finding my illusion, I shut and squeezed them together again, burning and fretting. In short, this devilish thing, with its impetuous girds and itching fires, led me such a life that I could neither, night or day, be at peace with it or myself. In time, however, I thought I had gained a prodigious prize, when figuring to myself that my fingers were something of the shape of what I pined for, I worked my way in for one of them with great agitation and delight; yet not without pain, too, did deflower myself as far as it could reach; proceeding with such a fury of passion, in this solitary and last shift of pleasure, as extended me at length breathless on the bed in an amorous melting trance.

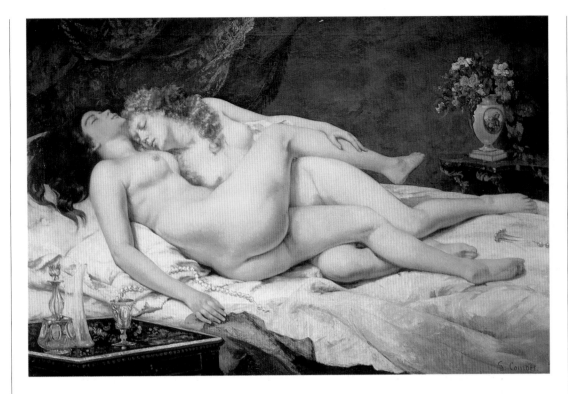

Gustave Courbet's *Le sommeil* speaks more about male voyeurism than lesbian love.

Fanny then goes on to explain how much better it is with a man. Many, however, have to content themselves with fantasy, and dream of the amorous parts of a phantom lover:

> With panting breasts and dying eyes,
> Fancied she seiz'd the manly prize:
> Her legs she canted in the air.
> Thinking to seize the phantom there;
> Then to her gap her hand applies
> Clinging close her legs and thighs.

Pornography is often used as an aid to masturbation. The diarist Samuel Pepys enjoyed pornography and recorded buying a 'roguish book' in January 1668:

> Thence away to the Strand to my bookseller's, and there stayed an hour and brought that idle, roguish book, *L'Escholle des Filles*; which I have bought in a plain binding (avoiding the buying of it better bound) because I resolve, as soon as I have read it, to burn it, that it may not stand in the list of books, not among them, to disgrace them if it should be found.

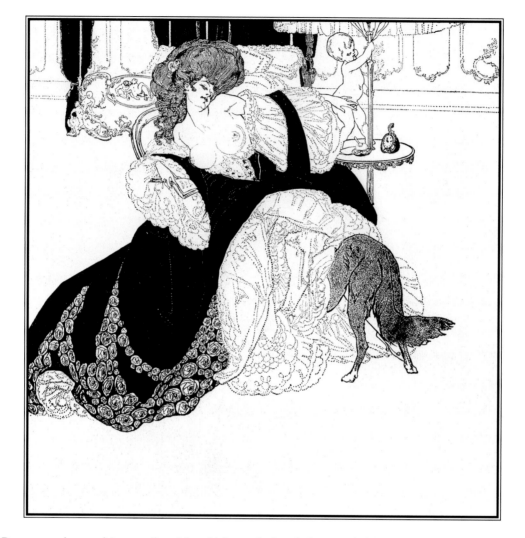

The Marquis Franz von Bayros discovers a lady and her faithful dog in Fleurette's *Purple Snails*, an eighteenth-century collection of erotic songs and poems.

Pepys condemned it as a 'lewd book' but admitted that 'it did hazer my prick...stand all the while'. In fact, the book takes the form of a rather charming discussion between two girls, Katy and Fanny, about the nature of sexual love:

Katy: I tell you what, since Mr Roger has fucked me, and I know what is what, I find all my mother's stories to be bugbears and good for nothing but to frighten children. For my part, I believe we were created for fucking, and when we begin to fuck we begin to live, and all people's actions and words ought to tend thereto. What strangely hypocritical ignorants are they who would hinder it in us young people because they cannot do it themselves? Heretofore, what was I good for but

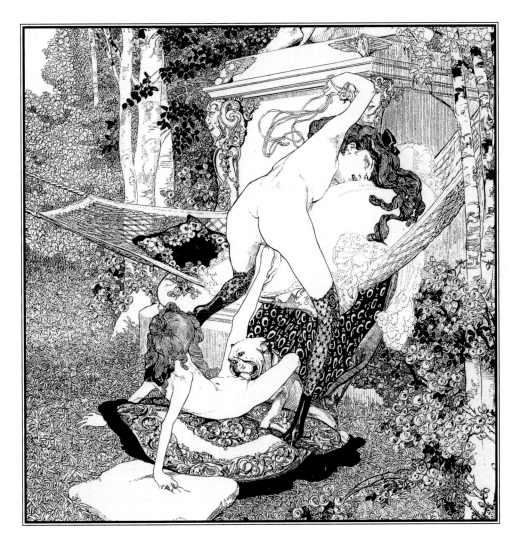

to hold down my head and saw? Now nothing comes amiss to me. I can hold an argument on any subject, and that which makes me laugh is this; if my mother chide, I answer her smartly, so that she says I am very much mended, and she begins to have great hopes of me.

Fanny: And all this while she is in darkness as to your concerns.

Katy: Sure enough, and so shall she continue as I have ordered matters.

Fanny: Well, and how goes the world with you now?

Katy: Very well, only Mr Roger comes not so often to see me as I could wish.

Fanny: Why, you are well acquainted with him then?

Katy: Sure enough, for we understand each other perfectly.

Fanny: But did not what he did unto you at first seem a little strange?

Katy: I'll tell the truth. You remember you told me much of the pleasure and tickling of fucking? I am now able to add a great deal more of my own experience, and can discourse as well of it as any one.

Fanny: Tell me then. I believe you have had brave sport, I am confident Mr Roger must be a good fuckster.

Katy: The first time he fucked me I was on the bed, in the same posture you left me, making as if I had been at work. When he came into the chamber, he saluted me and asked me how I did. I made him a civil answer and desired him to sit down, which he did close by me, staring me full in the face, and all quivering and shaking asked me if my mother was at home, and told me he met you at the bottom of the stairs and that you had spoken to him about me, desiring to know if it were with my consent. I returned no answer, but smiled; he grew bolder and immediately kissed me, which I permitted without struggling, tho' it made me blush as red as fire for the resolution I had taken to let him do what he would unto me. He took notice of it and said, 'What do you blush for, child? Come, kiss me again.' In doing of which he was longer than usual and thrust his tongue into my mouth. Tis a folly to lie, that way of kissing pleased me, that if I had not before received your instructions I should have granted him whatever he demanded.

Fanny: Very well.

Katy: I received his tongue under mine, which he wriggled about, then he stroked my neck, sliding his hand under my handkerchief he handled my breasts, thrusting his hands as low as he could.

Fanny: A very fair beginning.

Katy: The end will be as good. Seeing he could not reach low enough, he pulled out his hands again and whilst he was kissing and embracing me, by little and little he pulled up my coats till he felt my bare thighs.

Fanny: We call this getting of ground.

Katy: Look here, I believe very few wenches have handsomer thighs than I, for they are white, smooth and plump.

Fanny: I know it, for I have often seen and handled them before now, when we lay together.

Katy: Feeling them, he was overjoyed, protesting he never felt the like. In doing this his hat, which he had laid on his knees, fell off, and I casting my eyes downwards perceived something swelling in his breeches, as if it had a mind to get out.

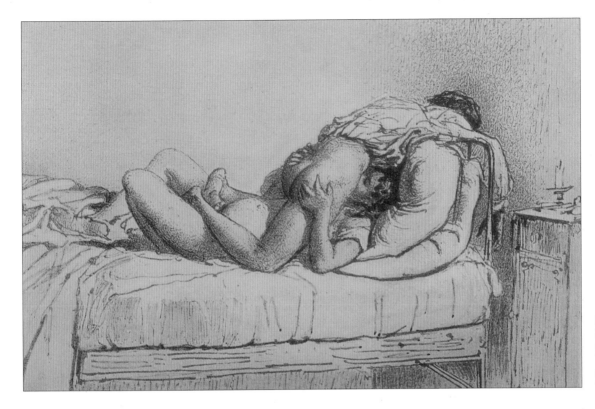

Michaly von Zichy's lovers enjoy fellatio. The woman also enjoys a fellow's toe.

Fanny: Say you so, madam?

Katy: That immediately put me in mind of that stiff thing, which you say men piss with and which pleaseth us women so much. I am sure when he first came into the chamber it was not so big.

Fanny: No, his did not stand then.

Katy: When I saw it I began to think there was something to be done in good earnest, so I got up and shut the door. Having made all sure, I returned and he, taking me about the neck and kissing me, would not let me sit as before on the bed but pulled me between his legs and, thrusting his hand into the slit of my coat behind, handled my buttocks, which he found plump, round and hard. With his other hand he takes my right hand and, looking me in the face, put it into his breeches.

Fanny: You are very tedious in telling your story.

Katy: I tell you every particular. He put his prick into my hand and desired me to hold it.

Fanny: This relation makes me mad for fucking.

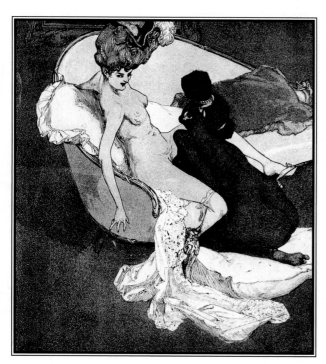

Two lesbians enjoy the added stimulation of inter-racial love.

Katy: This done, says he, 'I would have you see what you have in your hand,' and so made me take it out of his breeches. I wondered to see such a damned great tarse, for it is quite another thing when it stands. He perceiving me a little amazed said, 'Do not be frightened, girl, for you have about you a very convenient place to receive it,' and upon a sudden pulls up my smock.

Fanny: This is what I expected all this while.

Katy: Then he thrust me backwards, put down his breeches, put by his shirt and draws me nearer to him.

Fanny: Now begins the game.

Katy: I soon perceived he had a mind to stick it in. I desired him to hold a little for it pained me. Having breathed, he made me open my legs wider and, with another hard thrust, went a little farther in. He told me that he would not hurt me much more and I should have nothing but pleasure for the pain I should endure, and that he endured a share of the pain for my sake, which made me patiently suffer two or three thrusts more. Endeavouring still to get more ground, he takes and throws me backwards on the bed, but being too heavy he took my two thighs and put them on his shoulders, he standing on his feet by the bedside. This way did give me some ease, yet I desired him to get off, which he did.

Fanny: What a deal of pleasure did you enjoy! For my part, had I such a prick, I should not complain.

Katy: Stay a little, I do not complain for all this. Presently he came and kissed me and handled my cunt afresh. Being still troubled with a standing prick and not knowing what to do with himself, he walked up and down the chamber till I was fit for another bout.

Fanny: Poor fellow, I pity him; he suffered a great deal.

Katy: Mournfully pulling out his prick before me, he takes down a little pot of pomatum which stood on the mantle tree of the chimney. 'Oh,' says he, 'this is for our turn,' and taking some of it he rubbed his prick all over with it to make it go in the more glib.

Fanny: He had better have spit upon his hand and rubbed his prick therewith.

Katy: At last he thought of that and did nothing else. Then he placed me on a chair and by the help of the pomatum got in a little further, but seeing he could do no great good that way, he made me rise and laid me with all four on the bed, and having once more rubbed his tarse with pomatum he charged me briskly in the rear.

Fanny: What a bustle here to get one poor maidenhead! My friend and I made not half this stir. We had soon done and never flinched for it.

Katy: I tell you the truth verbatim. My coats being over my shoulders, holding out my arse I gave him a fair mark enough. This new posture so quickened his fancy that, no longer regarding my crying out, he kept thrusting on with might and main, till at last he perfected the break and took entire possession of all.

Fanny: Very well, I am glad you escaped a thousand little incidents which attend young lovers, but let us come to the sequel.

Katy: It now began not to be so painful. My cunt fitted his prick so well that no glove could come straighter on a man's hand. To conclude, he was sovereign at his victory, called me his love, his dear and his soul.

Fanny: Very good.

Katy: He asked me if I were pleased. I answered, 'Yes'. 'So am I,' said he, hugging me close to him, his hands under my buttocks.

Fanny: This was to encourage and excite him.

Katy: The more he pushed, the more it tickled me, that at last my hands on which I leaned failed me and I fell flat on my face.

Fanny: I suppose you caught no harm by the fall?

Katy: None, but he and I dying with pleasure fell in a trance, he only having time to say, 'There, have you lost your maidenhead, my fool.'

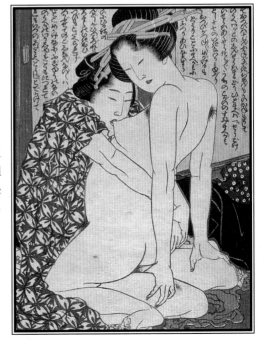

Katsushika Hokusai's canon of shunga prints also includes lesbian love scenes.

True to his word, Pepys burnt *L'Escholle des Filles* after he had finished reading it. But on the Continent, critics demanded sterner action. On 22 September 1791 a Monsieur Jorisse wrote to the Commissioner of Police after visiting a pornographic bookshop in Paris:

What shocked me most was that I saw in this bookshop a little girl of about twelve who was reading the books and offering them to me. I pointed out to her the dangers that she risked in reading such evil books and she said that her mother (who ran the bookshop) knew

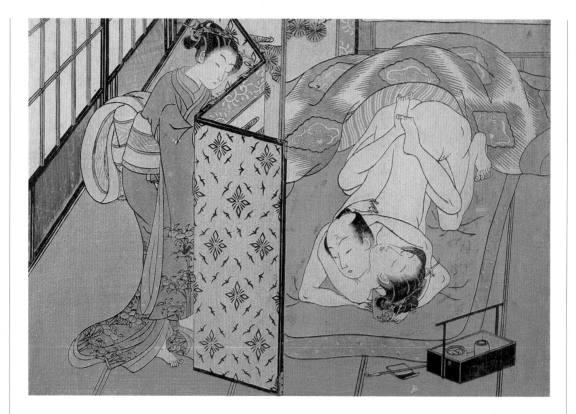

The maid watches the lovers from behind the screen, perhaps picking up tips. Each Japanese courtesan had two young maids whom she trained.

all about her reading the books. Then one evening, walking in the Palais-Royal [an area notorious for prostitutes at the time], I ran into the same little girl standing with another girl of her age in front of the Variétés. They asked me if I would give them some money and indicated that they were willing to let me do whatever I wanted with them. I threatened to call the corps de garde and they ran away. I am persuaded that they are susceptible to such vile acts only because of the evil books they have read.

The books he complained of had wonderful titles such as *The Catechism of the Libertine*, *My Erections*, *Afternoons in the Boudoir* and *Hymn of the Penis*.

Another aid to masturbation is voyeurism. We can only imagine what the Manchu poet Peng Hsieh-men got up to after he wrote:

> Against the red satin pillows
> Her cheeks shine like cream jade
> Her dainty eyebrows knit
> In the pain of joy he gives her.

Through door crack eyes are peeping
Missing nothing of the love scene.
In the delicate lamplight
Her snow-white arms turn pink around his neck.

In *La Puttana Errante* Renaissance writer Niccolo Franco tells the tale of Maddalena, a virgin of sixteen or seventeen, watching her cousin Frederico make love to his wife:

> I saw Caterina. She had taken off her blouse and was nude, and was looking to see if there were any fleas inside it. Frederico was lying on the bed nude. Below his belly, stood this erect thing. It was so fat and long it looked like a rabbit. While I was looking I was wondering how it had grown so long in four years. Then I said to myself: she is so small how is she going to take all that into herself? He will tear her apart. Then I thought to myself that he will just rub her, like my aunt rubbed me. Then I heard Frederico say, 'Caterina, come here.'
>
> She turned and, seeing him in that state, said with a smile: 'What do you want?'
>
> To which he said: 'Come here, please.'
>
> She put down the blouse and went to him and, putting her hand on his column, said: 'Aren't you ashamed to sit around in this state?'
>
> He said: 'Come on, kiss me.'
>
> She kissed him, and bit him, and put her leg over his. While he was still kissing her, he turned her over on her back with her face towards heaven. Then he got on top of her, opened the lips of her cunt a little with his hands and stuck his stiff pole into her.
>
> I was stupefied, expecting her to scream, waiting for her to die, when I saw her lift both her legs and put them on Frederico's shoulders. She took his buttocks in her hands and pulled herself on to him, lifting her arse by pressing her heels into his shoulders as if she was afraid he would fall out of her.
>
> Pressing against him and panting, she said: 'My love, push against me too as I am doing.'
>
> He could not have pushed as much as he wanted to, but he seemed to keep trying. In the end, they were pushing and panting, with sighs and moans, stretching their legs and arms, both pale and almost outside of themselves.
>
> To tell the truth, I thought Caterina was dead for sure, and Frederico was exposed. Then, as if rousing from sleep, she took her blouse and wiped him with it. His instrument had become small and wrinkled – it was no longer what it had been before. Then she kissed Frederico on the face, on the eyes, on the shoulders, everywhere. It was then that I realized that she had enjoyed it very much and a

great desire to experience the same thing sprung up in me. I almost went mad. Putting my fingers in my cunt, I began rubbing, all the while thinking how much more I could do if I had a young man in my arms.

Naturally, Maddalena is drawn into adultery with Frederico:

His prick was as hard as wood, he made me touch it. Sometimes he placed it between my thighs, and sometimes against my breasts. So extreme was his desire for me that I let him satisfy himself between my breasts. He squeezed one, then the other, rubbing himself up and down against them. Then I felt my neck all wet; and having dried it, I was happy to have allayed his passion somewhat. After many kisses and much talking, we went to sleep. But when I turned my back on him, I found that his ardour was not diminished. He pulled back the bedclothes and put it between my buttocks, not in my cunt as usual, in the other hole near there which was wet because it was near to its neighbour and it went in easily. I said nothing, but let him do it. Not only did it not hurt, but it also brought me sweet thoughts. Another time, before he got up, he wanted me the same way and I was happy to do what he wanted. For the three nights it lasted, he always wanted to lie with me and he did it to me not just between the breasts, but between the thighs and under the arms.

A Mughal album pictured shows two women interwined. Lesbianism excited men. It also passed the time in the harem.

Emperors of the Yuan or Mongol Dynasty raise voyeurism to an art form. The Emperor Hui-tsung (1333–1367) made a Tibetan monk, who was an expert in secret Tantric rituals, Master of the Yuan Empire. He directed Indian monks in what was known as the 'Discipline of Pairs':

They all took three or four girls of good families as sacrifices for his discipline. Then the Emperor engaged in these practices every day, assembling for it a great many women and girls. He found joy only in dissolute pleasure. He also picked a number of women from his concubines and made them perform the dance of the Sixteen She-devils. The Emperor's brothers and friends engaged in lewd embraces in front of the Emperor – the men and women were naked.

Fellatio has been popular the world over, down the ages. Literature is full of it. In *The Golden Lotus*, after swallowing an aphrodisiac, Hsi-mên challenges a young prostitute:

'Come here you little strumpet,' he said, 'and see whether your lips can make this subside. If they can I will give you a silver talent.'

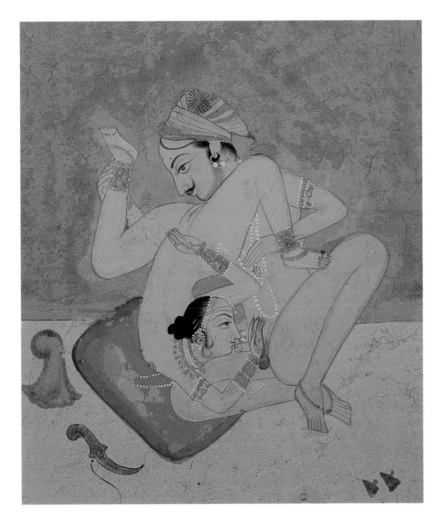

Before the twentieth century cunnilingus was generally described as unclean. However, it is frequently depicted in erotic art and was probably practised more widely than appears in literature.

'I am ashamed of you, you wretch,' she said. 'How can it go down now you have drunk that potion?'

Nevertheless she sat on the couch and put his penis between her red lips.

'It's so huge,' she said, 'it hurts my mouth.'

Then she sucked his penis and fondled it with her tongue. She licked the foreskin and pushed it to and fro with her lips. But although she caressed the mighty penis with her cheeks and played a thousand love games with it, it only became longer and thicker. Hsi-mên looked down on her. Her beautiful body seemed to shine among the silk sheets. With her delicate fingers she took his penis, inserted it between her lips and took it all into her mouth until she removed it drooping.

He also did it with a girl named Moonbeam:

> She passed a honey lozenge from her tongue to his. With her delicate hands she opened his trousers, drew out his penis and softly massaged it until it rose grandly, red in colour and rigid. When the man asked her to suck it, she bent her neck, opened her lips and took half the penis into her mouth where it moved to and fro, making a pleasant sound.

Fellatio could be quite matter-of-fact:

> When the maid had gone, Hsi-mên lay down on the bed, pulled down his trousers, took out his penis and told the woman to take it in her mouth while he enjoyed the wine.
>
> 'Suck it well for me,' he said, 'and I will give you an embroidered scarf that you can wear on holiday.'
>
> 'Verily,' she said, 'I should like to suck it.'

Or it could be prolonged:

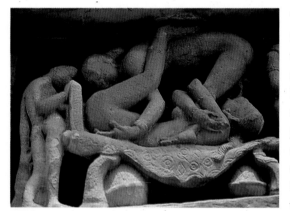

Cunnilingus often appears in Hindu art, even though it was discouraged by the *Kama Sutra*.

> The woman, sitting on her haunches, put her hands on the man's legs and took his penis between her lips. For a whole hour, she played and did not tire. Hsi-mên put his arms around her white neck and pushed his penis backwards and forwards between her lips with all his might. Soon her lips were wet with white froth and his penis became red. She caressed the penis against her cheeks and took it in her mouth. She fondled the tip and excited the nerve with her tongue. It remained firm between her lips and moved softly. Hsi-mên rejoiced and with his rising pleasure began to withdraw it.
>
> 'Hold it and let the semen come out,' he cried. And the semen came out into the woman's mouth, and slowly she sucked it up and swallowed it.

Another girl, Heart's Delight, is prepared to go even further:

> Soon he told the woman to lie with her legs parted and covered with a red cloth he lay upon her. He inserted his penis and moved it forward while she drew it into her white thighs. 'Tell me you love me,' he said, 'and don't stop. Let me plunge in completely.' She raised herself up to take the full length of him and, in a trembling voice, called him darling. For a whole hour they played until Hsi-mên wanted to stop. At last, when his penis was withdrawn she wiped it with a cloth, and they

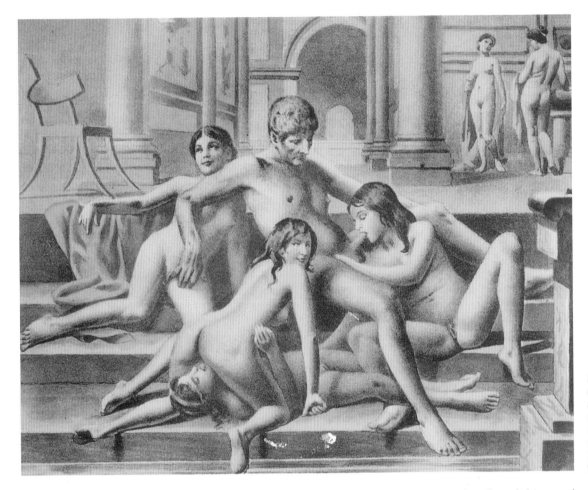

People had more fun in ancient times – or so nineteenth-century artists like Paul Avril thought.

went to sleep in each other's arms. Before dawn she woke up excited and took his penis in her mouth.

'Your fifth mother,' Hsi-mên said, 'sucked it all night. She wouldn't allow me to leave the bed when I wanted to piss, because she was afraid I would be cold.' 'What of it?' said the girl. 'I am thirsty too.' And Hsi-mên made water into her mouth.

Naturally, the *Kama Sutra* describes the different ways of fellating a man. There are eight:

1. Holding the man's lingam with the hand and placing it between the lips, moving the mouth about, is called nominal congress.
2. Covering the end of the lingam with the fingers collected together like the bud of a plant or flower, pressing the sides of it with the lips and teeth is called biting the sides.

Fellatio is a common theme in pre-Columbian art. This ceramic vessel comes from Peru, *circa* AD 500.

3. Pressing the lingam with the lips closed together and kissing it as if drawing it out is called outside pressing.

4. Putting the lingam further into the mouth, pressing it with the lips and taking it out is called inside pressing.

5. Holding the lingam in the hand and kissing it as if it were a lower lip is called kissing.

6. Touching it with the tongue and passing the tongue over the end of it is called rubbing.

7. Putting half of it in the mouth and forcibly kissing and sucking it is called sucking the mango.

8. Putting the whole lingam in the mouth to the very end as if swallowing it is called swallowing up.

Perhaps because literature is dominated by male writers, descriptions of cunnilingus are, however, few and far between. An anonymous Arabic poet, although acknowledging the practice, cannot bring himself to describe it in proper mouth-watering detail:

Her breath is like honey spiced with cloves,
Her mouth delicious as a ripened mango.
To press kisses on her skin is to taste the lotus,
The deep cave of her navel hides a store of spices,
What pleasure lies beyond, the tongue knows,
But cannot speak of.

This everyday Roman oil lamp depicts an everyday act of cunnilingus.

In many cultures, perhaps because of men's squeamishness about menstruation, cunnilingus was considered unclean. Even the *Kama Sutra* sweeps the practice aside:

The male servants of some men carry on the mouth congress with their masters. It is also practised by some citizens, who know each other well, among themselves. Some women of the harem, when they are amorous, do the acts of the mouth on the yonis of one another, and some men do the same thing with women. The way of doing this should be from kissing the mouth. When a man and a woman lie down in an inverted order, with the head of one towards the feet of the other and carry on this congress, it is called the congress of the crow.

For the sake of such things courtesans abandon men possessed of good qualities, liberal and clever, and become attached to low persons, such as slaves and elephant drivers. The Auparishtaka, or mouth congress, should never be done by a learned

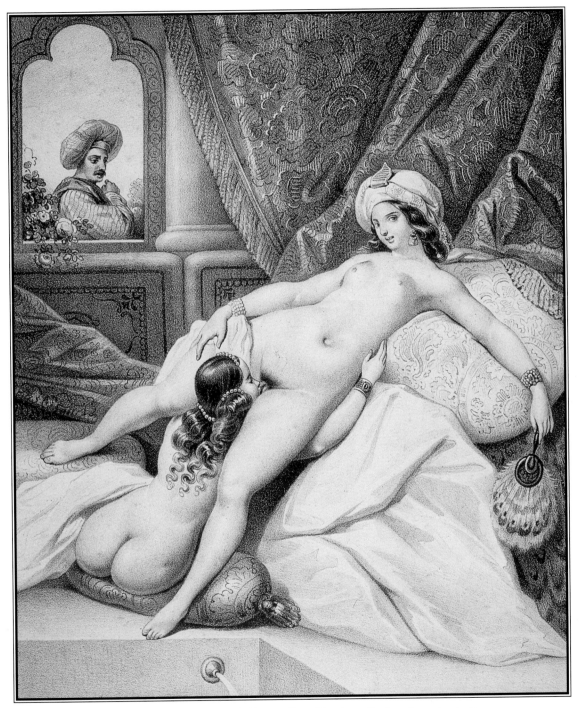

Eugene Deveria's *The Harem* depicts lesbian cunnilingus. The viewer, like the sultan, enjoys looking on.

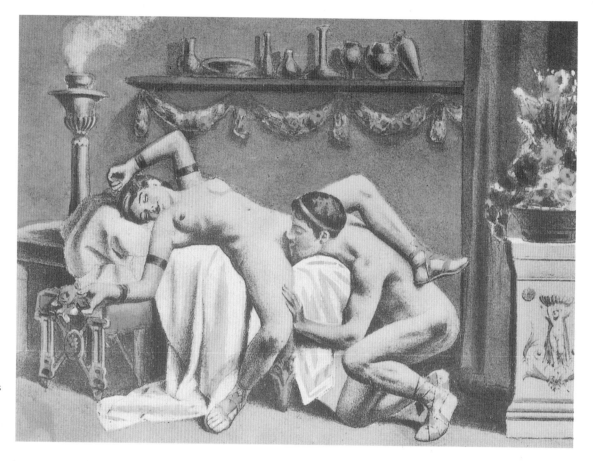

Paul Avril's *Ancient Times* is full of oral sex. The figures are plainly contemporary.

Brahman, by a minister that carries on the business of a state, or by a man of good reputation, because though the practice is allowed by the Shastras, there is no reason why it should be carried on, and need only be practised in particular cases. As for instance, the taste, and the strength, and the digestive qualities of the flesh of dogs are mentioned in works on medicine, but it does not follow that it should be eaten by the wise. In the same way there are some men, some places and some times, with respect to which these practices can be made use of. A man should therefore pay regard to the place, to the time, and to the practice which is to be carried out, as also as to whether it is agreeable to his nature and to himself, and then he may or may not practise these to himself, and then he may or may not practise these things according to circumstance. But after all, these things being done secretly, and the mind of the man being fickle, how can it be known what any person will do at any particular time and for any particular purpose.

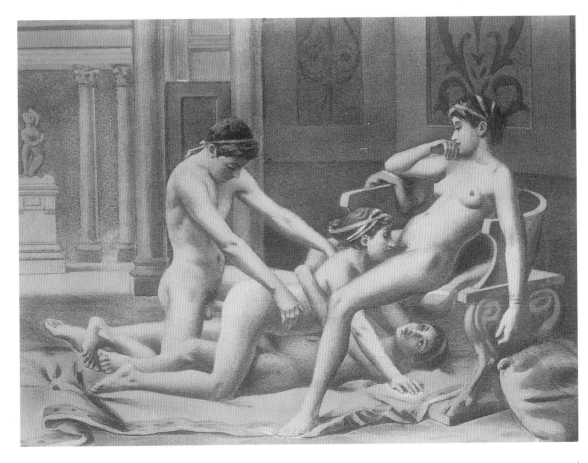

Although Paul Avril set his erotic scenes in classical times, he depicts more accurately the pleasures on offer in nineteenth-century bordellos.

For oral excess it would be difficult to beat Plymouth-born Cora Pearl, one of the most famous courtesans in Paris during the Second Empire. She charged the equivalent of £6,000 a night and numbered among her clients both Napoleon III and Bertie, Prince of Wales. Cora specialized in staging exotic entertainments for her gentlemen. One evening she invited six of them around for dinner. The menu featured a special dessert – herself:

> I received the gentlemen in my finest style, and entertained them to a dinner of excellent quality; the conversation was agreeable, the wines accomplished. When we had finished all but the final course, I excused myself in order to supervise its presentation. Slipping into the kitchen, I stepped out of my gown (when entertaining gentlemen it is never my habit to wear quantities of under clothing, and especially was this the case on this occasion) and mounting a chair lay on a vast silver dish which Salé had borrowed for me from the Prince d'Orléans' kitchens. I lay upon my side, my head upon my hand.

Frémont stepped forward, accompanied by Yves carrying as it were his palate – a large tray upon which was a set of dishes filled with marzipans, sauces and pastes, all of different colours. With that deftness and artistry for which he is so famed, Salé began to decorate my naked body with rosettes and swathes of creams and sauces, each carefully composed so that the heat of my body would not melt them before I came to the table.

As Salé was laying trails of cream across my haunches and applying wreaths of tiny button flowers to the upper sides of my breasts, I could not help noticing that Yves, chosen like all my servants for a combination of personal charm and accomplishment, and a young man of obvious and increasingly virile promise, was taking a peculiar interest in the chef's work. The knuckles of his hands were whiter than would have been the case had the tray been ten times as heavy, and the state of his breeches proclaimed the fact that his attitude to his employer was one of greater warmth than respect.

Having finished the decoration by placing a single unpeeled grape in the dint of my navel, Salé piled innumerable *meringues* about the dish, completing the effect with a dusting of castor sugar. The vast cover which belonged to the dish was then placed over me, and I heard Salé call the two other footmen into the room. Shortly I felt myself raised, and carried down the passage to the dining room. I heard the door opened, and the chatter of voices cease as the dish was carried in and settled upon the table.

Gerda Wegener completed *The Circle of Love* in 1917.

This Marquis von Baryos drawing *The Musicale* is captioned: 'But later we're going to play something more innocent.'

When the lid was lifted, I was rewarded by finding myself the centre of a ring of round eyes and half-open mouths. M. Paul, as I had expected, was the first to recover, and with an affectionate coolness reached out, removed the grape, and slipped it slowly between his lips. Not to be outdone, M. Perriport leant forward and applied his tongue to removing the small white flower that Frémont had placed upon my right tit; and then all, except for M. Goubouges, who I expected was as usual content simply to observe and record, were at me, kneeling on their chairs or upon the table, their fingers and their tongues busy at every part of me as they lifted and licked the sweetness from my body.

Despite writers' and poets' reticence to celebrate cunnilingus, they have no such inhibitions when it comes to anal sex. Many Arab women use it as a form of contraception and it is said that once a woman has learned to enjoy anal sex, she can have an orgasm by no other means. The practice is eulogized in verse in the *Arabian Nights*:

A Roman fresco from a lupinar, or brothel, in Pompeii was meant to inspire the clientele.

> She proffered me a tender coynte; quoth I: 'I will not futter thee!'
> She drew back, saying: 'From the Faith he turns, who's turned by Heaven's decree!
> 'And front-wise futtering, in one day, is obsolete persistency!'
> Then swung she round, and shining rump like silvern lump she showeth me;
> I cried: 'Well done, O mistress mine! No more am I in pain for thee;
> 'O thou, of all that Allah oped, showest me fairest victory!'
> Quoth she – for I to lie with her forbore – 'O folly-following fool, O fool to core:
> 'If thou my coynte for mortise to thy tenon reject, I'll show thee what shall please thee more.'

The ancient Chinese also enjoyed anal sex:

> He told the woman to get on the couch on all fours and to raise her buttocks. He put saliva on his penis and moved forward gradually. But the head of his penis was proud and arrogant and would only go in a little way. The woman furrowed her brow and bit on a towel.
> 'My darling,' she said. 'Take care not to enter too quickly for the rear is not like a door. I feel you inside me and I burn like a fire.'

And Chinese women appeared to enjoy it as much as their menfolk:

> Porphryry enjoyed one sport more than any other. When she had pleasured him as other lovers do, she wanted him to savour the flower through her back door, while she toyed with the flower in the front. This way she reached the blissful oblivion that is the goal of all lovers. She loved this so much that, in thirty days, her husband would enter by the front door only three times.
> Added to this, she would tickle his ivory staff with her lips and fondle it all night with desire. If her lord grew weary, her lips would revive his strength.

The Greek physician Dioscorides also recommends anal sex during pregnancy:

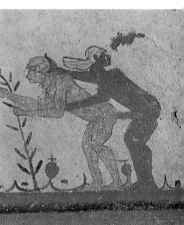

An Etruscan fresco from the lintel above the entrance of a tomb.

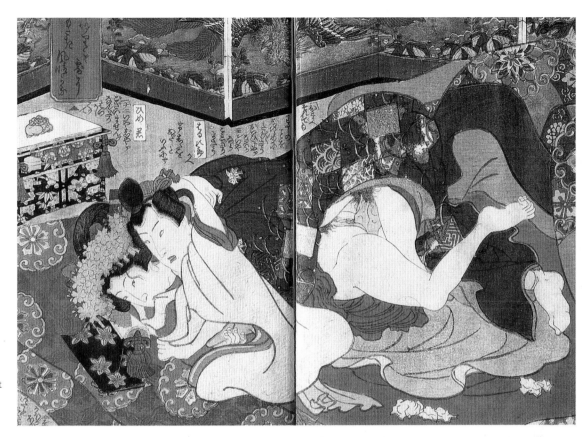

A Japanese shunga print showing an innovative, not to say impossible, position.

Never lean on her, when pregnant, face up on your bed,
Taking pleasure in the procreative act of love.
For there is a huge swelling in the middle, and it will be hard,
For her to be rowed while you ride at anchor.
So turn her around and take pleasure in her rosy arse,
And think of your wife as a boy.

And the ardent wife of Pietro Aretino's sonnets begs her husband to give her sex up the anus and is disappointed when he puts his penis into her vagina:

You play on me a dirty trick,
Fuck me like my master
Fill my vagina with your dick,
But don't forget my arsehole.

The Romans recognized few limits to their enjoyment of sex.

Though descendants I shall lack,
Keep fucking my behind,
The arse is as different from the crack
As water is from wine.

Fuck me anyway you want,
And satisfy your need,
Both my arse and my cunt,
Crave your careless seed.

There is no less fire in my arse
Than in my flaming cunt,
Though you're not built like a horse
Fuck me till I grunt.

Why take this old fashioned stand,
When my arse can take the brunt,
For if it were I that were the man
I would never want a cunt.

A Yoruba shrine carving from Nigeria showing two men and one women. The theme is fertility.

A variation of this is to combine oral and anal sex, a practice that surprised even the notorious libertine King Farouk. At the time, he was seeing the voluptuous eighteen-year-old Swede Birgitta Stenberg, former lover of Lucky Luciano, the American mobster who had been deported back to Italy in 1946. Luciano and Farouk met at Canzone del Mare, Grace Field's beach club on Capri. They had a lot in common: both were in exile; both had known great power; and both loved beautiful women.

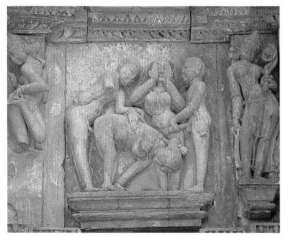

An erotic relief from a temple at Khajuraho in India.

Luciano had met Birgitta when she had been picked up by a Sicilian-American who said he had a job for her in New York. He had given her a ticket to New York with a stopover in Buenos Aires, and took away her passport for safekeeping. Luciano told her that the man was a white slaver. The stopover would be a permanent one. He got her passport back.

Farouk saw Birgitta with Luciano a couple of times. Then he spotted her in a restaurant in Rome with a young friend from the US Embassy and introduced himself. They spent an hour talking before he dropped her off home, in his bullet-proof Mercedes. Farouk then made a deal with Luciano to take Birgitta off his hands.

Birgitta liked Farouk because of his 'sweet eyes' and because he had once had the power of life and death over twenty million people. He liked her, he said, because she reminded him of his second wife Narriman. 'Why, because I am a teenage virgin?' she asked. He laughed.

She described her first sexual experience with him in her book *Manplay in Europe*:

'Now show me what you can do, young lady,' Farouk said.

I slipped down between his legs and kissed and played with his small penis. Then I let my face slip down between his testicles. I lifted his balls with my nose so I could press my tongue against his anus.

Farouk jerked with surprise.

I kept on twirling my tongue around.

'Why did you do that?' he whispered.

I continued. Then I did everything that was possible.

An hour later, Farouk was still asking: 'Why?'

'I know it feels good,' I said.

'Have you experienced it yourself?' he asked.

'Of course. How else would I know?'

Farouk looked at me as if I, not he, were the expert on sex.

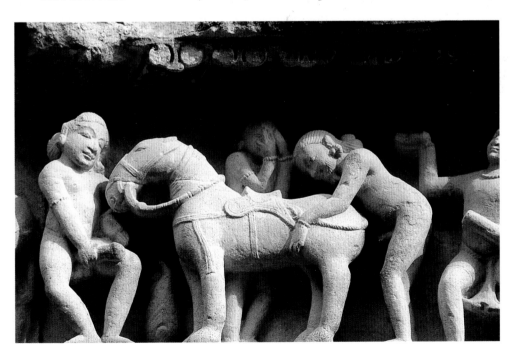

The erotic carvings at the Lakshmana temple in India also depict beastiality.

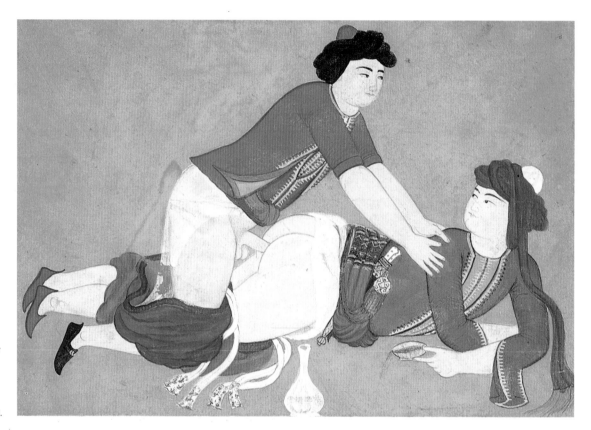

Homosexuality and anal eroticism have always been part of the Turkish culture.

The Chinese used all sorts of potions as an aid to lovemaking:

> She raised her legs so that her chicken's tongue appeared and asked Hsi-mên to put medicine in her. He fixed the silver clasp to the root of his penis, added the sulphur ring and smeared his knob with ointment. Then she grabbed his treasure and pulled him into her.
>
> 'Aren't your legs hurting,' said Porphryry. 'You lie on the couch and I will do the body movements.'
>
> Again she said: 'I am afraid you might hurt me. Don't you want to raise my legs higher.'
>
> So Hsi-mên tied her legs to the bed and leaned over her, pressing down without stopping. Her juices flowed out of her, all white and slimy like the trail of a snail.
>
> 'Why have you got so much of this?' he asked.
>
> He was on the point of spending, when Porphryry said: 'No, I will relieve you in my own way.'

Crouching down on her knees, she sucked him off with her, cleaning him with her licking tongue.

Once again, Hsi-mên was inflamed with desire. He turned the woman over and tried to enter her. But it was difficult and when she felt him with her hand he was only half-way in. She turned and said: 'My darling, I beg you to enter slowly. The root of your penis is bigger than I can bear.'

...At last, Porphryry raised herself on her hands so she could receive the vital stream and Hsi-mên came so violently that the liquid poured from him like a torrent. Then he withdrew, still wearing the ring and Porphryry washed him off with her mouth.

Hsi-mên carried his equipment in a silken kerchief. His kit comprised a 'silver clasp, a lover's cap, a sulphur ring, a white silk ribbon with medicinal properties and all sorts of things to increase passion':

First he put on the clasp, and tied a sulphur ring about the root of his penis. Then he refused to dismount from her, but played about the entrance so long that she cried out in frenzy: 'My heart, my honey. Either you must be a man quickly or I shall go out of my mind.'

He teased her some more, then:

With one thrust he reached the innermost part. Then he withdrew. He produced some powder called 'Delight of the Bedroom and Fragrance of the Penis' and applied it to the mouth of the frog. Then he went back on the attack. At once his warrior was tall and proud, full of fire and fury, while it gloried in the battle beneath him. She lay on the coverlet, her eyes half-closed, murmuring: 'Oh my delightful darling. You don't know what you are putting into me. This thing is driving me crazy. Spare me, I beg you.' She spoke without shame, but Hsi-mên took no notice. He drove on with all his might, his hands pulling on the coverlet, thrusting into her innermost part a hundred times before he withdrew again. The woman wiped her wounds with a towel, but still the coverlet showed the signs of battle and the warrior, still vigorous and fierce, was ready for more. 'The time has come,' Hsi-mên said, 'when the king must beat his drum.' With a sudden thrust he lunged forward into her innermost citadel; for in a woman there is a citadel like a flower which, if stormed by the conqueror, yields the most delightful pleasure. But she felt a sharp pain and pulled back. Inside her, the sulphur ring had broken.

Her eyes closed and her breathing became faint. She murmured faintly. Her tongue became ice cold and her body fell back lifeless on the mat.

Hsi-mên was frightened. Quickly, he untied the ribbons and removed the sulphur ring. It was snapped in two. He helped her to sit up. Slowly she revived.

'Darling,' she said. 'Why did you treat me so cruelly today? You nearly killed me.'

These sulphur rings were serrated metalwork, which fitted behind the glans to shield the sensitive corona from stimulation. The sulphur also acted as an astringent on the vagina, tightening it. The silver clasp went around the base of the penis, restricting the blood flow out of it, and thus sustaining the erection. This was Hsi-mên's favourite device:

> When they had taken a few cups together, she moved her seat nearer to his and they passed their wine from mouth to mouth. After checking that no-one was about, Hsi-mên put his arms around her and kissed her. He caressed her tongue with his own. Then she took his jade stem in her hand. Their passions caught aflame.
>
> They put down their cups and locked the door. Then they took off their clothes and Porphryry pulled back the covers on the bed. It was an hour before sunset, but the wine had set them on fire. Hsi-mên took a silver clasp from its case and put it in position while Porphryry fondled him with her delicate hands. To her, his weapon looked magnificent; the veins were swelled with purple blood, and the flesh was firm and strong. She sat on his knee and they put their arms around each other and kissed again. Then she raised one of her legs, and, with her hand, helped his sword find her scabbard. While they fenced, Hsi-mên ran his hands over her body. Her flesh was soft but firm. Her hair was silken and dainty. At length he ordered her to lie on the bed. He put her legs around his body and hurled himself ferociously on his prey.

The Chinese also used opium pills to prolong a man's erection:

> Take only a speck of it, once it comes on you
> Run like the wind to the bed chamber.
> The first encounter will leave you invigorated;
> The second will make you stronger than before.
> If twelve beauties, dressed in scarlet, were waiting for you,

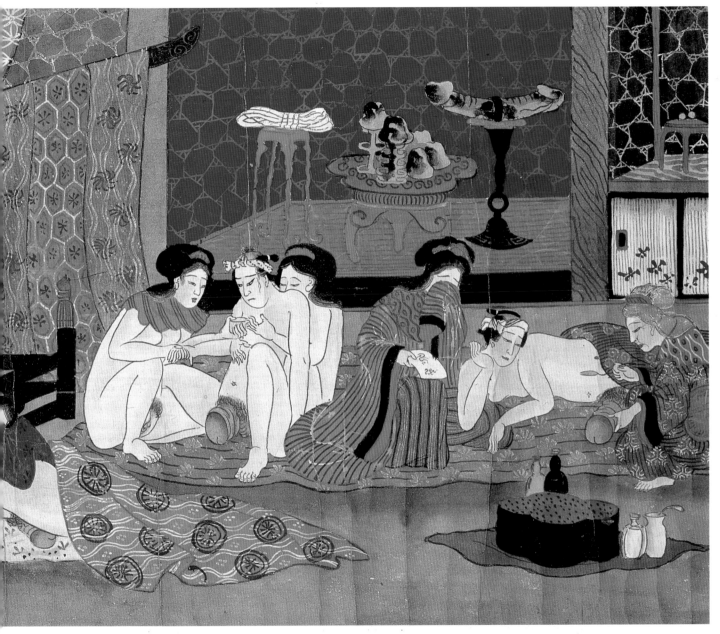

From the shunga scroll *Island of Woman*, this scene is called 'The Orgy'.

You would be able to have them all, any way you wished.
All night long, your weapon would stand on end.
You would find new strength in your limbs and belly;
Your testicles would constantly be refreshed and your penis envigorated.
If you take a grain or so each time,
Your weapon would be merciless,
Your manhood would be rigid.
At the first planting, the seed would germinate.
You can have ten women in one night
And feel no slackening of your vital powers.
Older women will furrow their brow.
Younger ones will be exhausted.
When you are satisfied and want to stop
Take a mouthful of cold water.
Withdraw your weapon
You will not be harmed.

Herbs were used if there were problems in gaining an erection in the first place:

If, upon rubbing and toying with it, the prickle will not stand at point, thy mistress must take dried aromatic herbs – such as are scattered upon corpses – a couple of handkerchiefs and a gugglet of water. Wash the prickle, as if it were a dead body, then shroud it with herbs and lament the untimely fate of such a young and vigorous yard; for such must ward away the Evil Eye, which has ensorcelled thy member. Verily, thy penis is buried so that it may soon experience resurrection.

To increase the pleasure and the pain, Hsi-mên 'burned grains of incense on her belly and at the entrance of the cunt of Lady Lin'. Another time, he went one better:

The woman lay down on the couch, and Hsi-mên took from his pocket three grains of incense moistened with wine, which he had kept from the time when he had his pleasure with Lady Lin. He took off her clothes and placed one grain on her breast, one on her belly and in her vagina. Then he lit them. He put his penis into her cunt, lowered his head to see it. It was not long before the incense had burnt down to her skin. She wrinkled her brow and gritted her teeth with pain. At last, in a trembling voice, she said: 'Stop, I cannot bear it any more.'

Certainly the smell of the burning incense must have added to the aesthetic experience. But a nicer, gentler effect was created by the tinkling of the tiny bells that Chinese women wore in bracelets around their ankles, so that they would sound during lovemak-

ing. But such delicate pleasures were not for Hsi-mên, who was a fiend for aphrodisiacs and other drugs:

> He took a little red powder from a silver box, no more than prescribed, and inserted it into the horse's eye. The medicine took effect immediately. His penis stood fiercely erect, its head swelled and the eye wide open. The cross-nerves could plainly be seen. It was dull red in colour, like liver, almost the length of seven fingers and much thicker than usual. Hsi-mên was very pleased. The medicine was a fine thing. The woman sat naked on his knee, took his penis in her hand and said: 'So this is why you wanted to drink spirits. You wanted to make him like this.' Then she asked him where he had got the medicine and he told her about the Indian monk.
>
> She lay on the bed with two pillows under her. He tried to insert his penis but, at first, it would not go in. But soon the juices of love began to flow from her and it grew easier. But he could still only get the tip into her. After a while the wine he had drunk began to take its effect. He withdrew slightly, then sank it back deeply into her, producing unspeakable pleasure. She too orgasmed, then lay on the couch as if she could not move. She said in a tearful voice: 'My dearest one, your wonderful penis will be the death of me.' But soon she whispered again: 'My life, my joy, don't you want to enjoy the pleasure from the rear?' She turned face down and his penis got to work again. 'Go on, go on, my darling,' she urged, 'don't hesitate. If you bring a lamp, the pleasure will be all the greater.' When the lamp moved nearer, she parted her legs wider. He plunged deeper into her, while she moved backwards on to him, playing with the flower of her womb at the same time.'

Later, Hsi-mên used his medicinal ribbon on her. He took it from his sleeve and:

> ...put it on his penis and tied the ends around his body. Then he drank a dose of medicine mixed with wine. She massaged the penis and soon it rose proudly. The skin reddened and the veins stood out. The silk ribbon was more effective than the clasp. Hsi-mên took the woman on his lap and put his penis into her. They drank wine, passing it from each other's mouth and playing with each other's tongue.

One thing led to another:

> She locked the door and went to wash her cunt. When she came back she took off her trousers and went to bed. They lay down together and put their arms around each other. Hsi-mên was still thinking of Captain Ho's wife and his ardour was inflamed. His penis was very hard. He told the woman to raise herself on her hands

and feet like a horse and he plunged himself into her back flower. He did this six hundred times. Her fundament made approving noises while she played with her front flower and whispered endearments.

But still Hsi-mên was not satisfied:

> He asked the woman to turn over and tied her feet with two ribbons to the bedposts to play the game of the golden dragon stretching its claws. Sometimes he thrust deeply into her, sometimes only a little way. Afraid that she might catch cold, he put a red silk coat around her. Then he brought the lamp nearer and bent his head to see the movements. Every time he took his penis out, he put it in again up to the hilt. He did this six hundred times. In trembling voice, the woman called out all the endearing names she could think of. Soon he withdrew himself altogether and put a little red powder on the tip of the penis. When he pressed it in again, the woman's cunt was so excited that she could hardly bear it. Raising herself on top of him, she begged him to penetrate further but the man deliberately dallied at the entrance, playing with her flower and would not go further. The erotic fluid came from a spring. Under the lamp Hsi-mên put her white legs around his body on both sides and looked closely. As he trembled, he saw her legs trembling too, and at the sight he was filled with an even fiercer desire.

The desire did not last, though. When Hsi-mên got home to Golden Lotus that night, although she fondled his penis and sucked it, she could not get it to rise. But she found his pills and gave him three of them. Then, while he was still asleep, she tied his ribbon around his penis and 'put some powder on the tip of his penis, and inserted it into her vagina. At once, it penetrated to the very heart of her flower.' She did this 200 times, then:

> ...she twisted herself about on his penis, which remained wholly inside her vagina, except for the two testicles which remained outside. With her hand she drew out the penis and marvelled at the wonder of it. The secretions poured out and in a short time had used up five towels. But although the tip of his penis glowed hotter than a coal, Hsi-mên did not come. Such was the constant constriction that he asked the woman to take the ribbon off. She did so and the penis remained rigid and he told her to suck it. She bent down, took the tip between her red lips and sucked it, moving it to and fro. Suddenly white semen poured forth like quick silver; she took it in her mouth but could not swallow it fast enough. At first it was semen, then it turned into a continuous flow of blood.

After that Hsi-mên realizes that he is ill and consults a doctor, who gives him some medicine:

Spanking has always been thought of as the English perversion – though this print is French, from the eighteenth century.

Hsi-mên drank the medicine, but his penis, as though made of iron, stood up permanently. Throughout the night the woman, not knowing what harm she could do, mounted him and made 'the candle upside down'. He fainted several times.

The red powder that Hsi-mên used was a mixture of cinnamon, mustard, pepper and ginger. It was designed to make the head of the penis and the mucus membrane of the vaginal walls swell, thereby increasing stimulation. Eventually Hsi-mên used too much of it and, during one tremendous orgasm, blew his head off.

Some Brahmins devised other bizarre methods of increasing the enjoyment of intercourse. They would provoke a bee to sting them on the penis before sex. This increased the swelling and, some said, gave the sensation of a pleasurable plain. And women in the harem would insert small weights between their labia, which would produce a pleasurable sensation from the slightest movement.

England, of course, has always been the home of flagellation. In the late eighteenth and early nineteenth centuries the notorious brothel of Mrs Theresa Berkeley at 28 Charlotte Street boasted:

> ...shafts with a dozen whip thongs in them, a dozen different sizes of cat-o-nine tails; battledores, made of thick sole-leather with inch nails run through, and curry-combs.

She also used 'holly brushes, furze brushes; a prickly evergreen called "butcher's bush" and stinging nettles to scourge her customers often, she remarked, restoring "the dead to life"'. If the customer wanted to beat, rather than be beaten, then One-Peg, Ebony Beth and other strong lasses were on hand. And for two hundred guineas the customer could flog Mrs Berkeley herself.

The playwright Christopher Marlowe was into flagellation:

> When Francus comes to solace with his whore,
> He sends for rods and strips himself stark naked;
> For his lust sleeps, and will not rise before
> By whipping of the wench it be awakened.
> I envy him not, but I wish I had the power,
> To make myself his wench for one half hour.

But the real joy of heterosexual flagellation is expressed in 'Madame Birchini's Dance':

> To look at her majestic figure
> Would make you caper with more vigour!
> The lightning flashing from each eye
> Would lift your soul to ecstasy!
> Her milk-white fleshing hand and arm,
> That ev'n an anchorite would charm,
> Now tucking in your shirt tail high,
> Now smacking hard each plunging thigh,
> And those twin orbs that near 'em lie!
> Ev'n them you'd find delightful things!
> But above all, you'd love that other
> That told you she was your step-mother!
> Then handing you the rod to kiss,
> She'd make you thank her for the bliss!
> No female Busby* then you'd find,
> E'er whipped you half so well behind!
> Her lovely face, whose beauty smiled,
> Now frowning, and now seeming wild!
> Her bubbies [breasts] o'er their boundary broke,
> Quick palpitating at each stroke!
> With vigour o'er the bouncing bum
> She'd tell ungovern'd boys who rul'd at home!

At the outer reaches of sex, costume and props often take over from consummation. Raphaël Kirchner called this picture *Through the Keyhole*.

Opposite: Otto Dix produced disturbing images of lesbian sadomasochism.

*Sir Richard Busby was the notorious headmaster of Westminster School, 1640–95.

The writer Bartolinius noted:

> Persians and Russians chastise their wives with blows from a stick on the posterior before they perform their marital duty. The bride in Russia would rather be without any other piece of household goods than rods. These rods are never used for punishment, but only for the purpose mentioned.

Women indulged in flagellation, too. The *Bon Ton Magazine* of December 1792 describes a female flagellants' club:

> These female members are mainly married women, who, tired of marriage in its usual form, and the cold indifference which is wont to accompany it, determined by a novel method to reawaken the ecstasy which they knew at the beginning of their married life...The honourable society or club to which we refer never has fewer than twelve members. At each meeting six are chastised by the other six. They draw lots for the order of procedure: then, either a written speech is read, or an extempore one delivered, on the effects of flagellation as it has been practised from the earliest age up to the present day: ...after which the six patients take their places, and the six flagellants begin the practical demonstration. The president of the club hands to each a stout rod, and begins the chastisement herself, with any variations she likes, while the others watch. Sometimes, by order of the punishment, the whipping starts on the calves and goes up to the posterior, until the whole region, as Shakespeare says, from milk-white 'becomes one red'.

Other people seek even more bizarre outlets for their lust. Paolo Mantegazza, the author of *L'Amour dans l'Humanité*, wrote:

> The Chinese are famous for their love affairs with geese, the necks of which they are in the habit of cruelly wringing at the moment of ejaculation, in order that they may get the pleasurable benefits of the anal sphincter's last spasm in the victim.

According to the Marquis de Sade, this custom, known as avisodomy, was also practised in Paris brothels in the eighteenth century, but a turkey was used instead of a goose. Lord George Herbert also reports the story of an Arab girl who favoured intercourse with a horse:

> Mohammed was my favourite stallion. He was more fleet than the wind, and so gentle that he obeyed my slightest word. He was of a bright wine colour and his shape was perfect. His head was small and gracefully set on his arching back. His brown eyes had almost human intelligence. His limbs were slender, and he walked so proud that he seemed to spurn the ground.

He came up to me, and after I had fed him from my hand, I spent some time braiding his mane. Then, for want of something else to do, I thought I would take a bath. A pool where the water gathered from a spring which fed the oasis made a fine bath. It was shaded by palm trees from the sultry heat which glowed on the surrounding sands. After bathing I threw myself at length on the short grass which bordered the pool. I was in no hurry to dress and stretched myself lazily on my back at full length.

Mohammed came and stood over me as if for company in our loneliness. I amused myself by making him stand with his forefeet on either side of my chest. Nothing could have induced him to step on me, not even if a gun had been suddenly fired. But there was nothing to startle him. We were entirely alone.

Pretty soon – as stallions will when standing in perfect repose – his shaft hung dangling out. In a spirit of mischief I put up both my feet and took it between them and began rubbing it gently. It gradually stiffened, and its crest hung down between my thighs and pressed against the lips there. He put his head down and touched my bosoms with his velvety nostrils. I still continued to rub up and down his shaft with my feet, till its presence between my thighs awakened a pleasant sensation. In fact, I became more wanton with desire and worked my feet more rapidly up and down his shaft. It suddenly shot out, and, stretching my sheath to its greatest tension, penetrated me to my loins.

I was ravished with the fierce thrill and the stallion's gushing sperm. It found no room in my distended orifice and spurted out of it again like a fountain descending over my belly and thighs. Luckily for me, the distance between his loins and mine was sufficient to prevent anything but the end of his shaft from entering. Otherwise, I know not but that it would have been driven through the length of my body and come out of my mouth.

As it was I scrambled out from under him with my lust completely quenched. From my waist to my knees I was dripping with the stallion's thick milky sperm. I hastened to wash it off and to bathe and cool my smarting sheath in the pool. For a long time I had to keep Mohammed away from me with a switch, but I did not strike him hard. I could not bear to hurt him for the consequences of my own folly.

This Roman lamp depicts the common fantasy of a woman having sex with a horse.

This was plainly a fantasy. But even more fantastical fun can be had doing it on a horse, according to Lord George:

> We were borne along at an unflagging gallop. Hasan held me in front of him like a baby in his arms, often kissing me, his kisses constantly growing more ardent; and then I left his stiff shaft pressing against my person. He suggested that I ride astride for a while and rest myself by a change of position. I obeyed his suggestion, turning with my face towards his and putting my arms around his neck, while my thighs were spread wide open over his own. He let the bridle drop over the horse's neck, whose headlong pace subsided into a gentle canter.
>
> Hasan put his arms around my loins and lifted me a little, and then I felt the crest of his naked shaft knocking for entrance between my naked thighs. I was willing to yield to Hasan anything he wished; but no sooner had the lips of my sheath been penetrated than I involuntarily clung more tightly around his neck and, sustaining myself in that way, prevented him from entering further. Hasan's organ seemed adapted to the place and excited a sensation of pleasure. I offered my mouth to Hasan and returned his passionate kisses with an ardour equally warm. A desire to secure more of the delightful intruder overcame my dread of the intrusion.
>
> I loosened my hold on Hasan's neck; my weight drove his shaft so completely home, notwithstanding the tightness of the fit, that his crest rested on my womb. It felt so unexpectedly good as it went in that I gave a murmur of delight. The motion of the horse kept partially withdrawing and completely sending it in again at every canter. The first thrust, good as it was, was entirely eclipsed by each succeeding one. I could have murmured still louder with delight; but what would Hasan think of a girl so wanton? But he was in no condition to think. He was fiercely squeezing and kissing me; while at every undulating movement of the cantering horse he seemed to penetrate me farther, and my womb was deeply stirred. The pleasure was too exquisite to be long endured. It culminated in melting thrill, and my moisture mingled with the sperm that gushed from Hasan's crest. He reeled in the saddle, but recovered himself. The cantering motion drove his shaft less deeply in as it became more limber. It finally dropped out of me, a limp little thing drowned in the descending moisture.
>
> 'What a conquest for a slender girl to achieve over such a formidable object!' I thought. Exhausted, but triumphant, I laid my head on Hasan's shoulder. Twice more during the night he slacked the speed of his horse, and each time we completed an embrace equally satisfactory.

There have been periods of history that make our own age seem positively puritan.

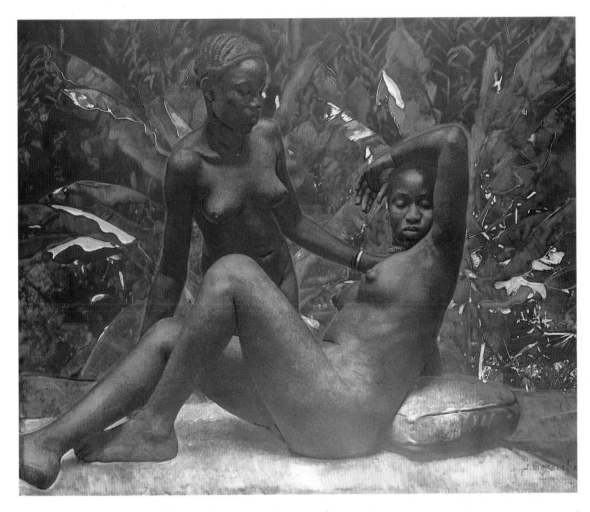

Jacques Majorelle painted *Two Friends* around 1900. African women have always had a particular sexual caché for European men.

According to Theopompus, a Greek historian of the fourth century BC:

> It was the law among the Etruscans that all the women were held in common. They took great care of their figures, practising gymnastics naked with men and alone. They had no shame in nudity.
>
> They did not eat with their husbands, but took their meals with any man they liked. They were very fond of eating and drinking, and were very beautiful. Often children were born without knowing who the father was. When they grew up, they lived in the same way, drinking heavily and having any woman that came their way.
>
> Etruscan men have sex quite openly with boys, actively and passively, for homosexuality is the common custom of the country. There is not disgrace in

From ancient times, white women have sought an extra dimension in sex with dark-skinned men.

sexual activity. If a visitor comes while the master of the house is enjoying his wife, the man will calmly explain that he was engaged in this or that indecent act.

When they have a party and have drunk enough, they go to bed. Servants then bring in to the lighted bedroom prostitutes, pretty boys and sometimes their wives. When they have sated their appetites, young men in their prime are brought to enjoy the women and boys. They worship love and sometimes watch while others are doing it, though generally a curtain is lowered. They like women, but generally prefer men and boys. They kept themselves beautiful by removing all the hairs from their bodies. There are many shops where hair is removed. They go there and have any part of their body depilated without worrying about the prying eyes of strangers.

The Roman Emperor Augustus was so oversexed that at banquets he would leave the table between courses and lie on a couch in the ante-room with whichever woman he

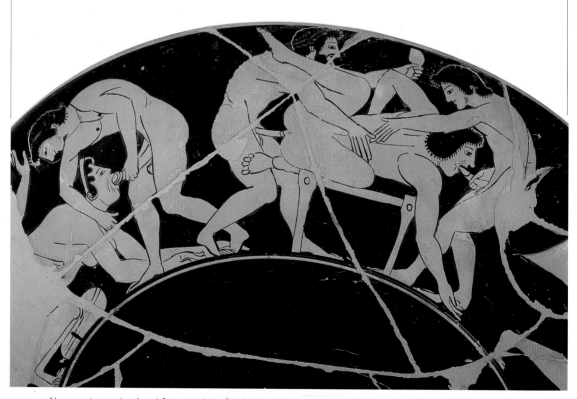

Above and opposite: A red-figure cup by a Greek artist known as the Pedeius painter showing an energetic orgy scene from the late sixth century BC. Many Greek artists worked in this style.

suddenly desired – even the wives of friends. Often he did not bother to adjust his clothes before returning.

Dionysius the Younger, the tyrant of Siracuse, was even worse, according to the Greek historian Clearchus:

> When Dionysius returned to his home-town Locris, he had the biggest house filled with roses and wild thyme. Then he sent for the young women of Locris, one by one, stripped himself and them naked, took them to bed and performed every obscene act imaginable.

Retribution was not long in coming, though:

> A little later, the outraged husbands and fathers caught up with Dionysius's children, forced them to perform all kinds of indecent acts publicly. After they were satisfied, they had needles driven under their fingernails and were put to death.

Women could be just as bad. Juvenal records the scenes that took place when the female worshippers of Bona Dea were left alone in the house:

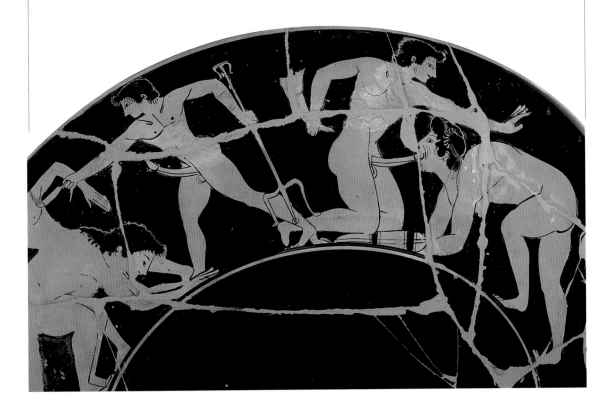

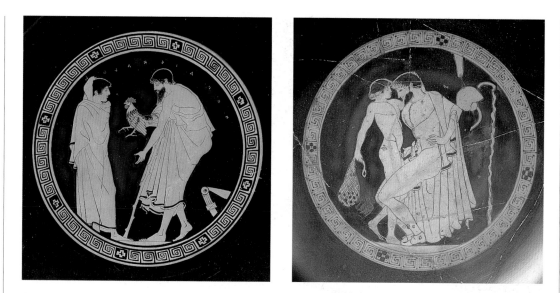

Homosexuality is a common theme in Greek pottery painting. Here a man offers a boy a cock.

A man arouses himself by fondling a boy, depicted by the Brygos painter around 500–475 BC.

> Shrieking flutes excite the women's loins, wine and the trumpet madden them. Whirling and shrieking, they are rapt by Priapus. Then when their hearts are ablaze with lust, the voices stutter with it, the wine gushes in torrents down their soaking thighs…This is no pantomime. It is the real thing. Even Priam's aged loins and Nestor cold with age would burn to see it. Their itching cannot bear delay. Woman are shrieking and crying everywhere in the house: 'It is time, let the men in!' If a lover sleeps, let him grab his coat and rush here. If not, they will grab the slaves. Not even slaves. They will take the scavengers of the street.

Casanova greatly enjoyed making love to one woman while another was present. He deflowered two young girls, called Helen and Hedwig, in the presence of each other:

> I overwhelmed them with happiness for several hours, passing five or six times from one to the other before I was exhausted. In the intervals, seeing them to be docile and desirous, I made them execute Aretin's most complicated postures, which amused them beyond words. We kissed whatever took our fancy…She was delighted and watched the process to the end with all the curiosity of a doctor.

He did the same with Annette and Veronique:

> Veronique resigned herself to the passive part which her younger sister imposed on her, and turning aside, she leant her head on her hand, disclosing a breast which would have excited the coldest of men, and bade me begin my attack on Annette. It was no hard task she laid upon me, for I was on fire, and was certain of pleasing her

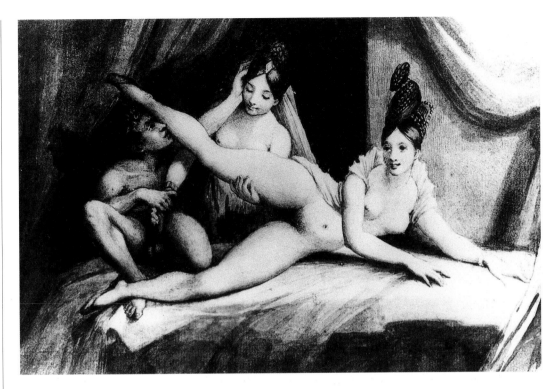

The ultimate man's fantasy – one women to arouse him, a second to satisfy him. This painting was falsely attributed to Fuseli, but is now believed to be the work of his pupil Theodor von Holst.

as long as she looked at me. As Annette was short-sighted, she could not tell which way I was looking in the heat of the action. Without her noticing, I managed to get my right hand free and so was able to communicate a pleasure as real, though not as acute, as that enjoyed by her sister. Whenever the coverlet became disarranged, Veronique took the trouble to replace it, and this offered me, as if by accident, a new spectacle. She saw how I enjoyed the sight of her charms, and her eye brightened. At last, full of unsatisfied desire, she showed me all the treasures which nature had given her, just as I had finished with Annette for the fourth time. She might well think that I was only rehearsing for the next night, and her imagination must have painted the joys to come in the brightest colours.

Casanova's enjoyment of this sort of activity sometimes provoked a spontaneous orgy. One evening he was having dinner with his business associate Bassi:

When the supper and wine has sufficiently raised my spirits I devoted my attention to Bassi's daughter, who let me do what I liked, while her father and mother only laughed, and the silly Harlequin fretted and fumed at not being able to take the same liberties with his Dulcinea. But, at the end of the supper, when I had reduced

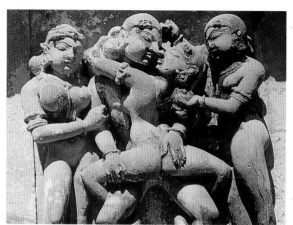

In Indian love scenes, there are often scantily clad maids to help the lovers with their lovemaking. This relief is from the temple at Khajuraho.

the girl to the state of nature and I myself was like Adam before he ate the first apple, Harlequin rose and, taking his sweetheart's arm, tried to draw her away. I imperiously told him to sit down. To my amazement, he obeyed me, but turned his back. His sweetheart did not follow his example though, but pretended to defend my victim, increasing my enjoyment, while my wandering hand did not seem to displease her.

This scene excited Bassi's wife and she begged her husband to prove his love for her. He acceded to her request, while modest Harlequin sat by the fire with his head in his hands.

The Alsatian was in a highly excited state, and took advantage of her lover's position to grant me all I wished, so I proceeded to execute great work on her, and the violent movements of her body proved that she was taking as active a part in it as myself.

Arab literature often relates tales of men sleeping with several women at the same time. But as the man has only one penis, this can cause problems:

The Caliph Haroon-er-Resheed once slept with three slave girls – one from Mecca, one from Medina and one from Iraq. The girl from Medina put her hand on his penis, fondled it and it grew erect. But the girl from Mecca grabbed it and drew it to herself.

'This is unfair,' said the Medinan. 'Mohammad said: "Whosoever quickeneth the dead land, it is his."'

But the Meccan replied: 'I was told that Mohammad said: "The quarry is his who catcheth it, not his who starteth it."'

But the Iraqi girl pushed them both away and took the erect penis herself.

'Until your dispute is resolved, it belongs to me,' she said.

For a good Muslim there is paradise to look forward to, where a man will be surrounded by 'two hundred doe-eyed houris':

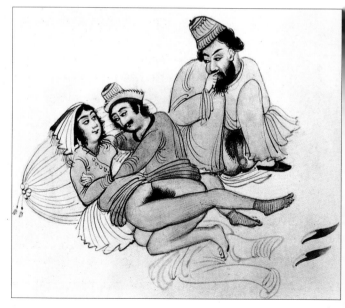

In this Persian drawing, the older man is plainly not aroused by watching the young couple make love. Perhaps he went first.

And when one blast shall sound the trumpet, and the earth shall be moved from its place, and the mountains also – and shall be dashed in pieces at one stroke – on that day, the inevitable Hour of Judgment shall suddenly come. And for the pious is prepared a place of bliss: gardens planted with trees, and vineyards, and damsels with swelling breasts and a full cup. Therein shall receive them beautiful damsels, refraining their eyes from beholding any besides their spouses, who no man shall have deflowered before their rightful spouses, neither any *jinn*. Verily, we have creation; and we have made them virgins beloved by their husbands, of equal age with them and deflowered by neither man nor spirit. And youths, which shall go around to attend them with goblets of brimming wine.

In the West, however, this sort of heaven may be found on Earth. In *A Night in a Moorish Harem* the narrator, Lord George Herbert, tells of a coupling of particular delight:

> The other ladies gathered around us, their kisses rained on my neck and shoulder, and the pressure of their bosoms against my back and sides; indeed they soon completely sustained Inez and myself that I seemed about to mingle by being with them all at once. I had stirred the womb of Inez with but a few thrusts when the rosy cheeks took a deeper dye, her eyes swam, her lips parted, and I felt a delicious baptism of moisture on my shaft.

The action moves on – one woman helps insert the penis, while arousing the other woman with a skilfully positioned finger.

In *The Way of a Man with a Maid* the male protagonist watches while a mistress strips and fondles her maid. Then he decides to join in:

> Leaning over her bottom, I gently parted her thighs, till between them, I saw the cunts of the mistress and her maid resting on each other, slit to slit, clitoris to clitoris, half hidden by the mass of their closely interwoven hairs, the sweetest of sights. Then after restoring her thighs to their original position closely pressed against each other, I gently thrust my right hand between the girls' navels, and worked it along amidst their bellies till it lay between their cunts!
>
> 'Press down, Alice!' I said patting her bottom with my disengaged hand; promptly she complied with two or three vigorous down-thrusts which forced my

palm hard against Fanny's cunt while her own pressed deliciously against the back of my hand. The sensation of thus feeling at the same time these two full fat fleshy wanton and throbbing cunts between which my hand lay in a sandwich fashion was something exquisite; and it was with the greatest reluctance that I removed it from the sweetest position it is ever likely to be in, but Alice's restless and involuntary movements proclaimed that she was fast yielding to her feverish impatience to fuck Fanny and to taste the rapture of spending on the cunt of her maid the emission provoked by its sweet contact and friction against her own excited organ.

On this seventeenth-century plate an angel counts her toes while a demon arouses her genitals.

Multiple-partner coition can be undertaken in a number of different configurations. But the *Turkish Book of Lusts* reminds readers that, if a woman is to have two men at the same time, she is going to require some artificial lubrication:

In Marquis Franz von Bayros's orgy, the lone man scarcely gets a look in.

The woman should lie straight, on her side. The man who is attacking her from the front should, after entering her, lift her upper leg and rest it on his buttock. The adversary having her from behind should then lie close to her and slide in. The two men can stab her as hard as they like. As long as the woman can keep herself straight and not pull away from one or the other, their blows will cancel themselves out and leave her fixed and steady.

In *A Night in a Moorish Harem* Lord George records the story of a young Circassian girl having three men in the Turkish seraglio at Erzurum:

We stripped entirely naked and amused ourselves by imitating the attitudes usually given by art to the most celebrated heathen deities. It was not enough for me to compare the forms of the young men by observation; I freely caressed and handled their genitals

Rubens' *The Rape of the Sabine Women* – the ultimate in classical orgies.

with my hands until they lost all restraint and gathered so closely about me that I was squeezed in their joint embrace.

I flung my arms around Qasim and bade him lie down on his back with me on top of him; his loins were elevated higher than his head by a pile of cushions on which he lay. I worked backward while he guides his shaft completely into me. My buttocks presented a fair mark for Selim, who mounted me behind and slowly worked his shaft into the same orifice that Qasim had already entered. It was the tightest kind of fit. The first entrance had stirred my desire to a flame, and made me welcome the second with great greediness. Qasim's position was such that he could hardly stir, but Selim plunged his long and slender shaft into me again and again with thrusts that required all his strength. My sheath was stretched to its utmost tension by the two shafts, but all its distended nerves quivered with lust.

Rashid now knelt close in front of me, with his knees on either side of my head. I lay for a moment with my flushed cheeks on his genitals, then I grasped his shaft in my hand and played rapidly up and down on it. Qasim, with his arms wrapped around my waist, was sucking my bosom. Selim squeezed my thighs in his grasp at every thrust he gave. I felt my crisis coming, overwhelming threefold intensity, inspired by the contact of such vigorous men at once. In my very wild abandonment I sucked Rashid's crest in my mouth, then I thrilled and melted with a groan that resounded through all the room.

All three of the young men followed me into the realms of bliss to which I soared. My sheath overflowed with the double tribute which gushed into it; my mouth was filled with Rashid's sperm. Both pairs of lips were dripping; my whole frame seemed saturated with the exquisite fecund moisture. When the mingled sighs of the young men, which echoed to my prolonged groans or rapture, had died away, I sank into a semi-conscious state from which I did not rise that evening. I was in a deep, dreamy, voluptuous repose which an occasional smarting sensation in my strained sheath did not disturb.

In Henry Neville's *The Isle of Pines*, published in 1688 – an erotic forerunner of Robinson Crusoe – the hero George Pine is shipwrecked on an island in the Indian Ocean with four women:

> Idleness and fullness of everything begot in me a desire of enjoying the women. Beginning now to grow more familiar, I had persuaded the two maids to let me lie with them, which I did at first in private; but after, custom taking away shame, there being none but us, we did it more openly, as our lust gave us liberty. The truth is, they were all handsome women, when they had clothes, and well shaped, feeding well. For we wanted no food, and living idly, and seeing us at liberty to do our wills, without hope of ever returning home, made us thus bold. One of my consorts, with whom I first accompanied, the tallest and handsomest, proved presently with child. The second was my master's daughter. And the other also not long after fell into the same condition. None now remaining but my Negro, who seeing what we did, longed also for her share. One night, I being asleep, my Negro, with consent of the others, got close to me, thinking it being dark to beguile me, but I awaking and feeling her, perceived who it was, yet willing to try the difference, satisfied myself with her, as well as with one of the rest.

After forty years Pine's offspring were said to number 565. But his sexual feats were puny compared to those of the heroes of the Arabian poem 'The Fabulous Feats of the Futtering Freebooters':

> The member of Abu'l-Haylukh remained
> In erection for thirty days, sustained
> By smoking hashish.
> Abu'l-Hayjeh deflowered in one night
> Eighty virgins in a rigid rite
> After smoking hashish.
> Felah the Negro did jerk off his yard

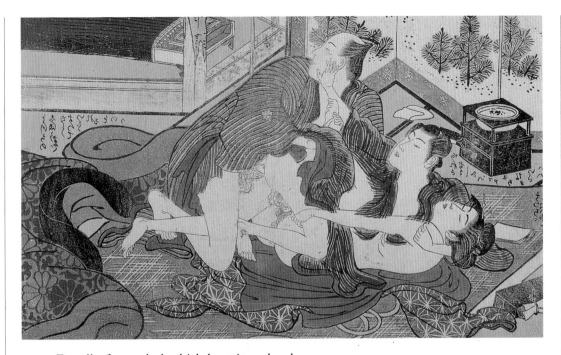

Two men busy
themselves with
one woman in
a shunga print
by Kitao
Masanobu.

> For all of a week; hashish kept it up hard.
> The Negro Maymum, with opiate,
> Without stopping to ejaculate,
> Futtered for fifty consecutive days.
> Allah bepraised him for having fulfilled such a task.
> But then, fresh vigour instilled,
> Obliged to furnish ten days more –
> Making sixty days of coition his score –
> He fain went on and finished the chore.
> During this ordeal Maymum, in bed,
> Smoked what held up his penis head: Hashish!

In ancient China a man would have to perform such feats on a daily basis, if he had a large household. And even when a man found one of his wives and concubines had grown old or ugly, it was a grave offence to overlook her:

> Even if a concubine is growing old, as long as she had not yet reached fifty, the husband shall have sex with her once every five days. She on her part, when led to his divan, will be clean, washed, neatly dressed with her hair combed and fixed, wearing a long robe with her shoes properly fastened.

And there was a right way and a wrong way to introduce a new concubine into the household:

> I recently heard of a civil servant who took a new concubine. He locked himself up with her for three days behind double doors. All his wives and concubines were great incensed at his behaviour. This is the wrong way.
>
> The right way is for the man to control his desire. For the time being he should ignore the new concubine and concentrate on the others. Every time he had sexual intercourse with another woman, he should make the new concubine stand beside the couch and watch. After four or five nights of this, he may have sex with the new concubine for the first time, but only with his principal wife and the other concubines present. This is the way to preserve harmony and happiness in the women's quarters.

Naturally, the Emperor would go one better, and the ultimate male fantasy is described in *The Erotic Adventures of Sui Tang Ti*. Among his many amazing constructions, the Emperor Yang Ti (AD 569–618) built the Maze Palace. The main palace was surrounded by thirty-six smaller palaces, all hidden in a forest of flowers:

> The magnificent main palace was a three-storey golden pagoda that glistened in the sunlight. Verandahs circled each storey. On them stood hundreds of palace maidens, smiling. They were clad in robes of the finest cicada-wing lace. With nothing underneath, their firm young breasts, slender waists and shapely legs could be seen – it was even more provocative than if they were nude.
>
> Inside the palace there were numerous rooms. These were connected by intricate passageways. In the main chamber Yang Ti had four enormous silk tents named Intoxicating Passion, Sweet and Fragrant Night, Delight of Autumn Moon and End of Spring Sorrow. Inside each tent, there were thirty or forty naked girls who played games, talked and joked or reclined on tiger-skin couches. Although the atmosphere was sedate, each of them secretly longed for the arrival of the Emperor, who would descend like a cloud.
>
> The walls of the chamber were lined with shiny bronze mirrors. They were hollow inside and incense was burnt in them. The room was full of the fragrance of jasmine, musk, peonies and orchids. Overhead were silk lanterns with pictures of naked beauties in provocative positions painted on them. They gave off the light of a faint moon and with candles inside them it looked like the naked beauties were about to descend any minute.
>
> When the Emperor arrived at the palace, he would be greeted by eight kneeling eunuchs. They would take his clothes and dress him in a leopard-skin loin cloth,

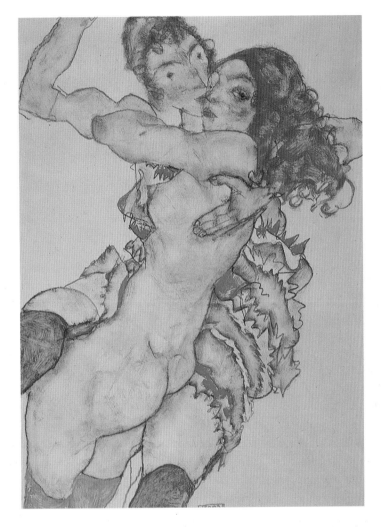

Two Girls Embracing by Egon Schiele.

lined with yellow silk. He would then wander about his palace, but he would always end up in the main chamber.

When he entered the girls would cry, 'May the Emperor Live a Thousand Years'. He would then drink ginseng wine from a golden goblet until he felt his jade stem stir beneath his leopard-skin loin cloth. Then he would grab any woman in sight, though being slightly tipsy and surrounded by mirrors he would find it difficult to distinguish the real women from their images.

Then he would enter one of the silk tents. With his eyes shut, he would let himself by guided by the women's voices. He found it more fun catching a woman this way. When he got hold of one, he would push her down on a bed, couch or

tiger-skin mattress. Quickly he would throw away his leopard-skin loin cloth and push his jade stem into her moist jade gate, with a thrust that could have torn through an animal hide. The giggling and whispering of the other women would continue. And, though he had not yet satisfied the first woman, he would jump up and grab another, taking her in a different position or having her standing up. When he was thoroughly satisfied, he would doze off. And when he woke up the love game would start all over again. As the light in the chamber was artificial, you could not tell whether it was day or night. And Yang Ti did not care.

The Roman emperors also furnished themselves with erotic delight. According to Suetonius, the Emperor Tiberius had a room in his villa on Capri:

> ...adapted to the purpose of secret wantonness, where he entertained companies of girls and catamites, and assembled from all quarters dancers of monstrous lewdness who he called Spiritraie...He had many bedchambers hung with paintings and sculptures depicting figures in the most lascivious positions and furnished with the books of Elephantis, so that none might want for a pattern for the filthy things they were expected to do. He arranged in the woods and groves recesses for the gratification of lust. In caves young persons of both sexes indulged their passions in the guise of Pans and nymphs.

Worse, Tiberius taught 'fine boys, the tenderest and daintiest that were available – who he called little fishes – to play between his legs while he was swimming and nibble at his private parts.'

Nero went even further, turning his orgies into uninhibited extravaganzas. Tacitus wrote:

> The most notorious and profligate of these entertainments were those given in Rome by Tigellinus [head of the Praetorian Guard]. A banquet was set out upon a barge on a lake in the palace grounds. This barge was towed about by vessels picked out with gold and ivory and rowed by debauched youths who were chosen in accordance with their proficiency in libidinous practices. Birds and beasts had been collected from distant countries, and sea monsters from the ocean. On the banks of the lake were brothels filled with ladies of high rank. By these were prostitutes, stark naked, indulging in indecent gestures and language. As night approached the groves and summer-

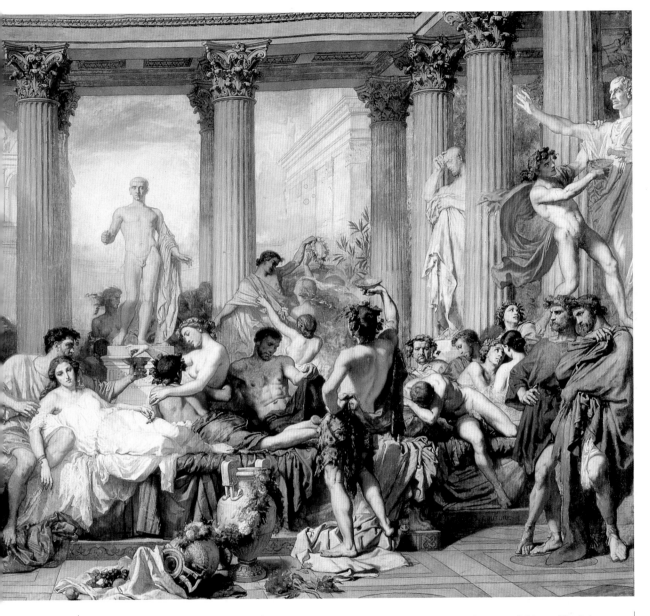

houses rang with songs and were ablaze with lights. Nero disgraced himself with every kind of abomination, natural and unnatural, leaving no further depth of debauchery to which he could sink.

Nero certainly was a past master when it came to vice. He tried to turn one of his lovers,

Above: Roman decadence through the eyes of the nineteenth-century painter Thomas Couture.

a boy named Sporus, into a girl by castration. It did not work, but he married Sporus anyway. Nero dressed him up in the clothing of an Empress and took Sporus around with him, kissing him amorously wherever he went.

He also liked to tie unwilling sexual partners of both sexes to the stake. Then he would dress up in the skin of a wild animal, be released from a cage and attack their sexual parts. Once he had been sufficiently turned on by this, he would be taken by a freedman named Doryphorus. They also married with, this time, Nero taking the female part. On their wedding night Nero was heard screaming and moaning, it was said, like a virgin bride being deflowered.

But the Italian Renaissance knew even greater excesses – at least in the form of male sexual fantasy. For some reason they always involved nuns. This one appears in *Don Bougre*:

> I was put on a bench, completely naked; one sister placed herself aside my throat in such as way that my chin was hidden in her pubic hair, another one put herself on my belly, a third one, who was on my thighs, tried to introduce my prick into her cunt; two others again were placed at my sides so that I could hold a cunt in each hand; and finally another one, who possessed the nicest breasts, was at my head, and bending forward, she pushed my face between her bubbies; all of them were naked, all rubbed themselves, all discharged; my hands, my thighs, my belly, my chest, my prick, everything was wet, I float while fucking.

But the literary master Pietro Aretino presents the orgy to beat all orgies, and the orgasm to beat all orgasms:

> In the end, the sisters on the bed with the two young men, the General and the nun he was riding, together with the chap in his backside and, last but not least, the sister with her Murano prodder, all decided to come together like a choir singing in unison or, more aptly, the blacksmith hammering in time, each attending to their own business until all that was heard was: 'Oh God, oh Christ.' 'Hold me!' 'Ream me!' 'Push your sweet tongue out!' 'Really give it to me!' 'Harder!' 'Hold on, I'm coming!' 'Sweet Christ, shove it to me.' 'Holy Father.' 'Hug me!' and 'Help!' Some were whispering, others were groaning loudly. To listen to them you would have thought they were practising their scales – so, fah, me, ray, doh. Their eyes were popping out of their heads. Their groans and gasps, their twists and turns made the chests, beds, chairs and chamber pots shake and rattle like the house had been hit by an earthquake.

One can only wonder what they did the next night.

Opposite: Rape in antiquity is a regular theme of Rubens. Here the victim is the daughter of Leucippus.

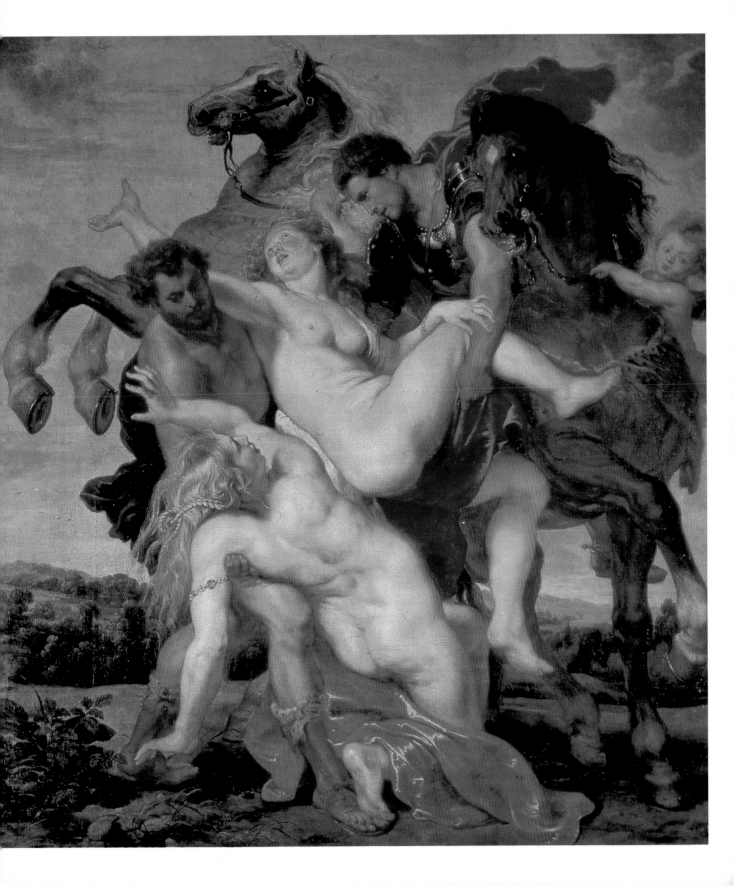

PHOTOGRAPHIC ACKNOWLEDGMENTS

The publishers are grateful to the individuals who allowed access to their private collections. Otherwise photos were supplied by:

Ancient Art & Architecture Collection, London: 161; /Museo Nazionale Naples: 58 top

Ashmolean Museum, Oxford: 115 top, 178 both

Gisbert Bauer: 160 btm

Bridgeman Art Library, London: /Alte Pinakothek Munich: 191; /Bonhams London: 9 top, 41, 66; Bosworth Books Leicestershire: 137; /Christie's London: 69; /Fitzwilliam Museum Cambridge: 67; /Victor Lownes Collection: 75, 97, 112, 113, 123, 131; /Max Lutze Collection Hamburg: 65; /Musée Bonnat Bayonne: 25; /Musée des Augustins, Toulouse: 7; /Musée du Louvre / Giraudon: 15; /Museum of Fine Arts Budapest: 80, 187; /National Gallery of Victoria, Melbourne: 8 centre; /Gerard Nordmann. Collection Geneva: 51, 153; /Private Collections: 37, 44, 49, 60 & jacket, 83, 93, 98, 103, 106, 116, 118, 119, 165; /Stapleton Collection: 32, 50, 76, 77, 101, 124, 125, 132, 135, 143, 145, 146, 151 top, 154, 155, 156; /Victoria & Albert Museum London: 107, 185; /Villa Stuck Munich: 130; /Whitford & Hughes Ltd London: 14, 20, 38, 61, 63 top, 138, 175

Trustees of the British Museum: 24, 129, 173

Christie's Images, London: 9 btm, 12, 16, 19, 21 btm, 22, 26, 31, 33, 35, 39, 46 top, 62 top, 62 btm, 86, 87, 96, 134, 162, 170, 171

Cyprus Museum, Nicosia: 152

Werner Forman Archive, London: 8 btm, 17 top, 53; /Anspach Collection New York: 36; /Centennial Museum Vancouver: 57 btm; /Egyptian Museum Turin: 120 btm; /Philip Goldman Collection: 17 btm, 89; /Private Collections: 43, 47, 88 top, 94, 95, 105, 109, 110, 111, 114, 117, 120 top, 121, 136, 148, 149, 159 top, 160 top; /Dr Kurt Stavenhagen Collection Mexico City: 88 btm

Kinsey Institute for Research in Sex, Gender & Reproduction, University of Indiana, Bloomington: 151 btm

MacQuitty International Collection, London: 6 btm, 115 centre, 150; /Museo Nazionale Naples: 46 btm, 48; /National Museum Athens: 115 btm

Musée des Beaux-Arts de Reims: 40 (photo: C. Devleeschauer)

Musée d'Ixelles, Brussels: 2

Museo Arqueologico Nazionale, Tarquinia: 158 btm

Museo Nazionale, Naples: 6 top, 8 top, 58 btm, 64, 68 top, 68 btm, 158 top, 159 btm, 176 top

Museum of Fine Arts, Budapest: 29

Pabst Gallery, Munich: 55

Réunion des Musées Nationaux de France (for Musée du Louvre & Musée d'Orsay, Paris: 45 (photo: H Lewandowski), 5, 63 btm, 176 btm, 177, 182 top (photo: Arnaudet), 189

Rheinisches Landesmuseum, Bonn: 57 top

Statens Konstmuseer, Stockholm: 70 top, 72

Staatliche Museen zu Berlin, Presussischer Kulturbesitz Antikensammlung: 52, 53 top, 59

Visual Arts Library, London: 4, 180 top; /Collection du Cercle d'Art: 13; /Musée Carnavalet Paris: 169 (photo: J. d'Hoir); /Musée du Petit Palais Paris: 139; /National Gallery London: 183; /Prado Museum Madrid: 21 top

Witt Library of the Courtauld Institute, London: 126, 179, 181